ICONIC
TAROT
DECKS

ICONIC
TAROT
DECKS

The History, Symbolism and
Design of over 50 Decks

SARAH BARTLETT

FRANCES
LINCOLN

First published in 2021 by Frances Lincoln Publishing,
an imprint of The Quarto Group.
The Old Brewery, 6 Blundell Street
London, N7 9BH, United Kingdom.
www.QuartoKnows.com

Text © 2021 Sarah Bartlett

A catalogue record for this book is available from the British
Library.

ISBN 978 0 7112 5171 7

10 9 8 7 6 5 4 3 2 1

Design by Paileen Currie
Printed in Singapore

Brimming with creative inspiration, how-to projects and
useful information to enrich your everyday life, Quarto
Knows is a favourite destination for those pursuing their
interests and passions. Visit our site and dig deeper with
our books into your area of interest: Quarto Creates, Quarto
Cooks, Quarto Homes, Quarto Lives, Quarto Drives, Quarto
Explores, Quarto Gifts, or Quarto Kids.

Picture credits

The publishers thank the following for permission to reproduce
the tarot cards in this book. Every effort has been made to provide
correct attributions. Any inadvertent errors or omissions will be
corrected in subsequent editions.

Illustrations from the following decks reproduced by permission
of Lo Scarabeo S.r.l., Italy. © of images belong to Lo Scarabeo S.r.l.
The Book of Thoth Etteilla Tarot (6, 51–5), Rider-Waite-Smith
Tarot (20–6, 57–3), Visconti-Sforza Tarot (28, 37–43), Sola
Busca Tarot (30l, 164–9), The Classic Tarot (83), The Universal
Tarot (84–5), The Mystical Tarot (86–7), John Bauer Tarot (100,
135–7), The Golden Tarot of the Renaissance (104–9), Mantegna
Tarocchi (111–15), Minchiate Etruria (117), Mitelli Tarocchino
(118–19), Tarot of the Thousand and One Nights (138–9),
Crystal Tarot (141), The Golden Tarot of Klimt (149), The Lost
Code of Tarot (152–3), Tarot Illuminati (187), Tarot of the New
Vision (206–7), Nefertari's Tarot (208–9)

Illustrations from the following decks reproduced by permission
of U.S. Games Systems, Inc., Stamford, CT 06902 USA. © U.S.
Games Systems, Inc. Further reproduction prohibited.
The Aquarian Tarot (70, 74–7), Morgan-Greer Tarot (78–81),
Crystal Visions Tarot (90–1), Paulina Tarot (92–3), The Golden
Tarot (96–9), The 1JJ Swiss Tarot (126–7), Deviant Moon Tarot
(150–1), Oswald Wirth Tarot (171–3), The Hermetic Tarot
(182–3), Bianco Nero Tarot (204–5), The Goddess Tarot (220–1)

Courtesy of Alchimia Publishing (191); Bibliothèque nationale
de France (19, 32, 44–9, 120–2); Illustrations from the Dreams
of Gaia Tarot deck reproduced with permission of Blue
Angel Publishing. Copyright 2020 Ravynne Phelan. Further
reproduction prohibited (203); The Church of Light (185); Ciro
Marchetti and Llewellyn Worldwide (158–9); Editions Vega
(14, 157); HarperCollins (145–7); International Tarot Museum
– Riola – Italy (124–5); James R. Eads, www.jamesreads.com
(155); Konigsfurt Urania (192–3, 217); Labyrinthos (17, 218–19);
Llewellyn Worldwide (198, 215); Nemo's Locker (213); Noreah
Press (31, 160, 195); Images taken from The English Magic Tarot
by Rex Van Ryn, Steve Dooley, and Andy Letcher. Tarot cards
and colorization copyright © 2016 by Stephen Dooley, used with
permission from Red Wheel/Weiser, Newburyport, MA. www.
redwheelweiser.com (175–7); Race Point (10, 89); Robert M.
Place (179–81); © Salvador Dalí, Fundació Gala-Salvador Dalí,
DACS 2021 (142–3); theasis/iStock by Getty Images (30r, 65-68)

Contents

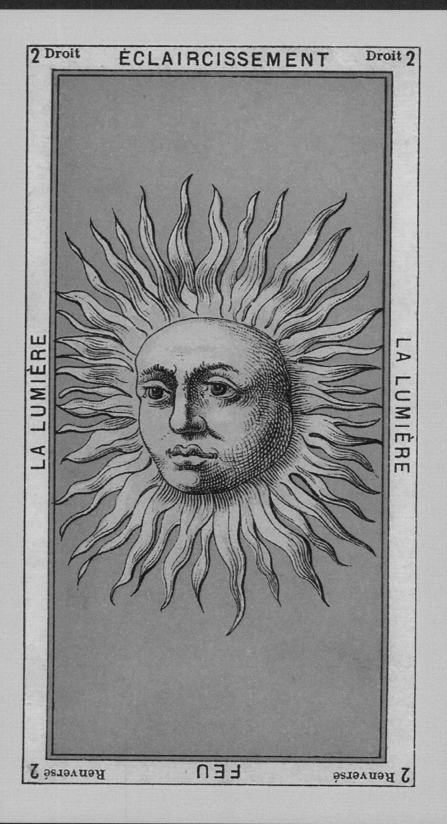

Introduction

In the world of tarot, it has become fashionable to use the analogy of the Fool's journey as our own as we set off down the path to self-understanding. The Fool, or oneself, meets other characters or experiences various states of being (as seen in the major arcana cards) that are considered stepping stones for personal growth. In fact, each card or stepping stone mirrors something ineffable and magical within us. Our tarot journey also enables us to learn to make decisions or take responsibility for our choices, or we begin to understand the deeper archetypal themes to which we resonate. But breaking away from this belief (and one to which I thoroughly subscribe), I would like to suggest that it is also the stories of tarot's creators, artists, mystics, occultists, nobility, poets and princesses that are also a reflection of you.

In fact, it is also these characters who are at the core of your tarot journey, whether it is the artist who painted the Renaissance miniature portraits or the occultist who craftily added esoteric symbols to a card's imagery. All these people and ideas are forever preserved in the tarot, and all of them reflect you.

That's why this book is unique, in that it's not just a history of tarot, nor a practical guide to interpretation, healing or divination. It is about the tales and secrets, the symbols and escapades that imbue and permeate tarot, and the legacy of all who have come across it, too. It is this cultural 'life' that brings tarot alive. Whether in its first use as a risk-taking game or as a reminder to dukes and courtiers of family folly, like a plum marinating in the finest wine, the tarot has soaked up the sweetest and most bitter flavours from the past. And again, whether as a medium for esoteric messaging or a divinatory tool, the tarot gathers in its wake, like a great train of thought, all images, ideas, philosophies, esoterica, cultural or social, of the places through which it has passed.

In this book, you will discover that all that is tarot is all of you, too.

The Seventy-Eight Cards

These days, the standard deck of tarot is made up of seventy-eight cards. They consist of four suits of fourteen cards each, known as the minor arcana, plus the major arcana made up of twenty-two cards. The four suits are usually referred to as Swords, Wands, Pentacles and Cups, although there are some variations depending on the creator's choice of title. But generally they relate to the elemental correspondences in western astrology. So Swords usually equate to Air, Wands to Fire, Pentacles to Earth and Cups to Water.

The Major Arcana

The twenty-two cards that make up the major arcana are numbered from one to twenty-one, while the Fool is unnumbered. With the Magician as I and the World as XXI, the major arcana are the most dynamic, personal and archetypal when used in divination or personal psychological work. The unnumbered Fool is sometimes considered the very essence of oneself.

Archetypes

The major arcana are usually interpreted as powerful archetypes known to us all, but often hidden away in the unconscious. When used in divination or self-healing readings, the images provoke a reaction within us that informs us of various states, which either need addressing or are already (or will be) manifest in our lives. These can also be outside influences such as events, experiences or people that we meet. Depending on the layout of the cards, the archetypal meaning can change from a positive quality to a more negative one and vice versa.

The Four Suits

The four suits usually have ten 'pip' cards, in other words cards numbered one (ace) to ten, and then four 'court cards'. These are usually, in ascending order, Page, Knight, Queen, King. This format is found especially in Rider-Waite-Smith styles of deck (see page 56). However, you will find in some decks that these titles have been changed so the Page may be known as a Princess, the Knight a Prince (as in the Crowley Thoth format, see page 64) and so on. Variations also occur in contemporary decks, with alternative court cards such as Mother, Father, Daughter, Son.

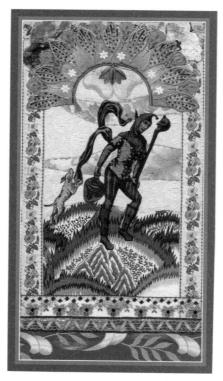

◄ MAJOR
ARCANA FROM
THE ENCHANTED
TAROT (SEE
PAGE 88)

*The Wheel of Fortune,
Strength, The Hierophant
and The Fool.*

The Major Arcana

Here is a brief guide to the symbolic correspondences and interpretations of each of the cards illustrated.

The Fool
Unnumbered: Unlimited potential
Astrological affinity: Uranus – freedom
Keywords/phrases: Spontaneity, impulse, blind to the truth, eternal optimist, ready for a quest, taking a chance, knowing the right way forwards, even if others think it's wrong.

The Magician
1: Focused action
Astrological affinity: Mercury – magic
Keywords/phrases: Getting magical results and acting with concentrated effort, persuasion, time to manifest results, knowledge is power, taking ideas and putting them into action.

The High Priestess
2: Mystery
Astrological affinity: The Moon – receptivity
Keywords/phrases: Silent potential, secrets revealed, feminine intuition, seeing the truth, seeing beyond the obvious to what is hidden or true.

The Empress
3: Abundance
Astrological affinity: Venus – indulgence
Keywords/phrases: Tangible or creative results, sensuality, fulfilment, pleasure in earthly delights, expression of joy, mother figures in relationships.

The Emperor
4: Authority
Astrological affinity: Aries – organization
Keywords/phrases: Official matters, masculine power, authority and discipline, wise counsel, accomplishment, motivation, father figures in relationships.

The Hierophant
5: Knowledge
Astrological affinity: Taurus – respect
Keywords/phrases: Conforming to convention, respect, spiritual mentor, discovery of new beliefs, doing your duty, understanding the law or code, dogmatic influence.

The Lovers
6: Love
Astrological affinity: Gemini – choice
Keywords/phrases: Temptation, making a choice in love, physical attraction, love triangle, questioning your feelings, what does love mean to you?

The Chariot
7: Self-belief
Astrological affinity: Sagittarius – achievement
Keywords/phrases: Determination, willpower, sense of direction and motivation to succeed, fearlessness, self-starting, controlling one's emotions, keeping on track.

Strength

8: Courage
Astrological affinity: Leo – power
Keywords/phrases: Gentle force, being in control of a tricky situation, taking responsibility, compassion and tolerance for others, conquering desires.

The Hermit

9: Discretion
Astrological affinity: Virgo – discrimination
Keywords/phrases: Inner reflection, contemplating the past, looking for meaning in life, soul-searching, understanding deeper needs, taking one step back to move forwards.

The Wheel of Fortune

10: Destiny
Astrological affinity: Jupiter – opportunity
Keywords/phrases: Going with the flow, take an opportunity, not fearing change, adapting to life's changing cycles, new beginnings, inevitability, karma.

Justice

11: Fairness
Astrological affinity: Libra – compromise
Keywords/phrases: Making a decision, accepting responsibility for actions, impartial judgement needed, justice, legal issues, fair play, harmony.

The Hanged Man

12: Paradox
Astrological affinity: Neptune – transition
Keywords/phrases: Looking at life from a different perspective, being in limbo, adjusting to circumstances, paradox, stop to think before acting.

Death

13: Change
Astrological affinity: Scorpio – transformation
Keywords/phrases: Changing feelings, end of one cycle and the beginning of another, letting go of the past or moving on, embracing change, accepting one's choices.

Temperance

14: Moderation
Astrological affinity: Cancer – cooperation
Keywords/phrases: Blending of ideas, need for compromise, moderation in all things, combining resources, are your needs compatible with your desires?

The Devil

15: Temptation
Astrological affinity: Capricorn – materialism
Keywords/phrases: Temptation, being bound by one's desires, materialism, living a lie, obsession, self-deceit, freeing oneself from illusions, your own worst enemy is you.

The Tower
16: The Unexpected
Astrological affinity: Mars – disruption
Keywords/phrases: Sudden turmoil or change, unexpected disruption, chaos all around, falling apart to fall into place, adapting to outside influences.

The Star
17: Realization
Astrological affinity: Aquarius – inspiration
Keywords/phrases: Manifesting an idea or dream, insight and self-belief, inspiration, truth revealed, seeing the light, abundance and success, realizing the truth.

The Moon
18: Illusion
Astrological affinity: Pisces – vulnerability
Keywords/phrases: Emotional confusion, using your imagination or intuition, blind to the truth, looking at deeper needs, self-deception, all is not as it seems.

The Sun
19: Joy
Astrological affinity: The Sun – vitality
Keywords/phrases: Positive energy, being enlightened, creativity and happy times, being the star of the show, living life to the full, vitality, expressing the truth.

Judgement
20: Liberation
Astrological affinity: Pluto – rebirth
Keywords/phrases: Seeing your true potential, an epiphany or wake-up call, re-evaluation and revival, the truth of the matter, accepting things as they are.

The World
21: Wholeness
Astrological affinity: Saturn – accomplishment
Keywords/phrases: Accomplishment, fulfilment, feeling at one with the universe, successful travel – literally or in the mind – accepting oneself, coming home.

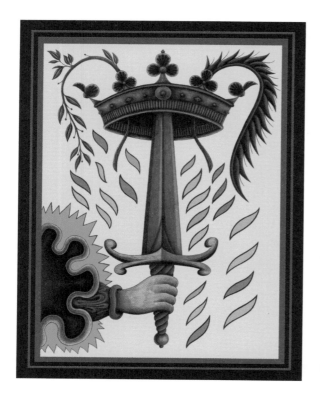

The Minor Arcana

The minor arcana suits – Swords, Cups, Wands and Pentacles – correspond to each of the four western astrological elements of Air, Water, Fire and Earth respectively. Here is a brief outline of their divination meanings.

Remember, that the minor arcana are usually about everyday experiences and our feelings, thoughts and needs. The court cards can sometimes represent people we meet who or are important influences in our lives.

The Suit of Wands: Fire
Inspiration, action, creativity, getting things done.
When we choose Wands cards in a reading, we are usually looking for more passion, excitement or achievement in our lives. Sometimes finding it comes into our life in ways we hadn't anticipated. We may be about to realize these goals, but Wands ask us to visualize what we truly desire before we act.
Fire signs: Aries, Leo and Sagittarius.

The Suit of Swords: Air
State of mind, reason, logic, thinking, mentality.
Swords are reminders that our mind is often the cause of most of our self-sabotage. We overthink, we let our thoughts control us, and we may use logic inappropriately, always trying to analyze or deny our feeling world. Swords ask us to stop overthinking and use our intuition.
Air signs: Gemini, Libra and Aquarius.

The Suit of Pentacles: Earth
Reality, tangible result, calculation, substance.
Pentacles bring us down to earth; they show us where to be realistic, how to thrive, survive and find inner and outer security. We can build up our status, our home life or our professional ambitions, but this suit also reminds us that too much emphasis on calculating the odds doesn't necessarily bring about harmony.
Earth signs: Taurus, Virgo and Capricorn.

The Suit of Cups: Water
Feelings, emotions, needs.
We feel, we react, we need, we love, and Cups show us the pathway to all that makes for emotional contentment, creativity and acceptance. Cups can show us our sorrow, but Cups can often reveal that tomorrow we will understand those feelings and acknowledge them as simply that, and grow with self-understanding.
Water signs: Cancer, Scorpio and Pisces.

◀ MINOR ARCANA FROM
TAROT NOIR (SEE PAGE 156)
Ace of Swords, Ace of Wands, Ace of Cups, Ace of Pentacles

Wands

Ace: creative vision
Two: pioneering spirit
Three: new departure
Four: harmony, celebration
Five: rivalry, frustration
Six: pride, recognition
Seven: defiance, standing your ground
Eight: unfinished business, acting quickly
Nine: resilience, self-belief
Ten: uphill struggle, burden

Swords

Ace: clarity, resolution
Two: denial, illusions of the mind
Three: betrayal, separation, painful truth
Four: contemplation, take a break
Five: conquest, no-win situation
Six: moving on, recovery, calmer waters
Seven: deception, cheating, running from truth
Eight: blindfold to the way out
Nine: wishing 'if only', refocus, don't be overwhelmed
Ten: time to move on from the past

Pentacles

Ace: focused, grounded
Two: flexible, juggling with options
Three: teamwork, cooperation
Four: attachment, creative order, mean
Five: hardship, neglect, lack
Six: having/not having, giving and receiving
Seven: re-evaluation, assessment
Eight: diligence, self-discipline
Nine: resourceful, accomplishment
Ten: the good life, affluence

Cups

Ace: new romance, an offer
Two: attraction, connection
Three: celebration, sharing
Four: not seeing what's on offer
Five: loss, regrets, dwelling on what's been
Six: nostalgia, goodwill, playfulness
Seven: wishful thinking, self-indulgence
Eight: moving on, leaving the past behind
Nine: feeling blessed
Ten: the promise of more, emotional joy

► MINOR ARCANA FROM
THE GOLDEN THREAD
TAROT (SEE PAGE 218)
Five of Wands, Three of Swords, Fur of Pentacles, Ace of Pentacles, Ace of Cups.

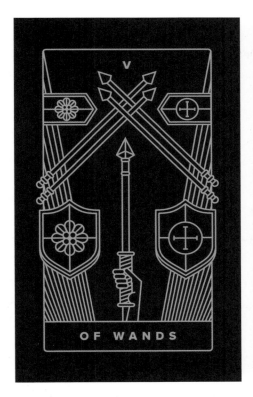

V

OF WANDS

III

OF SWORDS

IV

OF PENTACLES

ACE

OF CUPS

THE MINOR ARCANA

The Court Cards

Here are some useful interpretations for the court cards of each suit. The Page, Knight, Queen and King usually represent people you meet in life or who could be useful or troublesome influences when making choices. They can also represent part of yourself, something within you that you project onto others, so that the quality the card represents in yourself will be imported into your life through another person or is being expressed by you.

Pages
All pages represent playful energy, childish lovers or friends, opportunists, light-hearted adults.

Knights
All knights represent extremes of energy – for example, the knight of wands is a seductive lover, but also an insensitive rogue.

Queens
All queens represent feminine power, both creative and intuitive.

Kings
All kings represent dynamic, authoritative male or mature power.

Page of Wands
Child-like exuberance, a charming admirer, creative ideas.

Knight of Wands
Seductive but unreliable, adventurous but non-committal.

Queen of Wands
Self-assured, confident and charismatic.

King of Wands
Powerful authority figure.

Page of Pentacles
Whizz kid, creative friend.

Knight of Pentacles
Inflexible, stubborn, but gets things done.

Queen of Pentacles
Generous, caring, warm-hearted person.

King of Pentacles
Reliable, business-oriented, successful.

Page of Swords
Youthful ideas, intellectually dextrous.

Knight of Swords
Tactless and critical, but incisive and frank.

Queen of Swords
Astute, quick-witted, shrewd.

King of Swords
Articulate, analytical, eagle-eyed.

Page of Cups
Light-hearted, sensitive soul.

Knight of Cups
Ideal lover, but suspect intentions.

Queen of Cups
Compassionate, tender, kind.

King of Cups
Wise, stable, generous father figure.

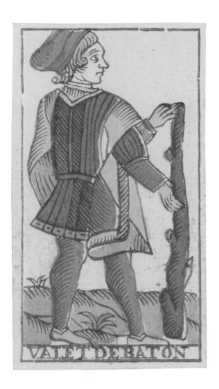

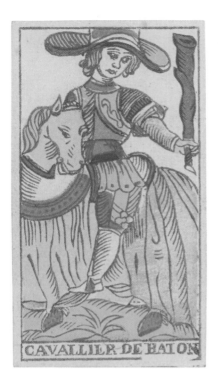

VALET DE BATON

CAVALLILR DE BATON

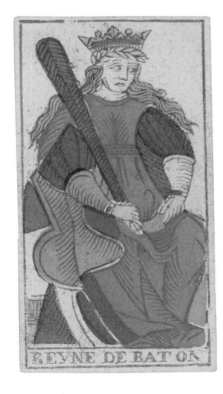

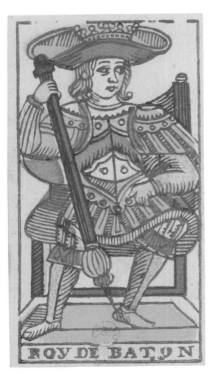

REYNE DE BATON

ROY DE BATON

▶ COURT CARDS
FROM THE TAROT
DE MARSEILLE
(SEE PAGE 44)

*Page of Wands, Knight
of Wands, Queen of
Wands, King of Wands.*

How to Use the Tarot

Although this book is mostly concerned with tarot decks and their stories, symbols and secrets, it is useful to know how tarot is used for divination and self-development purposes. Here is a brief introduction to using the cards.

Divination

Divination is rooted in a Latin word meaning 'to be inspired by the gods' and, in a way, it's about getting in touch with the spark of the 'Divine' that is within you. In fact, what you're doing when you 'divine', or try to find inspiration from the gods, is to open yourself up to the universal language of symbols and, by doing so, connect to the deeper workings of the unconscious of which we are all a part, and which can also be called the Divine.

These days, most people use the tarot for understanding who and what they are and their goals and intentions in life. The tarot is also used for inner reflection, spiritual growth and mostly for making decisions to ensure that responsibility is taken for the future. Although tarot was at one time labelled a 'fortune-telling' device, the truth of the tarot is that it mirrors and portrays not only the people who have created or illustrated these unique decks, but everything about you, too. In fact, the artist, occultist, the magician, the philosopher ... are all 'you'.

Fate or Free Will?

Tarot is thought to be an objective way to discover the opportunities you have and how to use that knowledge. It reveals the way things are now (usually represented by the 'you now' card), the influences and the way things were before this present moment (the past card) and the influences and the way things will turn out in the near future (a future card) in relation to the question or issue. Of course, the process of evolving and living means that we are always in flux, and so fate and free will are not mutually exclusive. Fate may seem to be something that happens without conscious intention, and free will something that happens through personal choice. But making choices and also meeting the unexpected are both part of the deeper resonance of 'you' in the universe. So, because they are both part of every moment, the two energies are simultaneously in play when using the tarot – don't think 'I am fated', think more along the lines of 'my character is my fate'.

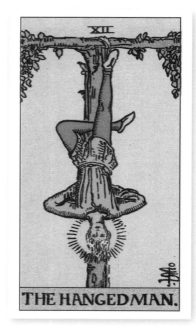

▲ THE HANGED MAN FROM RIDER-WAITE-SMITH (SEE PAGE 56)

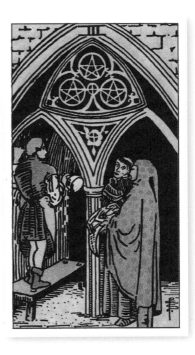

◀ THREE OF
PENTACLES
FROM RIDER-
WAITE-SMITH
(SEE PAGE 56)

If you're a beginner, it's worth referring to the main keywords and phrases until you start to understand what the card is telling you via your intuitive connection to the universe.

Tarot Reading

Tarot strikes through the illusion of opposites and shows you that its key message is not about prediction or fortune-telling; it's about who you are now and what you will do with that knowledge to take responsibility for your choices.

At the very moment you consult it, the tarot is a connection between you and the universe. Reading the tarot can help you discover more about your own self, your potential and what direction you are going in. The only time the tarot could be wrong is if you, the reader, project what you want to happen on to the cards, rather than reading what they are actually saying.

So, the best way to read the tarot is to, well, read it.

Card for the Day

An easy way to get to know the tarot is by choosing one card for the day ahead. If you are a beginner, it is sometimes better to work just with the major arcana separated from the minor arcana cards, and then shuffle the twenty-two cards alone.

As you shuffle (you can either mix the cards in your hands or just spread them face down on a table and swirl them around and then gather them back into a deck), think about what would be the nicest thing to happen to you today. You can imagine anything you like, but concentrate and focus on that intention as you shuffle. Place the cards face down in a pile on a table, cut once, then spread the cards out in front of you in a line (or in your hands if you can hold them all) and pick one.

Lay it face up on the table and then read the interpretation given. It is surprising how, throughout the day, you may discover connections and coincidences corresponding to the symbolic meaning of the card.

Once you have practised using a card for the day, try out a few simple spreads as given here, then once you have got used to interpreting the cards in a spread, you can start to invent your own, or follow other spreads suggested in many of the little white books that accompany the decks.

Each spread gives a brief sample reading.

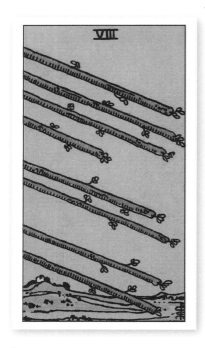

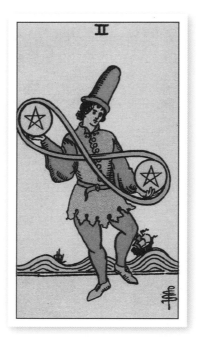

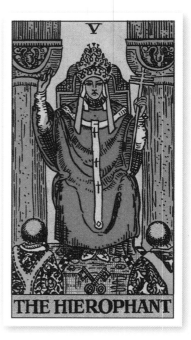

1. 2. 3.

Spread 1: What is going on in my life?

This layout uses a 'you now' card to describe your current state, a blockage card to remind you of what may be stopping you from making progress and a final card to tell you what action to take to resolve the obstacle in your pathway.

1. **You now**
 Eight of Wands – I need to sort out my priorities and be clear about what I want.

2. **What is stopping me?**
 Two of Pentacles – I need to stop juggling around so many crazy ideas.

3. **The action to take**
 The Hierophant – I must seriously reflect on what I want and listen to good, objective advice.

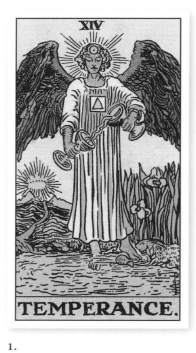

TEMPERANCE.

1.

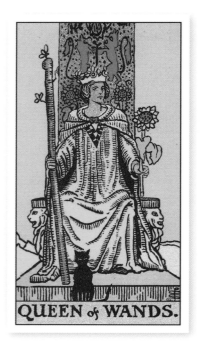

QUEEN of WANDS.

2.

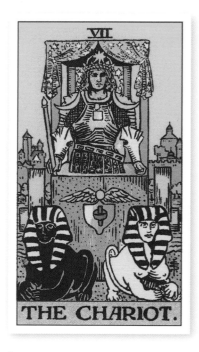

THE CHARIOT.

3.

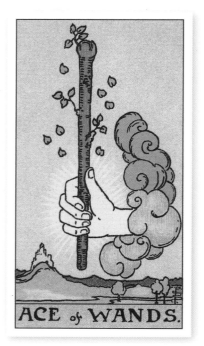

ACE of WANDS.

4.

Spread 2: How do I make the right choice?

This spread includes a 'you now' card and a card each representing good and bad influences. It can help you clarify what is beneficial in your life right now and what you need in order to make the right decision.

1. **You now**
 Temperance – I am always compromising and letting other people chose for me.

2. **Difficult influences**
 Queen of Wands – An arrogant female figure who doesn't have my best interests at heart.

3. **Beneficial influences**
 The Chariot – A no-nonsense, motivated friend or colleague.

4. **How to make the decision**
 Ace of Wands – Be creative with my vision and stick to my original ideas.

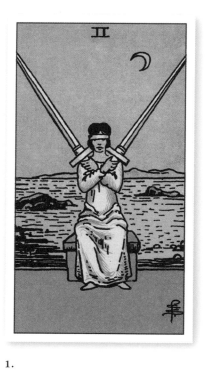

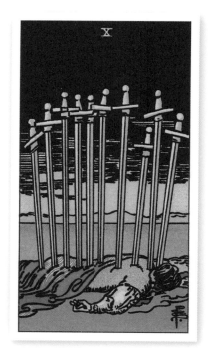

1.

2.

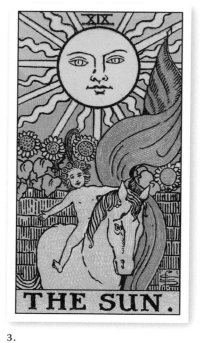

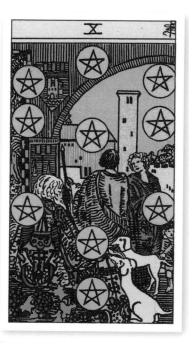

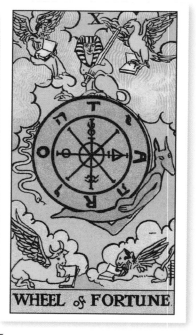

3.

4.

5.

Spread 3: How do I find love?

A slightly longer spread to help you find new love, including a 'you now' card, a blockage card and an outcome card.

1. ## You now
 Two of Swords – I put up barriers and I don't let people get close to me.

2. ## What's stopping you from finding love?
 Ten of Swords – Thinking everyone is against me.

3. ## The kind of lover you want right now
 The Sun – Someone fun-loving and playful, free-spirited.

4. ## What you must express
 Ten of Pentacles – Shows that I enjoy the good things in life.

5. ## The kind of love who will come into your life
 Wheel of Fortune – Someone who has already loved and lost and is ready to take a chance if I am open and honest.

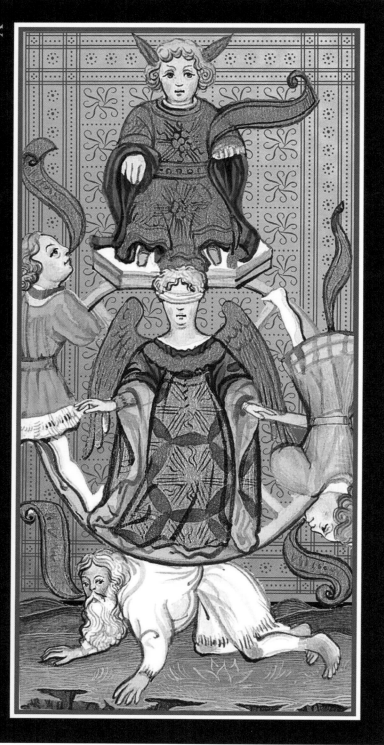

X

LA RUOTA - THE WHEEL - LA ROUE DE FORTUNE - LA RUEDA - DAS RAD

◄ THE WHEEL OF
FORTUNE FROM
THE VISCONTI-
SFORZA (SEE
PAGE 36)

The History of Tarot

Where did it all begin? There have been so many theories put forward in the past, and today tarot experts are still digging around in dusty tomes and art collections, searching for clues to discover occult secrets or whether there are any more ancient links. Here is a brief introduction to the history and development of tarot to put it into some kind of chronological context.

Renaissance

Most academics agree that tarot decks evolved from early playing cards in Renaissance Italy, probably in the middle of the fifteenth century (or some say earlier). For more detailed information please read the entries for Visconti-Sforza (see page 36) and other early Italian decks.

The dangerously beautiful courts of rival dukes were the perfect place for the growing fashion of risk-playing card games, known as *trionfi* (trumps). The earliest cards were hand-painted, but even with the arrival of new printing techniques, wealthy patrons and nobles commissioned their own private decks, usually gilded with no expense spared. These were either given as love tokens or celebratory gifts between families. The trump cards were often decorated with allegorical motifs or portraits of important family members, rather like a set of miniature paintings. This technique was already used to decorate handwritten books and medieval illuminated manuscripts, such as the Visconti family's late-fourteenth-century *Book of Hours*.

Although the cards may well have been used for more occult purposes, even the warmongering dukes had to be discreet about their fascination for humanist philosophy and the revival of the occult. Dabbling in alchemy and Hermetic magic was considered heretical by the Church, so it wasn't until the eighteenth-century's Age of Reason that any obvious occult usage of the tarot would come to light.

The Age of Reason

With the eighteenth-century's scientific revolution, and the Enlightenment, Europe was ablaze with new philosophies, which challenged traditional doctrines – in particular, the Church's dogma. Although witchcraft was still heresy, new spiritual ideas and occult secret societies were tolerated. In 1781, the French linguist and Freemason, Antoine Court de Gébelin, proposed that tarot was derived from the name of the Egyptian god of wisdom, Thoth, and was related to hieroglyphics that meant the 'royal road of life'. He also believed that the major arcana were based on an ancient set of tablets of mystical wisdom saved from the ruins of a burning temple. This Book of Thoth, outlined a secret language in which all gods could be contacted through hieroglyphs and numbers.

According to his Egyptian research, the number seven was a powerful mystical number and so, developing his own tarot format, he proposed that the major arcana contained three times seven cards plus the Fool, and each of the four suits of the minor arcana contained twice times seven cards. A few years later, whether coincidentally or by clever calculation, another French occultist, known as 'Etteilla', published his ideas on the correspondences between tarot and astrology and created the first deck exclusively for divination purposes (see page 50).

The Golden Dawn

The tarot came under scrutiny again in the nineteenth century, when another Frenchman, Kabbalist and philosopher Eliphas Levi (1810–75), believed it was rooted in the Hebrew alphabet's correspondence to mystical numbers. On the other side of the Channel, the British Hermetic Order of the Golden Dawn's founder members also took a deep interest in the tarot and constructed new esoteric theories about its origins and magical powers. One founding member, Arthur Edward

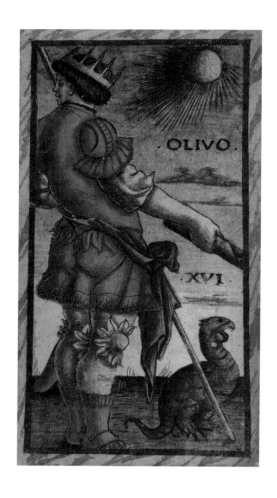

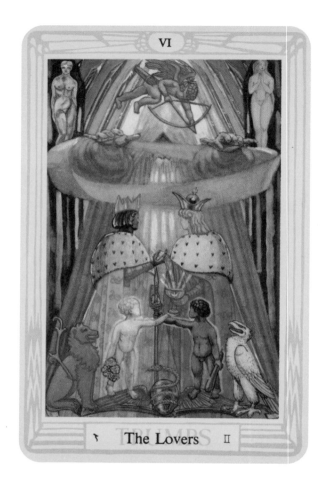

Waite, along with initiate and artist Pamela Colman Smith, created the first deck (apart from the alchemical Sola Busca Tarot, see page 164) to include symbolic imagery for the minor arcana cards. The Rider-Waite-Smith deck, as it is now known, has became one of the best loved, most used and most iconic of all decks (see page 56).

Crowley to Now

Another ex-member of the Golden Dawn, British occultist, Aleister Crowley, also designed his own deck in the 1930s, known as the Thoth Tarot deck (see page 64). Crowley believed the tarot was an intelligence in itself and a key to the archetypal world within each of us; a belief that has meant that the tarot has become more than just an occult tool, but a psychological one, too.

Tarot is currently used for self-help, life direction choices, meditation and many other spiritual healing issues, and still continues to fascinate us with its mystic power. But tarot is perhaps, more than anything else, not just about divination and interpreting the cards, but a symbol in itself of all that you are.

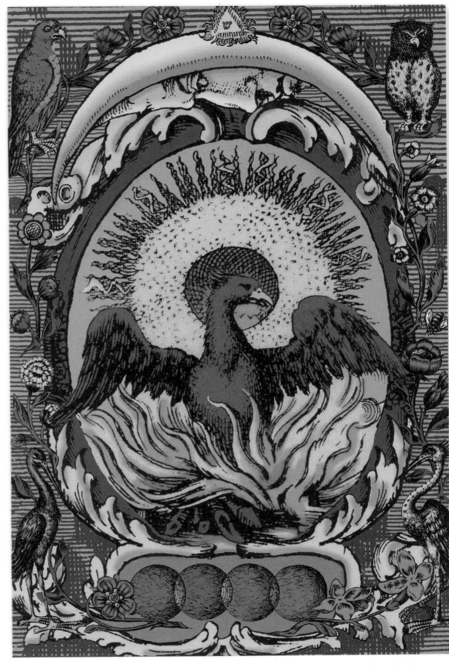

◄ TRUMP XVI – OLIVO FROM THE SOLA BUSCA TAROT (SEE PAGE 164)

◄ THE LOVERS FROM THE CROWLEY THOTH TAROT (SEE PAGE 64)

► FOUR OF DISKS FROM THE TAROT OF THE HOLY LIGHT (SEE PAGE 194)

4 of Disks 11-20° ♉ ruled by ☿

CHAPTER 1

Influential Decks

This is the story behind the outstanding and influential decks that have set the precedent for almost all tarot decks created since. This chapter is devoted to the tarot decks that have, to date, been the most influential in tarot history.

Italian Art

When tarot made its debut in the Renaissance as a collection of miniature paintings packaged as a voguish card game for dukes, ladies and rascals, it mirrored a new way of seeing the world. No longer did the sky and stars surround us, but they were part of us, and ancient thinking reawakened us to a realization that the universe was within the individual himself. Whether the tarot was, at the time, a subtle way of transmitting esoteric ideas via the gilded beauties held in one's hands or merely a Renaissance conceit, it set a precedent for the tarot legacy to follow. The story of the Visconti-Sforza deck is here referred to in some depth, simply because it was, and still is, the very embodiment of that legacy.

The Visconti-Sforza deck (see page 36) not only set a precedence for later tarot, but also reflected a period where corruption, intrigue and power lay at the heart of the Renaissance psyche, as did the quest for magical revelation. Pageantry, classical allegory and ruthless families and their power struggles vied with profound Greek philosophy and the rise of humanism. It was this collection of miniature paintings, the tarot, an illuminated manuscript in itself that truly showcased the Renaissance.

French and British Craft

These works of Italianate art were soon surpassed by the card-makers of the Marseilles print businesses, who set the bar high in terms of the production and widespread availability of card games across Europe. But the Marseilles-style decks were also trumped by one shrewd Frenchman who saw a new market for the tarot's divinational aspect. French occultist, Etteilla, epitomized an enlightened France at the end of the eighteenth century, and he astutely jumped on the business bandwagon by merchandizing his idea to the populace.

By the end of the nineteenth century, 'divination' cards such as Etteilla's had already proved a success for both parlour amusement and among profound esoteric thinkers. It was an English occultist from an eclectic backdrop of mysticism, along with an imaginative theatre designer, who created one of the most iconic tarot decks we know today – the Rider-Waite-Smith deck (often referred to as the RWS deck, see page 56). Then, in the late 1930s, the high society artist Lady Frieda Harris persuaded occult desperado Aleister Crowley to collaborate on a work of mystical art – a tarot deck that was not published until nearly thirty years after both of their passings (see page 64).

Visconti-Sforza

One of the earliest, most complete and
hauntingly mysterious hand-painted decks.

Creator: Commissioned by
Visconti-Sforza family, *c.*1450
Illustrator: Bonifacio Bemo (*et al.*)
Publisher: US Games, 1991

**One of the oldest, most beautiful and intriguing tarot decks, the
Visconti-Sforza is also the most telling. It reveals not only the fate
and fortune of two dynastic families woven into the art of these
exquisitely painted miniatures, but also something deeper at work.**

Versions of the various Visconti-Sforza decks date from the early
fifteenth century. The Pierpont Morgan deck, illustrated here, is
thought to be one of the most 'nearly complete' of these and dates
from around 1450 when Bianca Visconti and Francesco Sforza
took over the Milan dukedom.

The fifty-six pip cards and twenty-two trump cards (major
arcana) are made up of extant cards held in various museums and
private collections around the world. Four of the original cards
– The Devil, Tower, Knight of Coins and Three of Swords – are
believed to be lost or damaged, and replacements at various times
were designed to complete the deck.

The Esoteric Spirit of the Renaissance

Originally commissioned as a gift, as a sign of wealth and power
or as a luxury version of a fashionable card game, many experts
believe there is nothing esoteric nor divinatory about this
deck. Most art historians consider the trump cards are merely
personalized with family emblems and allegorical symbols
popular at the time. However, some tarot experts believe the
trump cards convey hidden clues to esoteric truths.

In fifteenth-century Renaissance Italy, classical art,
mythological symbolism and ancient philosophy flourished in
the courts of the wealthy families of the Italian city-states. The
fashionable risk-taking card game *trionfi*, likely got its name from
processional 'triumphs' derived from ancient Roman carnival-like
parades, which boosted the glory of the dukedoms. Various hand-
painted decks were commissioned by many wealthy families
across Italy (see the Golden Tarot of the Renaissance, page 104),
but the trump cards for these decks usually portrayed classical
gods or Christian virtues within some kind of hierarchy. None
were quite like the cards of the Visconti-Sforza decks.

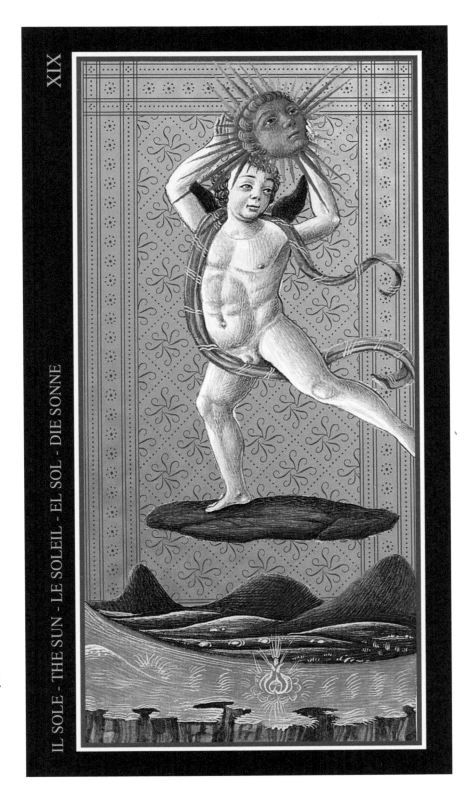

XIX

IL SOLE - THE SUN - LE SOLEIL - EL SOL - DIE SONNE

► **THE SUN**

Painted by an unknown artist (often attributed to Renaissance miniaturist Antonio Cicognaro), a robust cherub rides a dark cloud to grab the vibrant sun (Apollo's head) from the sky. Using solar magic, or Apollo's divine power, was believed to bestow wealth and glory on any zealous dynasty.

VISCONTI-SFORZA

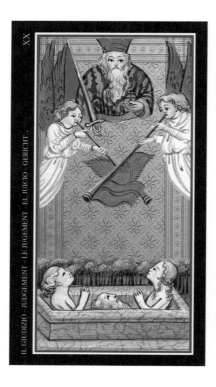

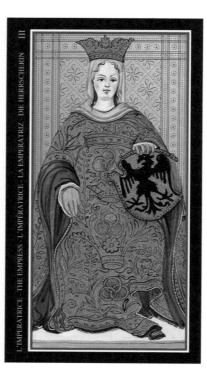

The Renaissance wasn't just a hotbed of allegorical nostalgia, but of revived, bubbling esoteric thought, too. The Greek philosopher Plato was the man of the intellectual moment, thanks also to the work of fifteenth-century philosopher and humanist Gemistus Pletho. Pletho's teachings also inspired wealthy Florentine duke, Cosimo de Medici to commission astrologer and scholar Marsilio Ficino to translate all of Plato's works in 1462.

Another fervent student of Pletho was the artist Bonifaco Bembo, the very artist commissioned by the third duke of Milan, Filippo Visconti, for earlier cards dating from the 1420s, and the one who painted most of the 1450 deck for Bianca and Francesco. Along with the Neoplatonic teachings of Pletho, a new wave of secret knowledge, Hermeticism, pervaded the courts of Europe, and the magical arts teetered on the brink of a heretical precipice. This wave of humanist thought, however precarious, also permeated the 'intellectual elite' of ducal courts. Their libraries were filled with precious manuscripts and texts on astrology and other esoteric arts.

This was an Italy with a rich astrological and magical tradition, even though any close associations to witchcraft were enough to keep most of these ideas underground. Prophecy by the stars was common practice, and astrologer-physicians were common advisors to those in power, forecasting favourable times to procreate, go to war, marry and avoid poisoners.

Cards as Cautionary Tales

Bianca Visconti's father, the ruthless Filippo, was, it seems, deeply superstitious. Filippo's biographer Decembrio, who was also interested in astrology, recounted how the duke, a reclusive sociopath, was fearful of darkness, singing birds and lightning. Interestingly, the Tower card, usually portrayed

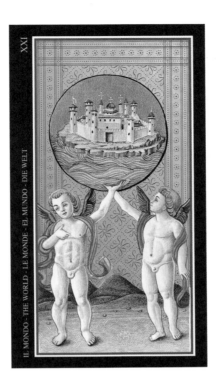

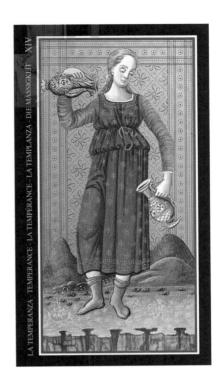

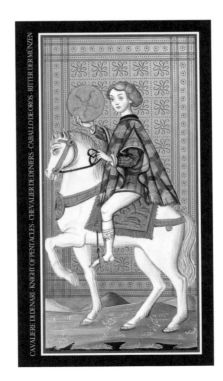

▶ THE WORLD

▶ TEMPERANCE

▶ KNIGHT OF COINS

▶ ACE OF SWORDS

VISCONTI-SFORZA

with lightning striking a burning tower, was either lost or destroyed. The Della Torre family were one of of the Visconti's major rivals during the thirteenth to fourteenth centuries, whose emblems included a tower alight with leaping flames. The inclusion of a Tower card may have been an allusion to their subsequent downfall.

But if so, did the Tower also represent a major omen of disaster when laid before the superstitious duke and his later successor, Sforza? Filippo apparently enjoyed card games, but was said to prefer using a *trionfi* deck with more serious applications. Did this mean he used it for a more unworldly, illuminating game? In 1412, Filippo had seized power to become the third duke of Milan. Allegedly, he then conspired to kill his twice-his-age wife, Beatrice (for her inheritance), and she was eventually beheaded for trumped-up charges of adultery. The trump card could well be 'Judgement'. From a tomb, a couple raise their faces seeking God's redemption. A third face peers up between the two, perhaps suggesting Filippo seeking vindication, too.

Sforza was also obsessed with signs and portents written in the planetary sky. When he became duke of Milan in 1450, influenced by Bianca's astrological heritage and the superstitious psyche that went with it, he consulted astrologers on a daily basis and became ruthlessly reliant on them for the rest of his life, as did his successors. The cards, the precious miniatures, were perhaps 'signs', too. As pictorial cautionary tales of family history, they may have provoked fear or wise reminders of how to act or make decisions. Simultaneously, perhaps they provided snippets of insight into esoteric thought, which literally 'played into the hands' of those in power, where such ideas could remain *sub rosa*.

New Symbols for a New Family

Francesco Sforza came from a family of *condottiere* or mercenary soldiers. His 'take no prisoners' father had been named Sforza (meaning 'force') by a higher-ranking officer. Married off to the illegitimate Bianca in 1441, and twice her age, Francesco adopted new emblems for the merger of the two families, such as the divine solar rays seen in the gold background on most of the cards.

The standard *trionfi* suits were swords for soldiers, batons for nobility, cups for clergy and coins for merchants. The court cards included crests, motifs and subtle references to the Viscontis. For example, the Empress has a proud Visconti eagle on her shield and the emblematic interlaced diamond rings of the family appear on her gown; the knights have heraldic emblems on their horses; and most of the court characters have golden blonde hair like the ancestral Viscontis (apart from Filippo, who was dark-haired).

It may also be that Neoplatonic ideas filtered through from the Visconti's court painter, Bembo, and his studio. The trump (major arcana) cards are unnumbered. The Fool, known as 'Mat', is shown as a haggard man with goitre – a disease rife in inland regions due to lack of iodine. But is this 'mat' or fool, in fact, a disguise for the ultimate fool, God or Plato's demiurge (a being responsible for the creation of the universe) himself?

The Hermit, the archetypal old man, appears in many guises throughout classical mythology and medieval Christian symbolism. Here he gazes at an hourglass, carries a long stick and represents both the figure of Saturn/Cronus and 'Time'. But he also bears a curious resemblance to a portrait of Pletho in a work by Benozzo Gozzoli. Could Bembo, in fact, have subtly alluded to his 'mentor' with a miniature of a living Neoplatonist who taught him ancient truths?

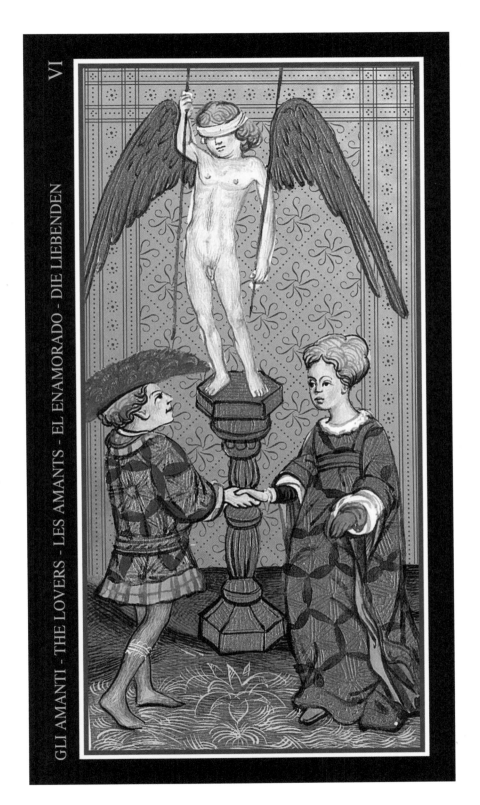

► THE LOVERS

This card is believed by some scholars to represent the marriage of Bianca and Francesco. Strangely, the blond male figure doesn't fit the documented references to the dark-haired Francesco Sforza nor Filippo Visconti if the card were referring to the latter's marriage to Beatrice. The bandaged Cupid symbolizes how love is indeed blind and the choices we make may not always reflect our true desires.

GLI AMANTI - THE LOVERS - LES AMANTS - EL ENAMORADO - DIE LIEBENDEN

VI

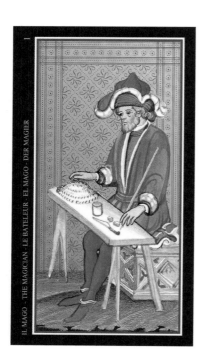

The side label on the image reads:

IL MAGO · THE MAGICIAN · LE BATELEUR · EL MAGO · DER MAGIER

▲ THE MAGICIAN

Hermes' Hat

The trickster archetype, the Magician, is one of the most ancient in world mythology. Here he plays with magical ingredients at his table. The curious hat under his right hand is similar to the wide-brimmed hat worn by the Greek god Hermes, who is also associated with magic. Hermes was an illusionist; he traded ideas, he made magic happen, he was an ancient trickster god assimilated from the Egyptian Thoth and reminiscent of the 'thrice-great-Hermes' of Hermetic philosophy.

The High Priestess is thought by some scholars to represent an ancestor of Bianca's, Maifreda da Pirovano. Maifreda was a nun and devotee of the mystic, Guglielma la Boema, who preached salvation for everyone, including sinners. Maifreda and her follower Andrea Samita were eventually burned for heresy. Yet, if painted in Bembo's studio surrounded by Pletho's ideas and Neoplatonic thought, could the Popess also be Plato's Diotima in disguise? If she were to be Diotima, could she not also be an archetypal sibyl, could she not be the one who divines our future, too?

An inventory from Filippo's library dated 1426 includes a vast collection of alchemical, philosophical, mythological, 'art of memory' and divinatory works, such as *Sortes taxillorum*, a work describing divination by casting dice. Books in the library of Sforza's castle in Pavia also contain a large collection of alchemical, astrological, prophetic and divinatory works, including Alfodhol's magical work *Liber iudiciorum et consiliorum* (Free Trials and Deliberations), about the art of geomancy (divination by interpreting random shapes and patterns of the earth or stones cast on the ground).

Surrounded by astrologers, seers and magical, platonic and Hermetic thought, the miniature paintings cast on the table before these elite dukes were a way for them to see how life not only had unfolded in the past, but was unfolding before their very eyes in the present. These images of family fate and fortune revealed the cyclic nature of their destiny, which, after all, is what tarot is actually about. If the Visconti-Sforzas believed in the power of the divine and astrological knowledge as a means to maintain rulership or avoid a terrible fate, it may be that tarot was the most subtle, secretive and artistic means to do so of all.

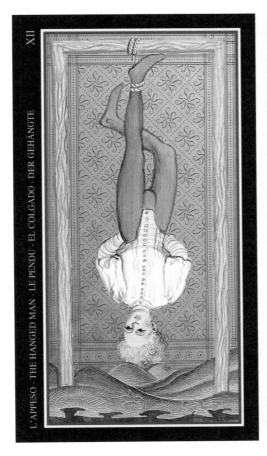

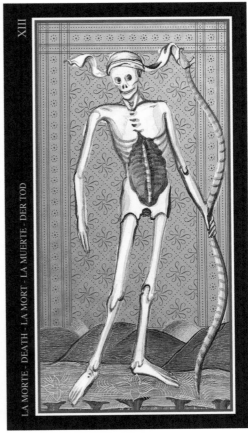

▲ THE HANGED MAN

The Hanged Man is a symbol of Sforza's own shame and glory. After victorious conquests, the Pope however refused to pay Sforza for his services. Sforza immediately changed sides and the angry Pope commissioned a portrait of him hanging from his feet. Known as shame paintings, or pittura infamante, the image of a traitor or man fallen from grace was displayed on public buildings.

▲ DEATH

The Death card depicts a tall skeleton, holding a bow in his left hand and a discrete arrow in his right hand, reminding dynastic power-mongers that the hunter can also become the hunted. The precipice is perhaps a warning to beware the abyss of heresy? Cliff edges also appear in the Temperance, Moon, Star and Sun cards.

Le Tarot de Marseille

Widely published in various formats and styles, the Marseilles decks are still used throughout Europe today for divination and game-playing.

Creator: Jean Noblet, 1650–60
Illustrator: Jean Noblet
Publisher: Editions Letarot.com

The Marseilles Tarot, as it is popularly known, was disseminated from earlier fifteenth- and sixteenth-century Northern Italian decks. The name Tarot de Marseille was coined by French card-makers Grimaud in the 1930s, after a specific version of the deck produced in the eighteenth century by Nicolas Conver of Marseille. The Marseilles style became one of the most popular tarot decks for divination and card-playing purposes.

In 1499, Charles VIII of France invaded Milan and the city was under French control until 1535. The popularity of the gambling game *tarrochi* quickly spread to France, Germany and Switzerland. Early coloured decks were produced with woodblock and stencil, then as printing developed, new methods took over. The oldest extant example of a printed tarot deck in France is that by Catelin Geofroy of Lyons, dated 1557.

Tarrochi Fashion

At the time, Marseilles was not only a flourishing port, but a lucrative paper and printing industry, and by the middle of the seventeenth century, the city had became a major centre for producing *tarrochi* playing cards. Heavily influenced by the Italian decks, one of oldest extant Marseilles decks is that of Jean Noblet (1650–60), which stands out from the others due to its striking imagery. No one knows very much about him, but Jean Noblet was apparently a master card-maker. Although the images are quite naive, and the size of the cards unusually small compared to the other decks of the time, they are the first to include titles or captions. The major arcana consist of innovative modifications of the imagery from other standard decks and a possible esoteric symbolism similar to the earlier Italian decks.

For example, the Magician's (Bateleur's) hat is shaped as the symbol of infinity, representing the never-ending cycles of the universe. He holds an acorn in his hand (a symbol of knowledge and growth) and has before him three dice, the popular game of gambling and of divination (recall how books on divination by dice and other means were numerous in the Milanese dukes' libraries.

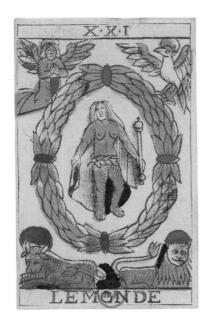

▲ THE WORLD

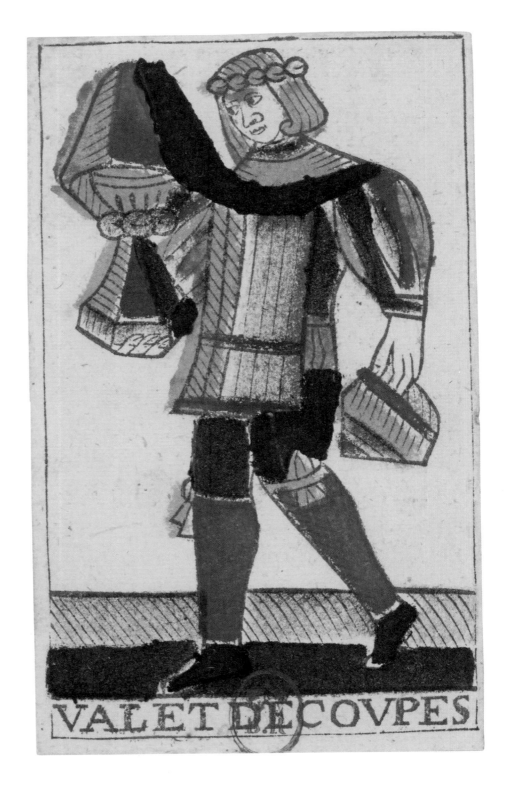

VALET DE COVPES

▶ PAGE OF CUPS

LE TAROT DE MARSEILLE

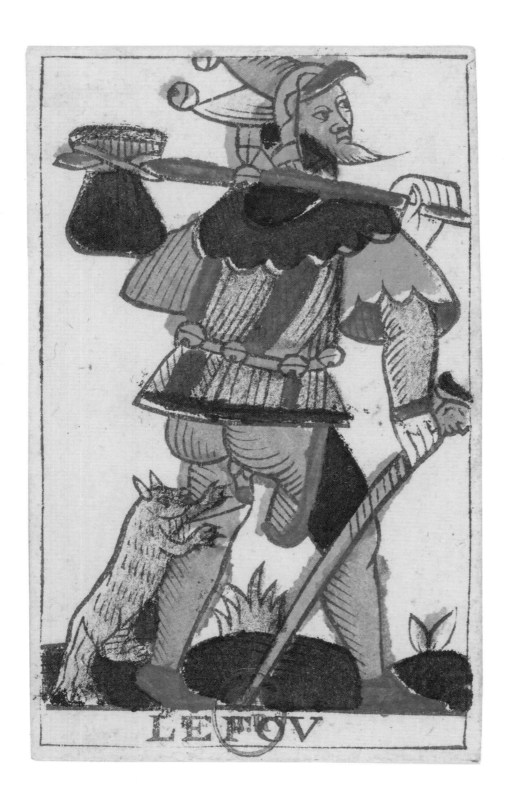

LEFOV

◀ THE FOOL

New Symbols

The Fool (Le Fou) is now presented as a court entertainer or king's fool, no longer a diseased or mad man, who struts precociously forwards, unaware of the cat (or some say civet) pawing at his genitalia. In heraldry, cats were symbolic of vigilance, while in medieval folk traditions they were associated with good luck (before they were linked to witchcraft). But whatever this animal is, it seems to want something from the mercurial *joie de vivre* of man. Perhaps it is symbolic of the creative power of the human mind?

The Star already represented honesty, truth and divine guidance in earlier Visconti imagery. In Greek mythology, truth was often depicted as the goddess Iris, who carried water from the River Styx in a jug whenever the gods had to take a solemn oath. Any god or goddess who lied would be stunned into a narcosis for a year as punishment. In art, her attributes were a herald's staff, a pitcher and jugs of wine to give to the gods.

The Death card, Le Mort, was for the first time identified as such. It was popularly known as 'the card with no name' due to cultural superstitions of the time. The image, once a grinning skeleton, is now a skeleton reaping the souls of the dead, implying the end, the finality of life itself, and a new beginning.

Along with the Noblet deck, Jacques Viéville, Jean Dodal and Nicolas Conver versions are thought to be the sources for all later Marseilles decks. According to French ceramist, artist and tarot historian Jean-Claude Flornoy (1950–2011), who re-coloured and reworked the Noblet deck in the 1990s, the colour used in the deck corresponded to various qualities in alchemy and magic. Red was associated with blood; black, the earth; blue, the body/soul; and green, human hope, and so on.

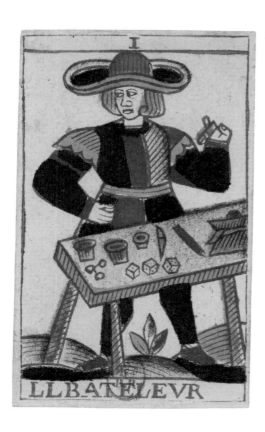

◄ THE MAGICIAN
*Is the phallic finger a sign of
fiscal defiance or an allusion
to Hermetic magic?*

Noblet's Magic

According to Flornoy, Noblet came from a
family tradition of card engravers and printers.
In France, around 1650, just after the end of the
Thirty Years War in central Europe, Louis XIV
imposed new taxes, one of which was on the
production of cards for gaming. To control the
number of decks being produced, all printed
sheets were counted and taxed accordingly. It
seems, though, that Noblet may have modified
one of his cards: the Bateleur. The Magician's
hand no longer holds the usual wand, but a finger
is depicted as a penis, perhaps as a sign of insult?
Was this a contemptuous, yet subtle defiance
against the fiscal impositions of the state, or is it
a cryptic reference to the Greek god Hermes and
his empowering phallus? Hermes had once been
sculpted or depicted with an erect penis on stone
pillars known as 'herms'. These were good luck,

empowering stones, directing travellers to walk
safely when alone. Likewise, the Magician directs
us to use both earthly and heavenly powers to
make our way through life.

Whatever the real reason behind Noblet's
modification to his Bateleur, this deck was to
become one of the most influential versions
interpreted by Antoine Court de Gébelin in his
1781 work, *Le Monde primitif* (see page 52). It also
set a model for subsequent tarot decks.

The Marseilles decks became widely popular on
two levels. First, as the simple card game, tarot or
tarocchi played throughout Europe, and second,
for the divinatory aspect of tarot. The latter began
to be popularized by the rise of interest in the
occult in the eighteenth century and the influence
of two men: Court de Gébelin, occultist, linguist
and Freemason, and an obscure Frenchman who
called himself Etteilla.

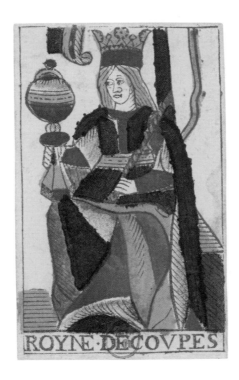

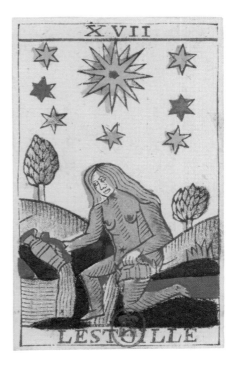

ROYNE·DECOVPES

LESTOILLE

► QUEEN
OF CUPS
*Signifies compassion
or nurturing energy.*

► THE STAR
*Attainable goals
are within reach.*

► THE
HANGED MAN
*Time to see life from
a new perspective.*

► THE MOON
*The modified lunar
landscape of a crayfish
crawling out of a dark
pool has astrological
and mythological
references.*

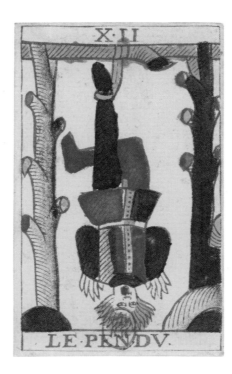

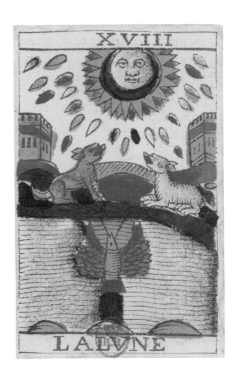

LE·PENDV·

LALVNE

The Book of Thoth Etteilla Tarot

The first deck exclusively created for divination.

Creator: Jean-Baptiste Alliette, 1788
Illustrator: Unknown – possibly Etteilla
Publisher: Lo Scarabeo, 2012

Etteilla's first deck of tarot cards, known as Grand Etteilla, set a precedent for the use of tarot from the end of the eighteenth century. It was the first deck devoted exclusively to divination and continued to be published in different formats throughout most of the nineteenth century. After a run of versions (the earliest dating from 1788), the Lo Scarabeo Book of Thoth Etteilla Tarot was finally published in 1870. Also known as the *Grand Jeu de l'Oracle des Dames* (Great Game of the Oracle of the Ladies), the iconic deck didn't stray too far from the previous printings and essentially conveys the same core concepts.

Up until the end of the eighteenth century, most decks had been based on the Tarot de Marseille (see page 44) and were considered, by the populace at least, to be mere playing cards (even if the occult elite felt they carried hidden symbols). Etteilla's radical publications elevated the tarot to a new platform, enabling the public to understand their fate and fortune.

Little is known about the real Etteilla and most biographical material is equally obscure. But it seems that, in 1770, Etteilla (pseudonym for Jean-Baptiste Alliette, *c.*1738–91) published a book on how to use playing cards for divination, *Ou manière de se récréer avec un jeu de cartes* (A Way to Entertain Yourself with a Deck of Cards). This was followed in 1785 with *Manière de se récréer avec le jeu de cartes nomées Tarots* (How to Entertain Yourself with the Deck of Cards Called Tarot).

Relying on ancient Egyptian mysticism and the Kabbalah, and working with various creation myths, he not only re-ordered and re-numbered the major arcana, but introduced keywords for every card, including the minor arcana. The first seven trumps of the major arcana equated to the archetypal creation myth, with the remaining cards made up of various hierarchal states of man and his relation to the cosmos. He also assigned zodiac signs and the four elements to specific cards. However, his random and rather confusing association with astrological qualitiesx was later scorned by the tarot experts. With hardly any academic education to back him up, and only his wits and business acumen, his Grand Etteilla deck was finally published in 1788.

► THE MAN AND QUADRUPEDS

► THE DEVIL

► PAGE OF WANDS

► THE MADNESS OF THE ALCHEMIST

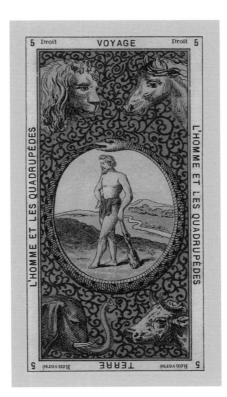

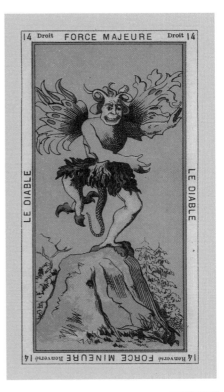

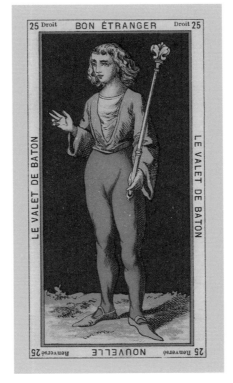

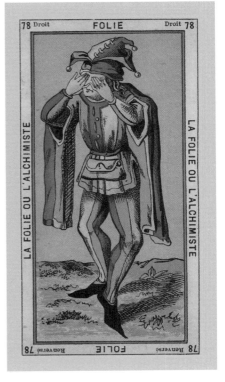

THE BOOK OF THOTH ETTEILLA TAROT

► THE BIRDS
AND THE FISH

The last card of the creation myth trumps depicts a still landscape filled with mythical birds and leaping fish. The upright card reads as appui, *meaning 'support', perhaps symbolized by the tree heavily-laden with birds, while the reversed divinatory meaning is 'protection'.*

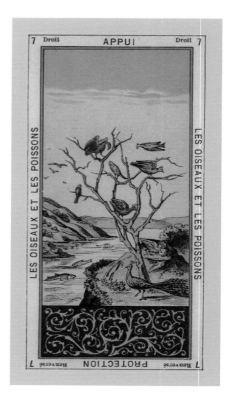

Gébelin's Influence

Was Etteilla's theory of tarot's ancient Egyptian origins influenced by the 1781 work of Court de Gébelin and Comte de Mellet's *Le Monde primitif* (The Primitive World) or did he come up with the idea himself? (Mellet incidentally wrote the part of Gébelin's work that describes the mystical connection of the tarot's twenty-one trumps and the Fool with the twenty-two letters of the Hebrew alphabet.)

In 1781, clergyman and occultist Court de Gébelin and Comte de Mellet claimed in their work that tarot was an ancient book of Egyptian wisdom made up of golden tablets engraved by scribes, the secrets of the universe as disclosed by the god Thoth to his adepts. Etteilla claimed that he had studied the tarot from

1757, long before Court de Gébelin's work and so had not been influenced by him. Yet most experts believe it's likely he had read Gébelin's work, which included an essay proposing the use of cartomancy.

Etteilla's version was that the original Egyptian book was composed by seventeen magi, who met with Thoth in a temple in Memphis where the secret information was revealed. Like Gébelin, he had no evidence for his claims. Also like Gébelin, perhaps caught up in the collective mood of 'enlightened thought' and the fascination for anything Egyptian, Etteilla simply jumped on the bandwagon and popularized an idea that was fermenting in more intellectual heads. But in this case, his tarot brainwave became the key to a great business future.

► CHAOS

Trump 1, Chaos, is used to represent a male querent, while Trump 8, Rest, represents a female querent.

► TWO OF SWORDS

The Two of Swords, usually interpreted as conflict in modern decks, here signifies companionship and friendship.

► PAGE OF COINS

Reveals a financial opportunity.

► JUDGEMENT

A significant stage in your life.

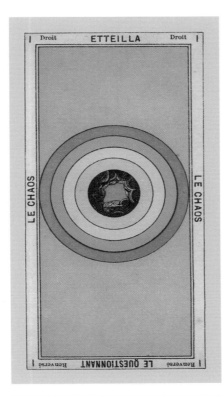

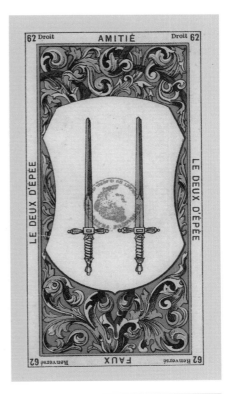

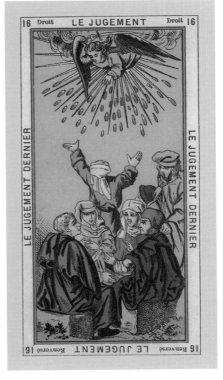

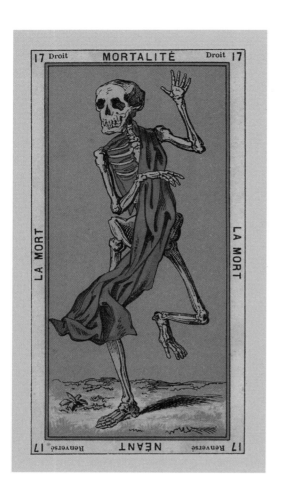

◄ DEATH

The reversed meaning of this card is captioned néant, *meaning 'nothingness', or 'insignificant', while upright,* mortalité *alludes to the struggle with our perception of our own mortality, questioning life and death. The skeleton likewise is animated, dancing in its red shawl, yet no longer living.*

Self-proclaimed Psychic

Nothing much is known of Etteilla's earlier life. His card-reading knowledge was apparently taught to him by an Italian friend and he may have already studied or come across various traditional fortune-telling systems, such as dice-casting and cartomancy, in the smoke-filled bars of Paris. Whatever the case, his tarot book was a success and the ex-seed merchant and print dealer changed his profession to astrologer, dream interpreter, numerology expert and all-round psychic expert.

Etteilla made a fair sum of money out of his new profession – just one brief reading with him cost 3 livres, while the handsome sum of 15 louis was demanded for an amulet to protect the client from all kinds of danger. At the time, a card-maker earned no more than 20 sous per day (20–25 sous was equivalent to 1 livre, and 24 livres equalled 1 louis). Whether charlatan, serious occultist or simply a clever businessman, Etteilla brought to the public eye the early nineteenth century's European obsession with all things Egyptian – particularly relevant after the discovery of the Rosetta Stone in 1799 – but, more importantly, he popularized the art of cartomancy and tarot reading. He was also the first tarot creator to reveal a choice of spreads for readings, describe how to consult the cards and create one of the first obvious links between tarot and astrological symbols, although erroneously.

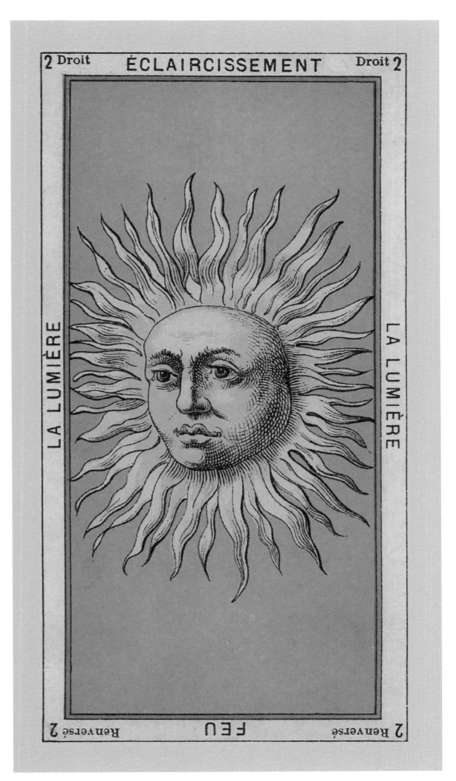

► THE LIGHT

Light corresponds to the sun and to the first day of creation, but strangely, in Etteilla's reckoning, it refers to the sign of Taurus and the element of Fire (Taurus is traditionally an Earth sign, not a Fire sign).

THE BOOK OF THOTH ETTEILLA TAROT

Rider-Waite-Smith

A compelling complete merger of art, divination and esoteric thought.

Creator: A.E. Waite, 1910
Illustrator: Pamela Colman Smith
Publisher: US Games, 1971

The Rider-Waite-Smith deck has set the precedent for most tarot decks since its publication in 1910, and synthesized the tarot's archetypal and divination significance into the twentieth century and beyond. Conceived by Arthur Edward Waite, a fervent member of the Hermetic Order of the Golden Dawn, the deck was originally published by Rider and Co., and is now commonly referred to as the Rider-Waite-Smith deck or RWS, to promote the artistic input of illustrator Pamela Colman Smith.

Revival of Esoteric Thought

Throughout nineteenth-century Europe, the tarot was becoming popular as a tool for divination. Various occult trains of thought shunted fashionable esoteric wisdom along many branch lines, such as the rise in Freemasonry, the mysticism of Kabbalah, the revival of astrology, supernatural psychism and spiritualism. In England, Madame Blavatsky's radical Theosophical Society helped to spearhead offshoots of Freemasonry and Rosicrucianism. Also bubbling away in London, a new society was being born. This was the Hermetic Order of the Golden Dawn, which synthesized Egyptian mythology, astrology, Enochian magic, alchemy, tarot and Kabbalah. The early teachings were based on an apparently ancient mysterious work, known as *The Cipher Manuscript*. Rife with tales about its pagan and pre-classical origins (the history of tarot still linked to ancient Egypt), it was actually a folio devised (according to A.E. Waite) by one of the Dawn's own members, Kenneth Mackenzie (1833–86), a Freemason and author of the *Royal Masonic Cyclopaedia* (1877).

The founders of the Golden Dawn, doctor and occultist, William Wynn Westcott, and aspiring Celtic revivalist and Rosicrucian, S.L. Mathers, had already put forward their version on the ordering and attributes of the major arcana. This was integrated into the Golden Dawn's lore, where initiates would use the tarot to predict the future, but, more importantly, to manipulate that future, too. Although such methods were shrouded in secrecy, revisionist member Arthur Edward Waite went on to adapt the Golden Dawn's tarot ideas, which have

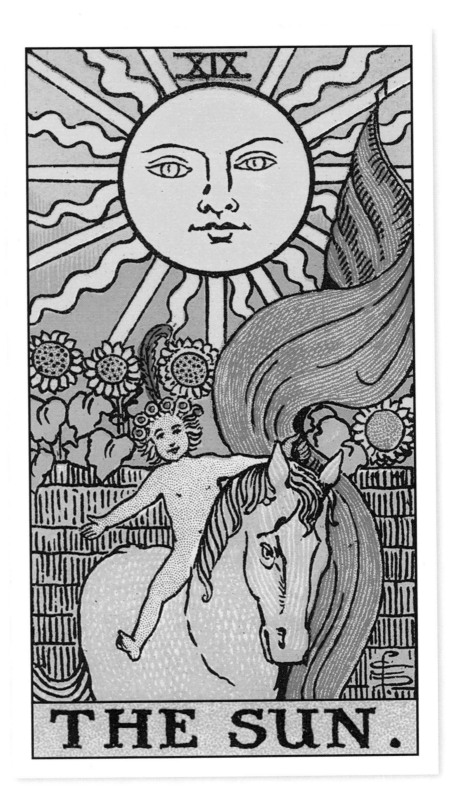

▶ **THE SUN**

Waite corresponded the Sun card to Gemini, and the playful child astride a horse as the adaptable, pleasure-loving, carefree spirit of the zodiac sign.

RIDER-WAITE-SMITH

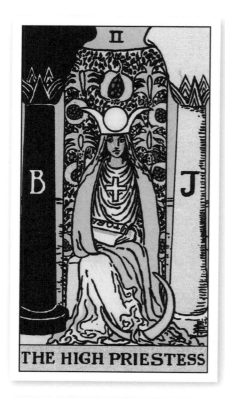

THE HIGH PRIESTESS

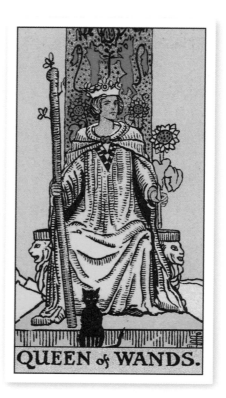

QUEEN of WANDS.

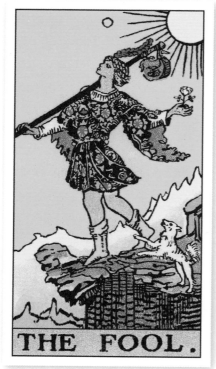

THE FOOL.

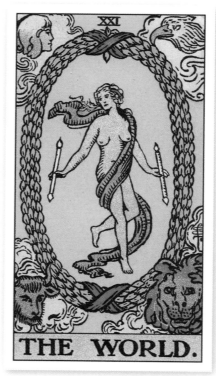

THE WORLD.

become the basis for most modern interpretations. The original Golden Order initiates included the inscrutable Aleister Crowley (see page 64) and poet and writer W.B. Yeats, who introduced artist Pamela Colman Smith to Waite.

A.E. Waite

Arthur Edward Waite was born in New York in 1857 and raised in England by his widowed mother. He joined the Hermetic Order of the Golden Dawn as the ninety-ninth initiate in 1891 (perhaps a significant number for him?), but the Order began to split and Waite formed a mystical offshoot – its adepts preferring spiritual enlightenment to occult practice. While Crowley was exposing secrets of the Order's methods in 1909, Waite, with input from Golden Dawn adept W.B. Yeats and illustrator Pamela Colman Smith, was ready to publish his own tarot deck. Emphasizing the tarot's link with Kabbalah, Hermeticism and astrology, his theories and analyses were well researched and innovative compared to Etteilla's earlier confused reckonings or Gébelin's and Levi's biased ones. Waite believed that there was no evidence of tarot being in use before the fifteenth century and that it was not Egyptian in origin.

Pamela Colman Smith

British born, Pamela Coleman Smith (1878–1951), known as Pixie to her friends, had lived in Jamaica and in New York where she studied art at the Pratt Institute in Brooklyn. On her return to England, her early projects included *The Illustrated Verses of William Butler Yeats* and a book on the actress Ellen Terry by Bram Stoker. Ellen Terry was impressed by the young illustrator, and 'Pixie' was taken under the wing of the Lyceum Theatre group. Smith travelled around the country with the group working on stage and costume design. She created her own miniature stage productions and wrote articles on design and decoration.

In 1901, she set up her London studio, frequented by artists, writers and the glitterati of the theatre. W.B. Yeats introduced Smith to the Golden Dawn, and when it splintered due to personality conflicts, Smith, now friends with Waite, followed him to his new order. In 1909, Waite chose Pamela as the illustrator for his visionary tarot deck and it seems that he gave her a list of ideas and symbols for the archetypal nature of the major arcana, and another list of ideas, which she developed into stories for the minor

RIDER-WAITE-SMITH

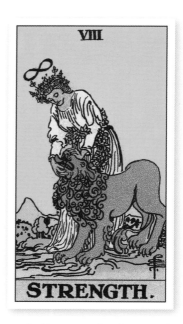

The infinity symbol reveals the power of mystical wisdom; the lion refers to the zodiac sign of Leo, and the taming of one's own ego.

cards. For example, the suit of pentacles relates to the story of a wealthy family and the temptations that lie ahead, when materialism equates with power.

After completing the deck, Smith carried on as a reasonably successful commercial artist and, later in life, she retired with a modest inheritance to run a priest's retreat in Cornwall.

Kings and Thrones

In an article about theatre design, written in 1910, shortly after the tarot deck was published, Pamela wrote, 'about us is the glowing beauty of the world, with its leaves and flowers, rags, gold and purple. Kings on thrones of iron, beggars on beds of clay, laughing, weeping, dreaming'. This resonates well with Smith's visual recreation of Waite's tarot and his rich range of astrological and other symbolic associations.

Examples include the rams' heads on the Emperor's throne representing Aries; the sigil for Venus representing Taurus on the Empress card. Rosicrucian symbols, such as roses and crosses, are included in Judgement, and letters on the pillars of the High Priestess card (B and J refer to Boaz and Jachim) reflect the stone columns of the mystical Masonic temple. The figure of Death holds a standard displaying the Mystic Rose of the Rosicrucians, representing life, while the Fool holds a rose in his left hand.

But Waite was also deeply fascinated by Christian mysticism and signs of this can be seen in the figure of Eve on the Lovers card, the four living creatures of Ezekiel displayed on the World card, and, on the Ace of Cups, the dove representing the Holy Spirit of medieval legend, who placed a wafer in the Holy Grail. Some tarot experts also believe a few of the figures in the deck are portraits of Smith's friends, such as actress Ellen Terry as the Queen of Wands, and actress Florence Farr as the female goddess creator of the World.

Eclectic Symbols

The Hermetic Order of the Golden Dawn's teachings and the symbolism in this tarot make this deck essentially an eclectic mish-mash of Hermeticism, Kabbalah, Freemasonry, Rosicrucianism, Greek mystery religion, Christian mysticism and astrology. In that, it reflects the late nineteenth century's cultural passion for all forms of mystical thought, and in itself reflects what the Renaissance tarot was, too – a visual feast of all that we are and seek in life and beyond.

But Waite, in his later years, became disillusioned with the Golden Dawn's teachings and, in 1926, published an article in which he stated that the tarot was filled not with occult truths, but mystical ones. He denounced the ideas of Kabbalistic correspondences between

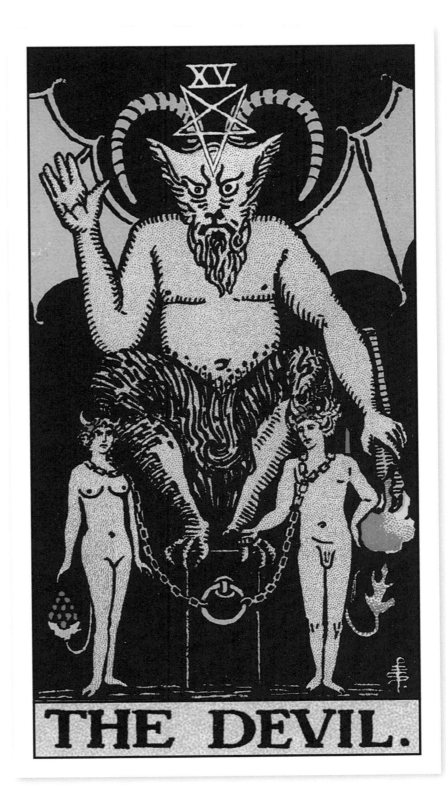

► THE DEVIL

The five-point downward-pointing star on the devil's head is a familiar symbol of evil, and the star shown this way up is associated with Satanism.

RIDER-WAITE-SMITH

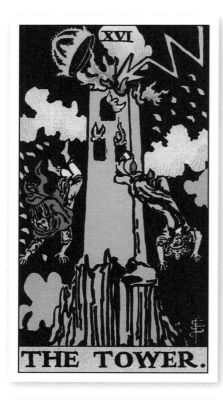

THE TOWER.

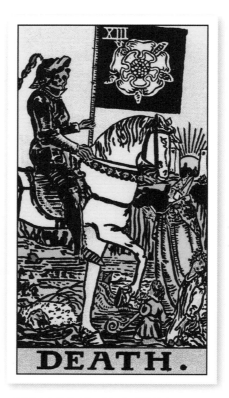

DEATH.

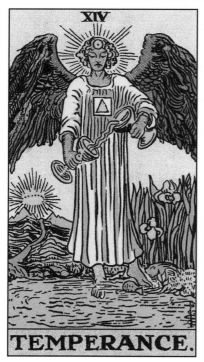

TEMPERANCE.

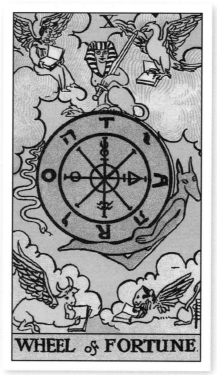

WHEEL of FORTUNE

► THE LOVERS

With pictorial allusions to the Garden of Eden – the serpent, a naked Adam and Eve and divine judgement from above – this card has many meanings depending on its position in a reading. Often interpreted as making a 'choice' in love, it can also imply betrayal, infatuation or simply asks the querent, 'What does love really mean to me? What kind of love am I searching for – physical, romantic, spiritual or self-love?'

◄ THE TOWER

◄ THE MAGICIAN

◄ TEMPERANCE

◄ THE WHEEL OF FORTUNE

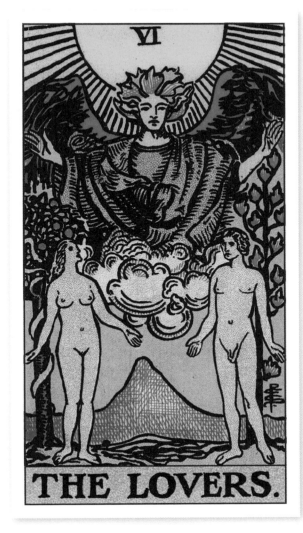

the Hebrew alphabet and the trump symbols, and perhaps influenced by W.B. Yeats, developed the idea of a link between the tarot suits and Celtic and Arthurian legends (erroneously), with emphasis on the Grail mysteries. In the accompanying book to his deck, *A Pictorial Key to the Tarot*, he created a spread that he called 'an ancient Celtic method of divination' (although he never said exactly what this Celtic method was). It has since become known as the Celtic Cross, now a highly popular layout in most tarot readers'

repertoires, whatever its true origins.

But with Waite's deck already in a league of its own, followed by the vogue for spiritual and supernatural knowledge which had, by the middle of the 1920s, spread worldwide, the art of tarot was now truly established and led the way for many more obscure, occult, beautiful and intriguing decks. As an easy pictorial focus for divination, the interpretations and imagery of the Rider-Waite-Smith deck has become the major influence on the majority of most New Age tarot decks.

The Crowley Thoth Tarot

An abstract, artistic deck filled with mystical symbolism.

Creator: Aleister Crowley, 1969
Illustrator: Lady Frieda Harris
Publisher: US Games, 2008

The forerunner of contemporary decks, which often discloses the psyche of its illustrator, Crowley's Thoth deck is a unique example of the artist's imaginative world.

The Thoth deck was intended as a work of art at its inception and has since fulfilled that objective. Made up of the twenty-two major arcana cards (although Crowley altered some of the traditional titles – the World became the Universe and Judgement was titled the Aeon) plus fifty-six minor arcana (with court cards Prince and Princess to replace the Page and Knight), it is a beautifully mystical work with an assortment of symbols derived rom Egyptian mysteries, the Kabbalah, Hermeticism and Greek, medieval, alchemical and astrological iconography. It was also a strange collaboration between the man who was known as 'the Beast' and a high society lady married to a Member of Parliament.

Libertines and Thelema

Controversial, quarrelsome and a notorious libertine, occultist Aleister Crowley was one of the early members of the Golden Dawn, whose reputation was dogged by scandal and accusations of sex abuse for the rest of his life. In 1944, he published a work entitled *The Book of Thoth: A Short Essay on the Tarot of the Egyptians* as a companion to a tarot deck, which incorporated a feast of esoteric traditions. However, the deck was not actually published until 1969, when New Age ideas and fashionable psychedelia peaked, and its stylistic abstraction sat easily in the more liberal, modern tarot mind.

In 1909, rebellious Crowley had published a work entitled *Liber 777*, disclosing the secrets of the Dawn's teachings and the attributions of the Hebrew alphabet and its mystical Kabbalistic associations with the major arcana. Clashing with the Dawn's founder MacGregor Mathers, Crowley went on to form his own occult group, while he travelled the world and pursued his love of mountaineering. With guidance from a 'spiritual entity' known as Aiwaz, who according to Crowley was an embodiment of Egyptian god Horus, the dissident magus founded an elite sect

▶ **ART (TEMPERANCE)**
The golden lion and the red eagle were used as motifs in medieval imagery to symbolize the alchemical process of the blending of elements.

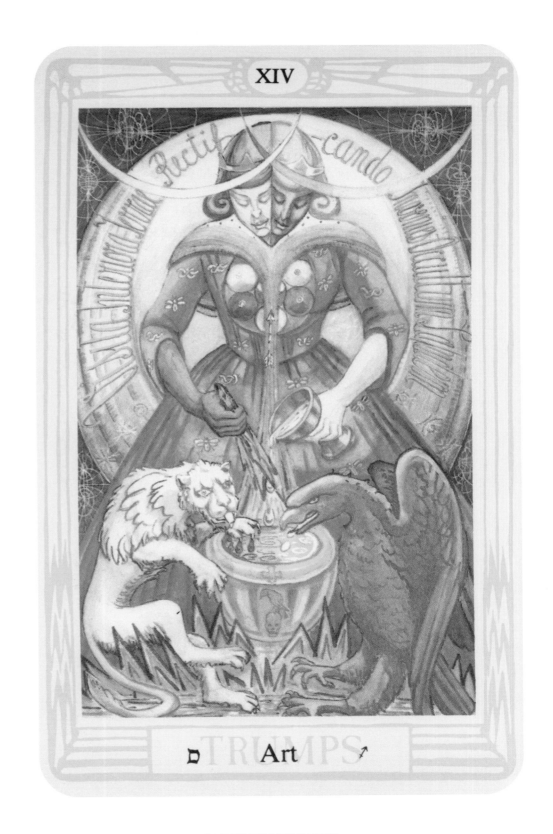

THE CROWLEY THOTH TAROT

Crowley's version of Strength, known as Lust, showcases his belief about the freedom to indulge in any sexual activity of one's choice. An ecstatic female 'harlot' rides a multi-human-headed hybrid lion. She holds aloft a cup, according to Crowley, a 'Holy Grail burned with love and death.' In her other hand she controls the lusting beast herself, yet is ready to let go and give free rein to her erotic desires.

that relied on sex magic as part of its teaching and his 'do as you will' philosophy. In 1920, he moved to Cefalù, Sicily and set up the Abbey of Thelema in a squalid villa. Proclaiming himself Chief Adept of the Order and, whether under the influence of drugs or an Egyptian god, 'the wickedest man in the world', his self-aggrandizement led him into steamy waters. When a twenty-three-year-old follower, Charles Loveday, died of hepatitis due mostly to lack of sanitation, his widow returned to England with sensational tales of drug abuse, promiscuity, sex magic, child neglect and bestiality. The Italian government intervened and Crowley was expelled from the island.

Lady Frieda Harris

Crowley's bisexuality, occult exploits and trips around the world are well described by many biographers. His early interest in the tarot culminated in the late 1930s when he met artist Lady Frieda Harris, a London socialite, through a mutual friend of Clifford Bax, former co-editor of the literary art magazine, *The Golden Hind*. In fact, it was Harris who persuaded Crowley to create a tarot deck she could illustrate, and he to write the accompanying book. At first, Crowley refused, and thought it might be easier just to redraw images from older decks. But Harris convinced Crowley to let her illustrate the tarot, mostly because she

offered to pay him two pounds a week to teach her everything about magic. At the time, Crowley was bankrupt, so he agreed.

Occult Tarot

Crowley's belief that tarot archetypes could be absorbed into the human psyche was an innovation that we might now call the personal psychological aspect of reading tarot. Coupled with his eclectic mystical knowledge, the deck was not just a tarot for divination, but for more occult purposes. As a Mason, Lady Harris was no stranger to esoteric subjects, but she had no knowledge of tarot or magic. So she diligently researched traditional tarot imagery and followed Crowley's tarot descriptions written in his magazine, *The Equinox*. She also worked from Crowley's sketches and notes, and thought nothing of repainting a single card as many as eight times to get it right.

Lady Harris finally exhibited the paintings in Oxford in 1941 and again twice in London in 1942. Crowley, however, was not in attendance, nor does his name appear anywhere in the programme. It's likely that Crowley and Harris fell out, and as someone who was not known for his generous praise of anyone, he did, however, pay tribute to her in *The Book of Thoth*: 'She devoted her genius to the Work … may the passionate "love under will" which she has stored in this Treasury of Truth and Beauty

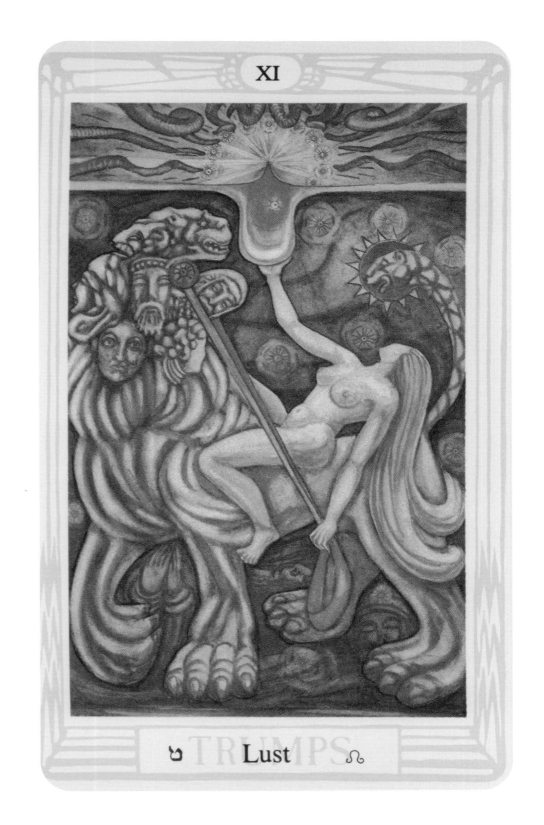

THE CROWLEY THOTH TAROT

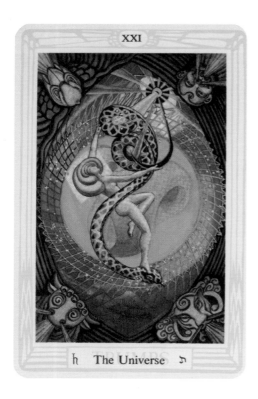

XXI — ♄ The Universe ♃

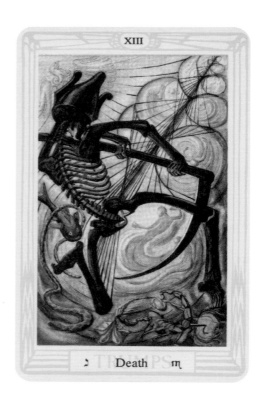

XIII — ☽ Death ♏

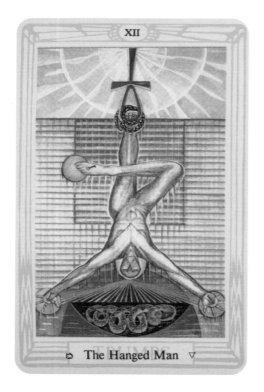

XII — מ The Hanged Man ▽

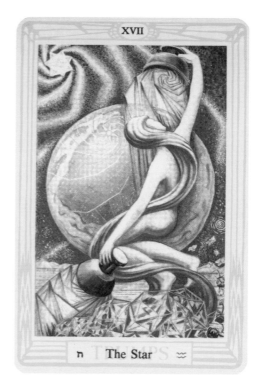

XVII — ה The Star ♒

· ·

A lecture, given by Lady Harris at the fashionable Sesame Club in 1942, recalled in some detail the artistic choices made for certain cards. According to Harris, Death represented the notion of reincarnation, 'weaving with his scythe a geometrical web of new forms'. She explained that while the suit of Cups typified compassion and receptive ideas, too much water in a reading could reveal loss of identity or self-expression. The Fool is based on Pierrot in the Commedia dell'Arte and is the prankster of life's theatre, the one who leads the dance.

Harris's depiction of Crowley's brief for the Universe offers a different perspective to the established concept of the World. Usually, the female figure in the World card is identified as the Anima Mundi (Soul of the World), or Gaia. But here, surrounded by a serpent, Harris's figure has been identified with Eurynome, the ancient Pelasgian goddess of creation who rose naked from Chaos and danced her serpent lover, Ophion, into being. The card here represents universal 'oneness' and, like much of Harris's artwork, was an inspiration for the new generation of spiritual seekers when it was finally published in 1969. Lady Harris's art and Crowley's inspiring insights (although neither lived to profit from the deck financially, nor see their work as a complete deck) created one of the most avant-garde, mysterious and influential decks of the twentieth century.

· ·

flow forth from the Splendor and Strength of her work to enlighten the world.'

McMurtry and Beyond

In 1944, Crowley published the first edition of the book, assisted by a young American soldier, Lieutenant Grady L. McMurtry, a member of Crowley's new magical order, Ordo Templi Orientis. Apparently, McMurtry met Lady Harris at her home in London, just before he departed for the D-Day Normandy invasion. McMurtry had driven his army jeep to visit Crowley in the depths of the countryside. The penniless Crowley asked McMurtry to deliver some important papers to Harris back in London. When he arrived, London was already blacked out, and as he approached Harris's door, he heard Debussy's 'Claire de Lune' being played and the sound of quiet chatter. There was obviously a soiree in progress. Lady Harris greeted him politely, turned and looked towards the interior, then raised her eyebrows at his uniform and boots. McMurtry recalls her saying that however much she would have liked to invite him in, his presence would have spoiled the evening's jolly mood. It is very likely that that was the first and last time he saw Harris, yet ironically it was McMurtry who arranged for the seventy-eight paintings to be photographed and published as a deck of tarot cards in 1969.

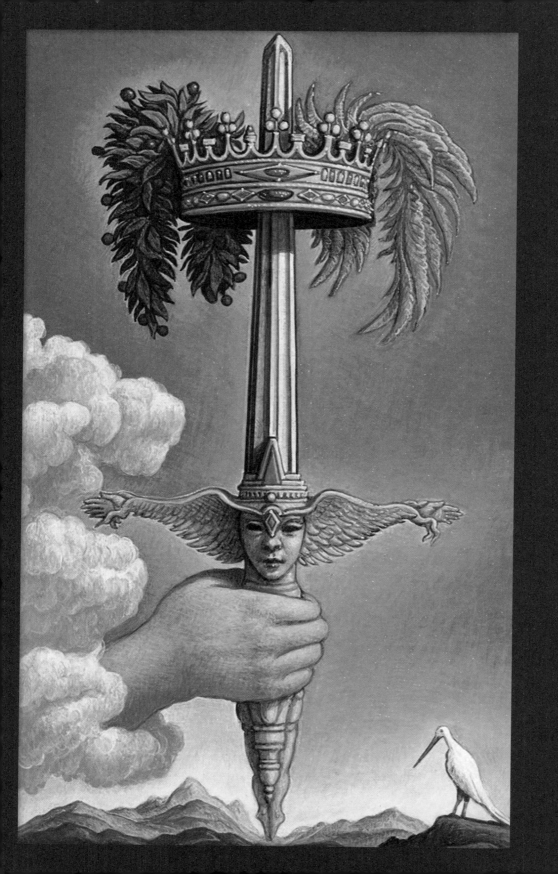

Beginner's Divination Decks

When it comes to beginner's decks, those that stand out usually conform to the traditional format of seventy-eight cards, including four suits of pictorial images for pip cards, and simple, but striking imagery and archetypal symbols for the major arcana. Learning and reading the tarot is a process combining intuitive connection to the symbols and a key to their interpretation. So any help given, such as keywords or powerful scenes depicting people 'doing things', set the bar for these beginner decks.

The Rider-Waite-Smith deck is acknowledged as one of the major influences for most modern tarot decks, and with this kind of imagery, as well as its influential illustrative style, it has spawned many other creators to follow suit. This chapter looks at some of the contemporary decks that offer different perspectives on tarot interpretation, but are still easy to understand.

For example, the Aquarian Tarot by the late David Palladini (see page 74) epitomizes the style and mood of the hippy generation of the 1960s and early 1970s. It is less angled at fate and fortune, and more at psychological insight and self-reflection.

Other decks focus on simplicity of colour and design, such as Morgan-Greer and Crystal Visions, where stylish composition creates easily understood imagery without the reader having to search for specific symbols.

Other less complicated but masterful decks include Kat Black's Golden Tarot (see page 96), which showcases the art of collage, using medieval and early Renaissance paintings with a modern twist. Then there is the Good Tarot (see page 94) and Paulina's (see page 92), which highlight the power of using simple images laced with the creator's own artistic and spiritual take on how to interpret the cards. These decks point less towards divination and more towards learning to make conscious choices for yourself by working with the reflective nature of the tarot, and to realize you are responsible for your destiny. These decks have all become classics in themselves.

The Aquarian Tarot

Art Deco and Art Nouveau imagery combine with medieval stained-glass effects to create a uniquely aesthetic deck.

Creator: David Palladini, 1970
Illustrator: David Palladini
Publisher: US Games, 1991

Born in Italy and emigrating to America as a child, David Palladini has a rich cultural background that is revealed in the lush creativity of his work. After studying art, photography and film at New York's Pratt Institute (the same college as tarot illustrator Pamela Colman Smith), David's first professional assignment was as a photographer for the 1968 Olympic Games in Mexico City. He went on to become a successful photographer and artist in his own right. The Aquarian Tarot deck was published in 1970, when he was twenty-four years old.

Brought up in Italy and surrounded by stained-glass windows, which shaped his view of art, Palladini was inspired by the intensity of hues he had seen in Art Nouveau-style leaded glass. There are direct tributes to both the colours and style of stained-glass work in all his tarot paintings. Palladini's message was also that tarot was not about prediction, but about knowing 'thyself' to provide insight into one's situation.

While studying as a long-haired, bell-bottomed-jeans art student in 1965, Palladini was surprised to be asked by a trend-setting New York agency to design a set of tarot images. This was to complement a series of fine art paper, produced by Brown Paper Company. After completing the work and back in art college, Palladini was approached by a small publisher, Morgan Press, who commissioned a complete tarot deck from him for a princely sum (it seemed to him at the time) of $100 per card. Palladini spent a year on the paintings, feeling as if he had been inspired from deep within. After submitting the work, he never heard from Morgan Press again, but a few years later, after making his own success in the design world, he walked down Madison Avenue and spotted his deck in a New Age shop. His tarot journey restarted, this time 'down the right street', and led him to further success. In 1970, Stuart Kaplan of US Games bought the rights to the Aquarian Tarot from Morgan Press and his deck became one of the classic tarots for the Aquarian Age. Since then, Palladini created a revised version of the deck known as the New Palladini Tarot, and his other notable work was an illustrated version of novelist Stephen King's *The Eyes of the Dragon*.

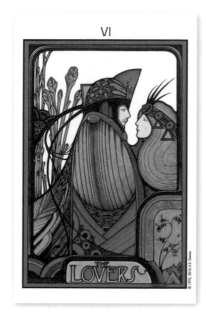

▲ THE LOVERS

BEGINNER'S DIVINATION DECKS

XVII

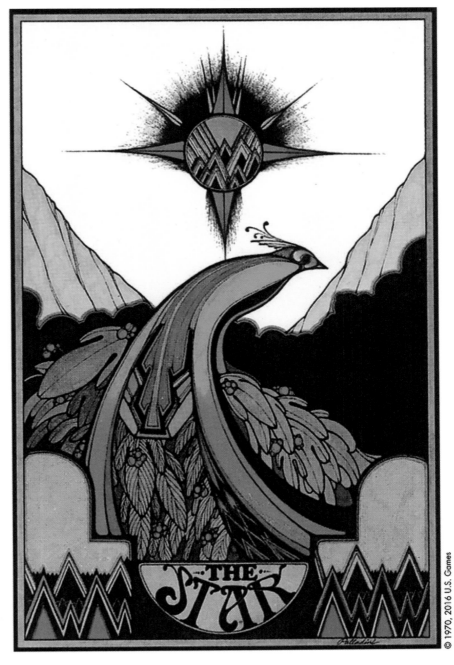

▶ THE STAR

THE AQUARIAN TAROT

► THE WHEEL OF FORTUNE

Signs of Egyptian influence are evident in the bull with wings, a pharaoh-like wheel-spinner and two serpents rising. The snakes are symbolic of the cyclic nature of the world, as the Wheel turns and time moves on. This is a sign of how to regain energy to create a positive engagement with life.

► THE MAGICIAN

The infinity symbol is a popular motif in modern decks.

► ACE OF PENTACLES

The powerful red pentagram denotes materialism.

► FOUR OF SWORDS

Time to reflect, contemplate.

► THREE OF RODS

Journey forth, set off on a quest.

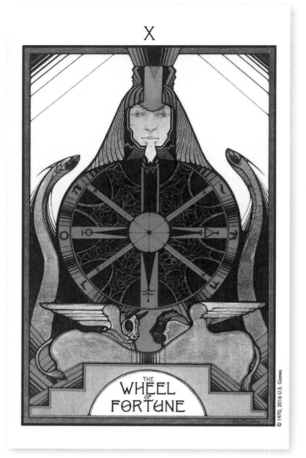

© 1970, 2016 U.S. Games

Palladini also introduced some of his own artistic license to traditional images. For example, the Star card is obviously different from any previous depictions of the Star. A bold, majestic bird, possibly a bird of paradise or some mythological bird, rests on a bed of leaves, poised as if ready to fly towards an eight-pointed star in the distance. The Star has eight points as depicted in most tarot decks. This is usually associated with the Star of Venus, or the Mesopotamian goddess Ishtar and her counterpart, Innana. The bird suggests that if we take flight towards the light of the star, or the goddess, she will bless us by rewarding us with success, but we must take conscious action to do so and not assume reward comes to us by magic.

Based generally otherwise on RWS imagery, the Lovers card for example, fuses the rich colours of an Arts and Crafts stained-glass panel with Pre-Raphaelite-inspired lovers. Vibrant yet simple, it is an immediate image of courtly love. The Four of Swords alludes directly to a resting or sleeping knight as a time of inner reflection, while the Three of Rods (Wands) reveals a determined, but stoical knight on a quest.

Palladini, too, was on a quest – one for a beautiful new world where using the tarot would help the querent to understand oneself and to make one's life more fulfilling. This deck is unique in that most of the imagery is shown in close-up, but it also gives us a close-up view of our own inner world.

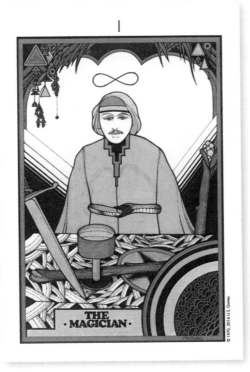

I

THE
· MAGICIAN ·

ACE OF PENTACLES

FOUR OF SWORDS

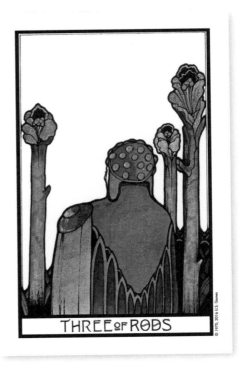

THREE OF RODS

THE AQUARIAN TAROT

Morgan-Greer

Colour unlocks the emotional and symbolic meaning of each card.

Creators: Bill Greer and
Lloyd Morgan, 1979
Illustrator: Bill Greer
Publisher: US Games, 1991

Illustrated by Bill Greer, under the direction of Lloyd Morgan, this deck's traditional nature and simple images have made it a classic beginner's deck. The Morgan-Greer is based on various tarot, including the RWS (see page 56), Marseilles (see page 44) and American occultist Paul Foster Case's B.O.T.A Tarot.

Lloyd Morgan and Bill Greer relied on two primary sources – the RWS and the Marseilles – to create their deck during the 1970s, not long after Palladini's successful Aquarian tarot, and there are elements of Palladini's close-up character style throughout this deck, as well. One of the easiest decks for beginners to use, it has a bold, eclectic feel. For example, the High Priestess is a simplified image of RWS's Priestess, with a crescent moon and expanse of water hidden behind a veil. The Chariot is however, based on the Tarot de Marseille, and depicts horses pulling the vehicle. The Wheel of Fortune is influenced by a totally different deck, and there is no hint of RWS or Marseilles symbolism in this at all. It draws on the 1JJ Swiss deck (see page 126), in which a king and queen are caught up in a spinning wheel. Another human figure has lost their grip and falls into the abyss below, but his foot is caught in the queen's flouncing gown – will she fall too, or will the falling figure be pulled back on the wheel to live another day?

So who are Bill Greer and Lloyd Morgan? There is little available information on Lloyd Morgan. Bill Greer is mentioned briefly in the *Little White Book* (the companion booklet) as having been born in Missouri, having attended Kansas City Art Institute and having always been fascinated by the archetypal nature of myth and mysticism. He worked on the deck in the middle of the countryside, away from all distractions, and his colour choices were inspired by Paul Foster Case's book *The Tarot: A Key to the Wisdom of the Age*. He said the colour palette was used to 'create an emotional reaction to each card, even before the image could be looked at in depth'.

In fact, colour is one of the most archetypal but subtle of symbols in most tarot decks. Without thinking about it, we

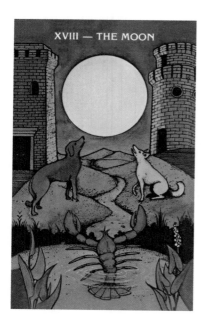

▲ THE MOON
Bold and striking, the bright yellow orb of the full moon takes centre stage. Can we trust in our feelings and moods during the time when wolves howl and strange creatures rise up from the depths? The card asks us to reflect, listen to our intuition and proceed with caution.

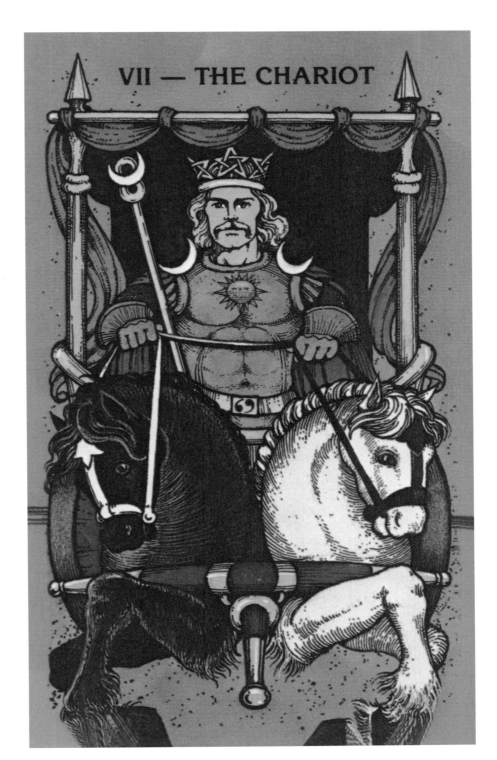

VII — THE CHARIOT

▶ **THE CHARIOT**

The charioteer is ready to tackle the world as his pair of 'yin/yang' horses gallop furiously towards the reader. Proudly displaying a confident face, this princely champion knows he will be victorious because he is determined to succeed.

MORGAN-GREER

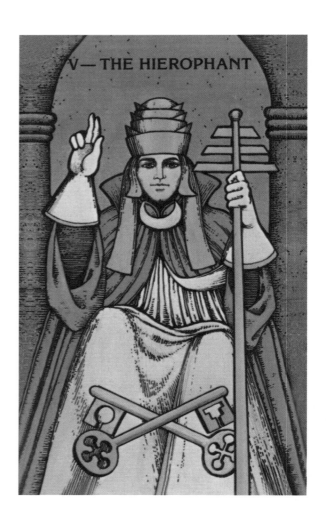

can easily associate red with passion and fire, green with the natural world, blue with water and feelings or yellow with the sun and joy. These are archetypal symbols, and are also related to the four astrological elements, red to Fire, blue to Water, yellow to Air and green to Earth.

Most of the characters in this deck have an array of medieval headwear, from helmets and fascinating hats to the layered 'turban-like' headpiece of the Hierophant. The crossed keys on this card are a symbol of the power of hidden knowledge, while the multi-layered hat represents all levels of knowledge or, perhaps, the steps we must take to true enlightenment.

▶ THE DEVIL

▶ KING OF
PENTACLES

▶ DEATH

▶ ACE OF RODS

The Classic Tarot

Engraved Italianate deck with useful captions and simple imagery.

Creator: Ferdinand Gumpennberg, c.1835
Illustrator: Carlo Della Rocca
Publisher: Lo Scarabeo, 2000

This engraved deck from the early nineteenth century set the standard for later Italian decks, much like the Rider-Waite-Smith deck set the twentieth-century tarot tradition. Also known as the Lombardo or Soprafino deck, Carlo Della Rocca's name is signed on the base of the King of Bastoni.

Around 1830, Ferdinand Gumppenberg, a German printer who had moved to Milan in 1809, asked etcher Carlo Della Rocca to make him a deck of tarot cards. Della Rocca had studied under Italian engraver and etcher Giuseppe Longhi (1766–1831), but never achieved the master etcher's level of fame. Although he was apparently quite popular in his time, there is no record of his date of birth or death.

These tarot cards feature the four traditional Italian suits – Swords, Batons, Cups and Coins – but incorporate flamboyant, theatrical characters, perhaps influenced by earlier rococo painting. The court cards, along with the major arcana characters, have more individuality and personality than ever before, and the major arcana cards include several features unique to the artist. For example, the Death card is now unlabelled (a sign of the superstitious Italian nature); the Hermit carries a little open flame in a holder instead of a lantern, and there is a curious face turned to glance at the reader at the bottom of the Hierophant (*Il Papa*, the Pope). Does this suggests either a wry self-portrait, or is it a subtle sign that there are many who do not conform to the papal power this card represents?

The deck isn't overwhelmed by symbols, but simply depicts characters 'doing things'. More recent editions include multilingual keywords (Italian, English, French and German) on all cards (including the minor arcana), making them easy to interpret and helping readers to understand the non-pictorial pip cards. This particular version, known as the Classic Tarot, is a reproduction of the first deck published in Milan in 1835. It was copied extensively throughout Italy for over a century and reprinted by Bordoni in 1889. The Classic Tarot deck is filled with detail, lush colours and expressive figures, and its fanciful quality makes it a characterful first tarot deck.

▶ **JUDGEMENT**
The archangel Michael blows a trumpet to release us from the internal hell of fear and self-doubt, and free us also from self-righteous behaviour.

▶ **DEATH**

▶ **THE DEVIL**

▶ **THE HIEROPHANT (THE POPE)**

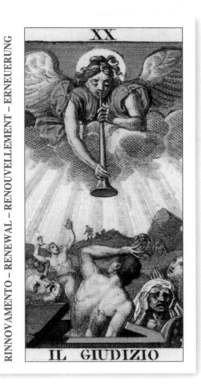

XX

RINNOVAMENTO – RENEWAL – RENOUVELLEMENT – ERNEUERUNG

IL GIUDIZIO

XIII

TERMINE – END – FIN – ENDE

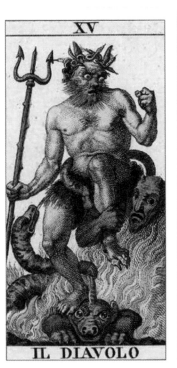

XV

ISTINTIVITÀ – INSTINCTIVENESS – INSTINCT – INSTINKTE

IL DIAVOLO

V

ISPIRAZIONE – INSPIRATION – INSPIRATION – EINGEBUNG

IL PAPA

The Universal Tarot

A basic version of the RWS deck, but gold dust to the beginner.

Creator: Lo Scarabeo, 2003
Illustrator: Roberto de Angelis
Publisher: Lo Scarabeo, 2007

THE RWS Tarot has been frequently replicated by many publishers or re-drawn by tarot illustrators. Here is one of best-known versions and visually the easiest to interpret.

The Universal Tarot is a refreshingly 'light' version of the RWS deck, with a contemporary, dynamic feel, also tinged with realistic detail of heroes and legendary characters. The King of Swords looks like a truly Arthurian-style king, who means business, while the Queen of Wands is accompanied by a menacing bodyguard cat. Keeping close to RWS imagery and its esoteric symbolism, there is also a hint of the illustrator's fanzine style in the uncluttered, linear images.

Roberto de Angelis was born in 1959, and he is an Italian painter and comic illustrator, best known as official cover artist of the comic worldwide success, *Nathan Never*, published by Sergio Bonelli Editore. His distinct, graphic, magazine style gives the archetypal narrative of the suits their own storyline, and each character has a part to play in the tarot journey. Highlighted in light, dynamic colours, de Angelis has created an easy first tarot deck where the hero, or the Fool, sets off blithely on his journey to meet life's characters along the way to personal enlightenment. We feel the emotions of such characters as the smug warrior in the Nine of Cups, or we sense the wry smile of the Magician who knows how to make things happen, right now. We can feel the penetrating gaze of the Emperor or the impartial one of the Lady Justice. In fact, each card teaches not only about the Fool's journey and who he meets on the way, but about the embodied emotions that are simply a reflection of ourselves.

The deck may simplify the original colouring and imagery of the RWS deck, but it also brings to life the characters with a modern twist, whose facial expressions, like in any comic or fanzine, speak directly to the reader.

This is an easy-to-understand tarot deck with a standard format and simple artwork, which any new tarot reader will enjoy.

RE DI SPADE
ROI D'EPEES

KING OF SWORDS
REY DE ESPADAS

KÖNIG DER SCHWERTER ZWAARDEN KONING

▲ KING OF SWORDS

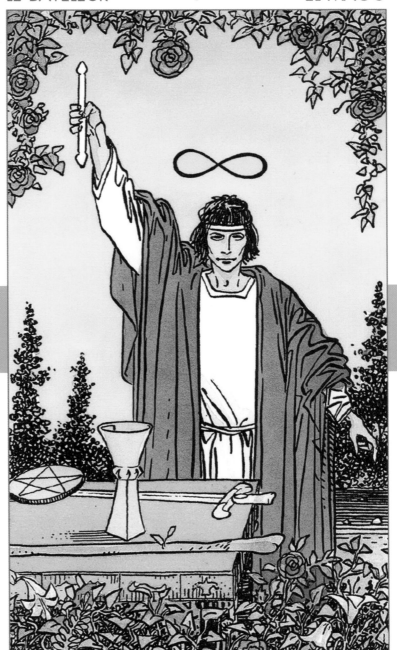

IL MAGO
LE BATELEUR

I

THE MAGICIAN
EL MAGO

DER MAGIER

DE MAGIËR

▶ **THE MAGICIAN**

The Magician has all earthly talents at his disposal, represented here by the symbols of swords, wands, pentacles and cups. The so-called 'infinity symbol', drawn as a figure of eight, is identified by a variation of the ouroboros, an ancient image of a snake eating its own tail. This represents creativity and corresponds to the quintessence, or fifth element, from which the sorcerer will be able to manifest his potential.

THE UNIVERSAL TAROT

The Mystical Tarot

Detailed imagery and rich symbolism form a pathway to self-understanding.

Creator: Lo Scarabeo, 2017
Illustrator: Luigi Costa
Publisher: Lo Scarabeo, 2107

Realistic but whimsical, dream-like but down to earth, this highly imaginative deck, published from original oil paintings by Italian artist Luigi Costa, is based on the RWS deck, but conveys a Renaissance-style atmosphere enriched with detailed symbolism. The artwork cross-fertilizes medieval, Pre-Raphaelite and Surrealist art, with nuances of Sola Bosca characters (see page 164).

Attention to detail is the key to using this deck, and the reader is asked to 'look within', not only into the imagery but into oneself. Like many contemporary beginner decks, these beautiful cards ask one to take a journey into self-understanding and deeper awareness of one's true desires and motivations, rather than just assume this is a deck for forecasting the future.

Luigi Costa also illustrated the Pre-Raphaelite Tarot for the same publisher and manages to blend an assortment of symbols from a range of different cultures. Strangely beautiful, the Six of Swords, for example, depicts the usual figure rowing a boat towards a mythical realm of peace. Yet, there is a strange lobster-like beast in the water about to upset the oarsman's rhythm; the hazy sky is filled with planets too close for comfort, while a divine light from above awakens the 'swords' to the truth.

The Strength card depicts a lady dressed in flowing chiffon, reminiscent of the works of late-eighteenth-century French romantic painters such as Élisabeth Vigée Le Brun. This self-assured heroine easily controls the roaring (or is he yawning?) lion. Egyptian influences run through the Magician, while suit cards have detailed backgrounds filled with personified clouds or astrological symbols to add depth of meaning to every card.

This deck embodies magic and realism at its best and pushes the reader to think carefully about what is real in their own life.

▲ ACE OF SWORDS
The white crane or heron is a symbol of knowledge and the birth of an idea.

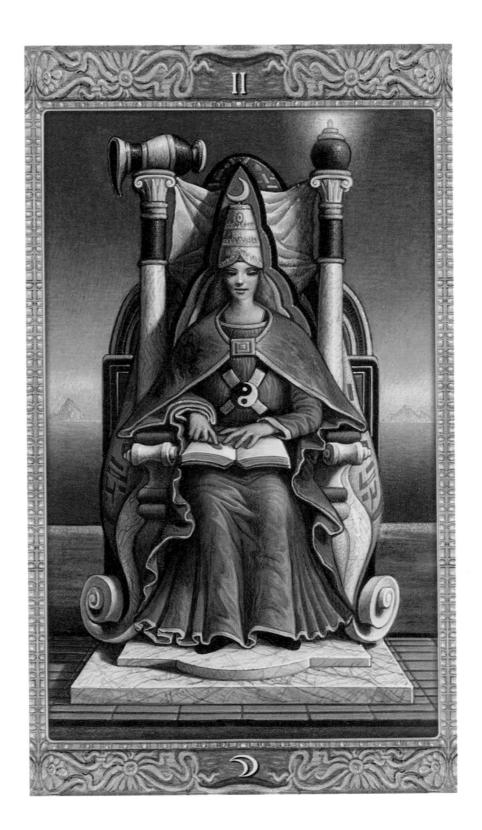

▶ THE HIGH PRIESTESS

The yin-yang symbol of ancient Taoism reveals the balanced feminine receptive energy (yin) and dynamic masculine energy (yang), which represents oneness.

THE MYSTICAL TAROT

The Enchanted Tarot

Richly textured artwork for imaginative tarot reading.

Creators: Amy Zerner and Monte Farber, 1992
Publisher: St Martins Press, 2007

Known as a 'spiritual couturist', the well-known collage artist Amy Zerner has co-authored many mystical books and oracle decks with her partner Monte Farber. Her exclusive designer clothes are said to spiritually empower the wearer and have been purchased by celebrities that include Rihanna and Goldie Hawn.

The Enchanted Tarot draws on myth, magic, mystery and spirituality, and Amy's artwork for each card was created using elaborate collages made up of paint, lace, paper and a wide range of jewels, amulets and fabrics.

The accompanying book by Monte explains how to interpret the cards on three levels, a system he devised after working with unconscious, conscious and spiritual states, realizing that the key to connecting all three was with an oracle such as the tarot. The first level he calls 'The Dream' (what the card represents in your unconscious self); the next is 'The Awakening' (what the card represents in your life now); followed by 'The Enchantment' (how to work with the essence of the card). The Devil card, for example, represents the darker urges and temptations of the deeper self in the Dream state; in the Awakening, your attachment to negative thoughts is the source of negative influence; and in the Enchantment, the reader is directed as to how to work with those feelings to restore self-love.

There is also a quick and easy guide to interpreting the cards for beginners, so the deck provides many different levels for understanding and it is a beautiful system for self-discovery and divination.

▶ **PRINCESS OF PENTACLES (LOTUS PETALS)**
The suit of Pentacles is predominantly green – the colour associated with growth, nature, materialism and abundance – and emphasized here by lotus petals symbolizing peace.

THE ENCHANTED TAROT

Crystal Visions

Elegant, fantasy deck filled with
light and clarity of interpretation.

Creator: Jennifer Galasso, 2011
Illustrator: Jennifer Galasso
Publisher: US Games, 2011

New Englander Jennifer Galasso is a successful Young Adult
fiction writer, fantasy artist and illustrator. The name and artwork
for this deck was originally inspired by singer-songwriter Stevie
Nicks' album 'Crystal Visions', released about the same time that
Jennifer was planning the deck. Already fascinated by Stevie's
poetic lyrics, ethereal spirit and mystical creativity, Jennifer added
another play on the deck's title with her other interest, crystal-ball
scrying. Both scrying and tarot give the querent clear messages,
whether gazing into a crystal or seeing the image of a tarot card as
a reflection of oneself.

Jennifer admits that, to begin with, she was confused about
how to work the tarot's themes. She began randomly painting,
but soon returned to the drawing board, creating sketches and
using the elemental associations – Fire, Earth, Air and Water
– and their colour associations as a basis for the four suits.
For example, the suit of Cups is coloured in a haze of blue/
purples astrologically associated with Water; the suit of Wands
is associated with Fire and red; the suit of Swords with Air
and yellows; and the suit of Pentacles with Earth and greens.
This modern fantasy deck gives beginners simple but striking
imagery to connect to the deeper archetypes and meaning behind
the cards.

◄ **THREE OF WANDS**
*Accompanied by her familiars, the
wild cat and a fantasy dragon, the
seeker peers into her scrying crystal
to discover her true pathway.*

BEGINNER'S DIVINATION DECKS

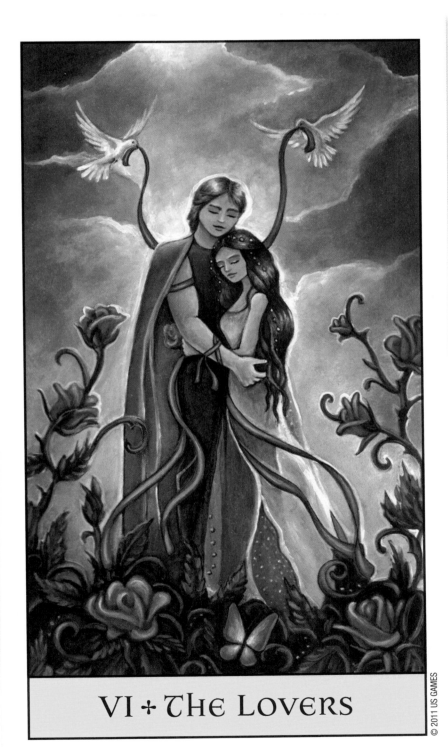

© 2011 US GAMES

VI + THE LOVERS

► **THE LOVERS**
Red roses have always been a symbol of passion, love and devotion.

CRYSTAL VISIONS

Paulina Tarot

Romantic spirit world, enchanting mystique.

Creator: Paulina Cassidy, 2009
Illustrator: Paulina Cassidy
Publisher: US Games, 2009

Delightful, romantic faeries and chimerical spirits flow across the cards of the Paulina Tarot. A deck based on the RWS, the illustrations by Paulina Cassidy are fun, light-hearted, mercurial and animated. Painted in pale shades, these watercolour paintings are filled with intricate detail. The author/illustrator was inspired to illustrate most of the deck while living in the New Orleans area, and many of her fanciful sprites are dressed in nineteenth-century Mardi Gras costumes, such as the Lovers and the Two of Wands.

The symbolism of the cards runs with the archetypal motifs of the RWS deck, but each card holds other symbols too, enough for any intuitive reader to find more than just a pretty picture on the surface. For example, the Emperor's armour is embellished with all-seeing eyes (a symbol of insight and power) and the mysterious lady is the Hermit, whose aides are mythical animals, one carrying a pocket watch, the other a lampshade (symbols of time and illumination).

Here and there, too, if you look closely, are tiny enchanting mystical beings or spirit folk, such as the astonished faces in the bark of the tree on the Death card. Many of these sprites and faeries apparently wanted to be included in the cards during the eighteen months of creation of the deck by the artist. Paulina spent days, and sometimes weeks, concentrating, delving into her unconscious and 'living' each card's meaning and symbolism. Her deck brings mystical enchantment for positive tarot readings.

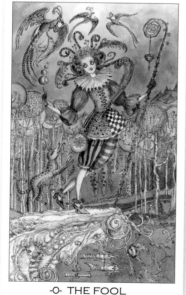

-0- THE FOOL

▲ THE FOOL

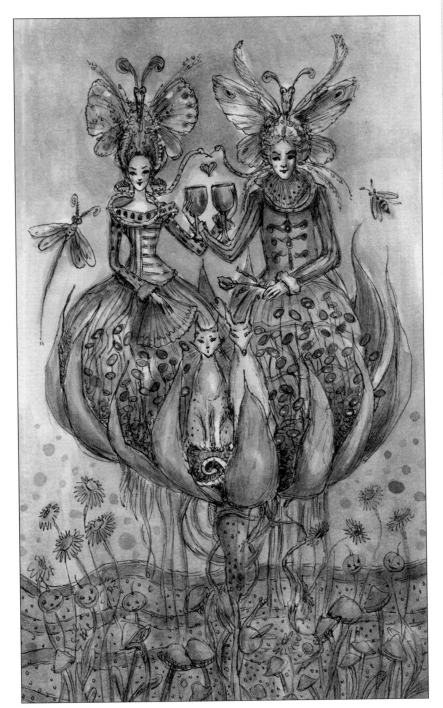

► THE TWO OF CUPS AND THE BUTTERFLY HEADDRESS

Butterflies symbolize conjugal happiness in most Eastern folk traditions, but to the ancient Greeks the butterfly was an embodiment of the human soul. The soul, or breath of life, was known as Psyche, who fell in love with the god Eros, who gave her the gift of immortality.

TWO OF CUPS

93 PAULINA TAROT

The Good Tarot

Subtle, illuminating images for personal growth.

Creator: Colette Baron-Reid, 2017
Illustrator: Jena DellaGrottaglia
Publisher: Hay House, 2017

Professional intuitive Colette Baron-Reid and digital artist Jena Della Grottaglia had already collaborated on various oracle card decks before The Good Tarot was published in 2017. Dog-lover, celebrated author and spiritual teacher, Colette has many fans who call her the Oracle Queen, after her many appearances on popular radio and TV shows across the USA. The Good Tarot deck is a standard seventy-eight-card deck, made up of borderless images filled with artfully designed digital compositions, collages, stunning details, misty photos and subtle colours. This is a deck mostly for transformation, self-development, meditation and spiritual growth.

The Good Tarot is so-called for its focus on the good of all and for positive outcomes, self-understanding and a connection to the universe. The present is more important than trying to divine future events, and it aims to offer immediate solutions. Although the traditional archetypes are at the core of each card's imagery, the seeker is asked to acknowledge the symbolism, but look for a positive result. For example, the Devil is considered on some levels to mean 'being bound by one's desires': here it would be that, yes, we all have desires and there is a devil within each of us, but accept and acknowledge and work with those desires, rather than deny them.

Another example is the Hanged Man card, which depicts a fallen angel or maybe Icarus (a golden orb, suggestive of a symbolic sun-chariot, is behind him). This can be interpreted as a time to accept of our failings or a fall from grace. Also, if we are unsure of how to move forwards, it is now appropriate to look at life from a new perspective.

► **TEMPTATION AND THE APPLE**
An ancient Christian symbol of temptation and the fall of Adam and Eve, the apple has long been identified with sin and forbidden fruit.

► **TWO OF AIR**

► **TRANSFORMATION**

► **STRENGTH**

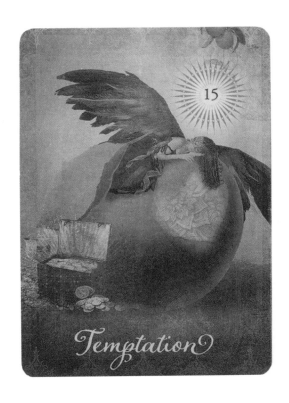

Temptation

15

2 of Air

13

Transformation

8

Strength

The Golden Tarot

Digital collage treasure, derived from a
mystifying collection of medieval art.

Creator: Kat Black, 2004
Illustrator: Kat Black
Publisher: US Games, 2005

**The Golden Tarot includes symbols and imagery taken from
Christianity, as well as an eclectic range of esoteric sources.**

Australian-born artist, creative VJ (video and film improviser)
and writer, Kat Black has been on a journey to create this deck,
originally begun as a hobby. In 2000, during her travels around
the USA and UK, she had an idea to create a deck showcasing
late medieval art, which had little funding or interest at the time.
After creating the first series of cards, known as version 1.0, she
was encouraged by followers of her site, including New York
artist Judy Sidonie Tillinger, to find a serious publisher for the
deck. With US Games on board, she tweaked the cards to make
them symbolically accessible, and the deck has now become one
of the most successful collage-created decks to date.

Kat used different elements from various artwork, dating
from the twelfth century through to the Early Renaissance of
the fifteenth century, to create her stunning imagery. These
snippets of art were taken from frescos, oil paintings, gilded
work and illuminated manuscripts to create a cohesive painting
for each card. She worked in digital detail, blending the hands of
a character from one image with a face from another, and then
digitally matching the skin tones as closely as possible.

Medieval Art

For nearly every card, Kat provided sources for her collages: for
example, the High Priestess is based on a Madonna painting by
the fourteenth-century Italian painter Vitale da Bologna; the
ceiling, columns and floor are from a fresco by the well-known
Florentine painter Fra Angelico, *The Annunciation*, from the late
1430s; the hat, book and sceptre are from fourteenth-century
Sienese artist Simone Martini; the black robe from *Madonna with
Angels Playing Music* is by Spanish painter Pedro Serra, from the
1390s; and the fabulous cheetah or leopard is from a painting
called *Procession of the Oldest King* by Benozzo Gozzoli dated
around 1459–60.

She also explains that although she stuck to similar
depictions of the RWS deck, in some cases she chose a different

▶ THE MAGICIAN

▶ TWO OF CUPS

▶ FOUR OF SWORDS

▶ ACE OF COINS

I

THE MAGICIAN

TWO OF CUPS

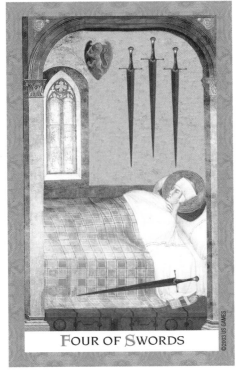

FOUR OF SWORDS

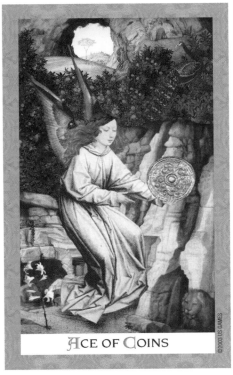

ACE OF COINS

THE GOLDEN TAROT

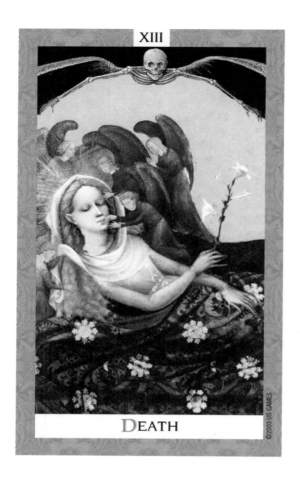

XIII

DEATH

©2003 US GAMES

◀ DEATH

Kat believed that the first version of this card was too scary for anyone to understand its rich meaning, so her second version offers a gentler approach to change. It suggests that if we go with the flow and get on with life, rather than letting our fears take control of us, we can achieve all those things that truly matter.

theme, such as linking the High Priestess card with the legendary Pope Joan from the Middle Ages. Although she includes the pillars, and a woman in robes holds a book, she added doves and other Christian symbols, plus a cat instead of a moon to represent feminine mystery.

The Justice card also depicts a different element on the theme of 'balance'. The staff is topped with a gilded owl rather than a sword. Here, balance and harmony is best achieved by wise counsel rather than the threat of force. Kat's original version, 1.0, lacked angels for harmony and the symbol for self-knowledge, the owl, so these were added in the second version. The Tower is depicted at a more menacing, medieval angle than that of RWS. God's wrath is shown by the presence of a cruel, avenging angel, commonly depicted at the time. Her

interpretation is that we all must realize that life is fragile, we can fall from grace and things can fall apart, so we must be grateful for what we have.

Kat's vision for her tarot deck is based on the belief that we are all responsible for our own life, dependent on how we work with external influences. By using the mirroring influence of tarot, we can make informed choices for our future based on what is happening in the here and now, and also learn to accept others for who they are, too.

If the modern tarot is a tool for analysis and self-knowledge, encouraging self-understanding and compromise, then Kat's imagery invokes not only a sense of our deep connection to the archetypal realms, but also to the imagination of the human soul, which came alive through the art of the late medieval and early Renaissance period.

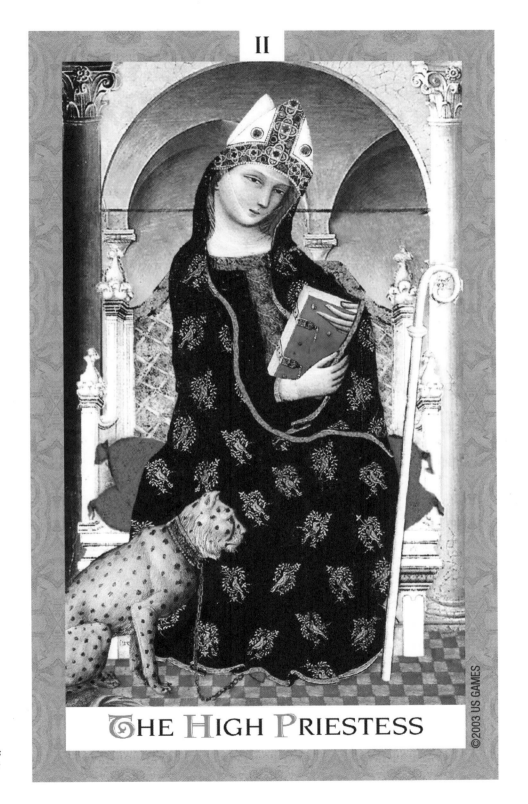

II

THE HIGH PRIESTESS

► **THE HIGH PRIESTESS**

The leopard is a symbol of stealth and also the ability to observe life from different perspectives with clarity and stay hidden if need be.

VI

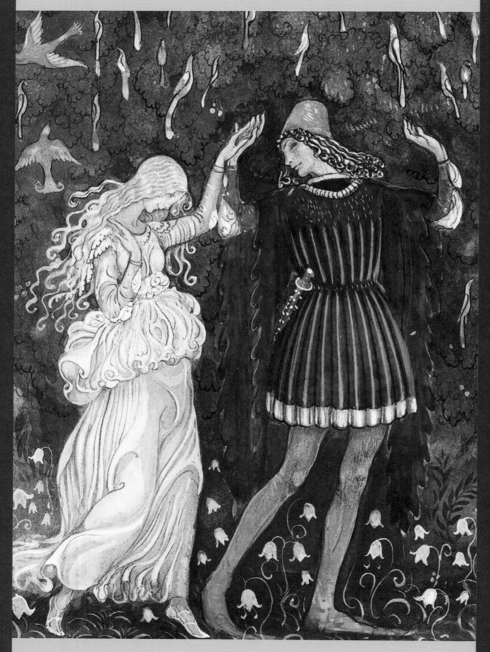

VI

Art and Collector's Decks

This section includes an eclectic selection of tarot decks
that sing from the heart, call to the soul and connect to the
universal spirit that leads us on our tarot journey. These decks
are woven inextricably into the story of tarot's art and history,
as either legendary, intriguing, worthy of being great works of
art or just highly desirable. In addition to the vastly influential
Visconti-Sforza deck (see page 36), there are some other early
classic Italian decks from the Renaissance era that compete for
collectability value, but most of all for their fascinating stories.
It is, after all, the power of an image, the artist's vision and our
ability to connect to that vision, whether through symbols or a
tale to tell, that makes us realize that we are all mirrored in the
artist's eye. Yet sometimes the artist mirrors the goings-on around
them, too, more than just a story of their own creation.

The rarity of a deck comes into this category, too. If it's out of
print, but still accessible, it obviously becomes a prize among
tarot collectors. From the Renaissance d'Este family's incomplete
decks (see page 104) and the so-called Mantegna Tarocchi (see
page 110), to the anonymous eighteenth-century French deck and
its mirror of Paris life (see page 120), there is more than just tarot
at work here. There is life reflected in the tarot, either of periods
of history, the people who lived or the creators and how they
influenced those decks, not forgetting the changing vogues in the
art world.

For example, the unconventional Le Tarot Astrologique (see
page 128) came at a time when the Art Deco movement swept
through the Western world. Later, publishers and creators used
the works of well-known artists to depict a new vision of tarot,
such as John Bauer (see page 134), Botticelli and Klimt; artists
such as Salvador Dalí created their own decks themselves (see
page 142).

This section also includes contemporary art-collector's decks,
such as Ciro Marchetti's tarot (see page 158), one of the first to
use digital fantasy techniques for illustrating the tarot and who
is still refining and developing his art; not forgetting the subtle
vision of artist Elisabetta Trevisan (see page 140) and the quirky
world of Patrick Valenza (see page 150).

This section brings you the beautiful, true and unique in
art terms.

The Golden Tarot of the Renaissance

Animates the ruthless beauty of the House of Este.

Creators: Giordano Berti
and Jo Dworkin, 2004
Publisher: Llewellyn, 2004

The Golden Tarot of the Renaissance was designed and created around an incomplete deck of hand-painted cards, which are now held in the Bibliothèque nationale de Paris. The cards were incorrectly known as the Charles VI or Gringonneur Tarot for some time, and are also known as the Estensi deck, referring to the d'Este family who ruled Ferrara in northern Italy in the late fifteenth century.

It may be that, originally, the cards were not intended to be a *trionfi* game-playing deck, but a series of miniatures, made up into elegant cards as gifts for princely commissions. With only seventeen cards remaining of the original deck, the creators, Giordano Berti and Jo Dworkin, found inspiration for the images from the frescoes in the Hall of the Months in the Palazzo Schifanoia – a palace where the d'Este nobles relaxed away from the politics of court life. The name Schifanoia is thought to originate from *schivar la noia* meaning 'to escape from boredom'. In 1469, Francesco del Cossa and Cosmè Tura painted a series of beautiful allegorical and astrological symbols, characters and motifs on the walls of this mansion. The portrait painter Baldassarre d'Este was later commissioned by Duke Borso d'Este to repaint the faces in a more favourable style. But who were the d'Este family and what was the curious link between the tarot decks they commissioned and those of the Visconti-Sforza?

The d'Este dynasty

The d'Este family, like the Visconti-Sforzas (see page 36), were highly superstitious and noted for their reliance on astrologers to forecast danger or delight. It is the family's scandalous stories that bring this tarot deck to life, with scenes depicting a dynasty full of triumphs and disasters.

In 1418, the Duke of Ferrara, Niccolò d'Este, at the ripe old age of thirty-five, was married to fourteen-year-old Parisina. In those days, age differences were unimportant, but according to Niccolò's astrological advisors, heirs were needed, particularly as the duke's first wife, Gigliola, had died childless of the plague of 1416. Niccolò himself was born out of wedlock and like most

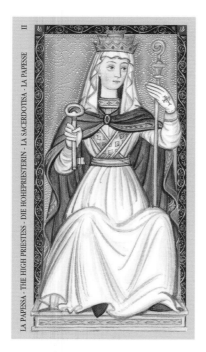

▲ THE HIGH PRIESTESS

► THE WHEEL OF FORTUNE

The Wheel of Fortune depicts the Renaissance notion of fate and is probably based on the Visconti-Sforza version. The braying donkey at the top of the wheel reminds us that we are not masters of our destiny, and even when we have reached success, we are still slaves to it.

LA RUOTA · THE WHEEL · DAS RAD · LA RUEDA · LA ROUE

THE GOLDEN TAROT OF THE RENAISSANCE

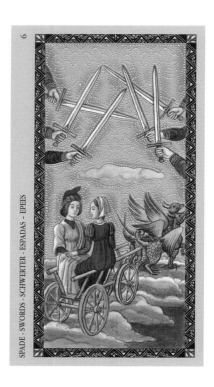

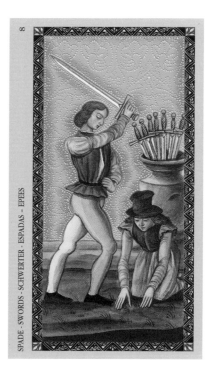

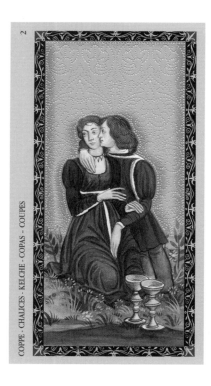

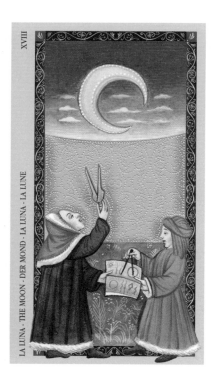

◄ **SIX OF SWORDS**
*A couple are being dragged
along on a chariot, perhaps
to the execution.*

◄ **EIGHT OF SWORDS**
*An actual execution
is taking place.*

◄ **TWO OF CUPS**
*A couple are sitting
rather too close together
to suggest anything other
than a sexual liaison.*

◄ **THE MOON**
*Astrologers and seers were
favoured by Renaissance
courts, and the moon, its cycles
and eclipses were powerful
omens of doom or fortune.*

ART AND COLLECTOR'S DECKS

Italian nobles, had adulterous affairs and spawned a range of illegitimate offspring, including sons Ugo, Leonello and Borso.

In 1423, Parisina, perhaps fascinated by the growing fad among ladies of the court for playing card games, commissioned from Florence a deck of expensive *imperadori* or 'Emperor' cards, which were first mentioned in the d'Este accounts of that year. This very special set of cards was to be gilded in the finest gold. She sent her manservant, Zoesi, to collect the cards at the cost of seven florins plus travel expenses. Ironically, it was Zoesi who was also responsible for another kind of accounting, and one that was to end in tragedy. It was not long before the frivolous card games, candlelit frescoes, carnivals and triumphant parades would be 'game over' for Parisina.

The Betrayal

The following year, Niccolò ordered his nineteen-year-old son Ugo to accompany Parisina on a journey to Ravenna. On their way back, and with the outbreak of the Black Death in Ferrara, they were sent to stay for the summer in a villa near the Po river. Here Ugo and Parisina fell in love and their clandestine, forbidden affair developed. When Zoesi glimpsed a weeping chambermaid fleeing from Parisina's apartment, his investigation led to the two lovers being caught between the sheets, and Zoesi reported the adultery to Niccolò. In May 1425, Niccolò reacted, as any cuckolded Renaissance duke would, by ordering the beheading of both Parisina and Ugo, along with any other guilty accomplices. In his rage, he also announced that if any adulterous wife be known in court, then they would be beheaded, too.

It wasn't until nearly twenty years later, in the early 1440s, that any kind of tarot decks or playing cards were mentioned in the d'Este accounts again. Maybe the courtly caprice for card games was a grim reminder of Parisina's frivolous adventure, and one which led to her terrible fate?

Bianca's Gift

When the lives of the Visconti and d'Este families crossed in the early 1440s, *trionfi* decks returned to the world of palaces, dukes and capricious courts. Niccolò d'Este was in the middle of proclaiming himself mediator in the long political war between Milan and Venice and, to that end, suggested to Filippo Visconti (the Duke of Milan) an arranged marriage between his son Leonello and Bianca Visconti to cement good relations between Milan and Ferrara. From Visconti's point of view, agreeing to the engagement was merely a pretext to rile the hot-headed Sforza (who was also negotiating Bianca's hand), and force him to abandon his warring mission. So to make it more convincing, Visconti sent his daughter to Ferrara, to look as if she was about to marry the d'Este.

Received in grand celebratory style at the Ferrara court, Bianca may well have talked about her father's love of beautiful miniature paintings and exquisite golden decks of cards (see page 36) and about their superstitious beliefs and Neoplatonic thinking, not forgetting their astrological advisors. In Ferrara, surrounded by doctors, musicians, artists and the highly cultured 'connoisseur of art' himself, Leonello, Bianca became excited by this artistic haven and was described as being a little wild, flirty and headstrong, too.

Perhaps it was Leonello who may have come up with a great ruse to woo both Bianca and her family to agree to a marriage, but it seems the tarot would be the key to doing so, or not. The court painter Sagramoro was commissioned to paint fourteen

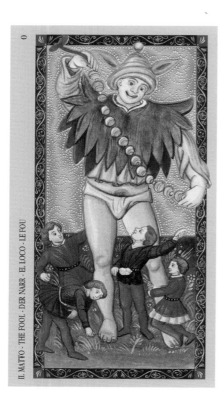

II. MATTO · THE FOOL · DER NARR · EL LOCO · LE FOU

◀ THE FOOL

The Fool here is represented as a court jester, and was inspired by frescos in the Schifanioa Palace, Ferrara. This card represents the carefree innocence of the querent who must follow the tarot pathway to discover self-understanding.

miniature gilded paintings for Bianca, either as a gift or a love token. The cards were presented to Bianca in January 1441. But the card trick did not fall in Leonello's favour, and by March 1441 Bianca had left Ferrara and in October was married to Francesco Sforza as part of the peace deal between Milan and Venice.

Whether sorrowful, wistful or trumped by the Visconti-Sforza marriage, Leonello's list of expenses for 1442 included various purchases of the very type of *trionfi* cards preferred by Bianca and her father. From then on, decks were frequently commissioned by the d'Este family. Various extant cards exist and are to be found in museums and collections.

Cursed Game

Inspired by the allegorical frescoes in the Schifanioa Palace, the Fool, for example, a figure from the fresco for the month of April, is the court jester Scocola, shown with Borso d'Este and various nobles. The Two of Wands depicts the dying Atys,

who was punished for his unfaithfulness, depicted in the fresco for July. The Sun shows a lady with bow and arrow, a sign of aiming high, and the sun a sign of happiness and solar spirit – a nod perhaps to Bianca's carefree spirit and card-playing days in Ferrara, and an innocently shot, well-aimed Cupid's arrow at the love-struck Leonello. This was the last deceptive seduction that brought the apparently cursed game of *trionfi* back into the lives of the d'Este family.

All these cards are vivid reminders of the power, glory and tragedy of these Renaissance dynasties. The Tower and the Six of Swords depict scenes reminiscent of the tragedy of Parisina and Ugo after their discovered adultery. The World depicts a woman above a green circle, containing a world and sky within – a symbol that mundane success is as ephemeral as the clouds in the sky. This is perhaps also an allusion to the d'Este's rulers lives, where living by the stars meant you must live as decided by the fate of your soul's journey.

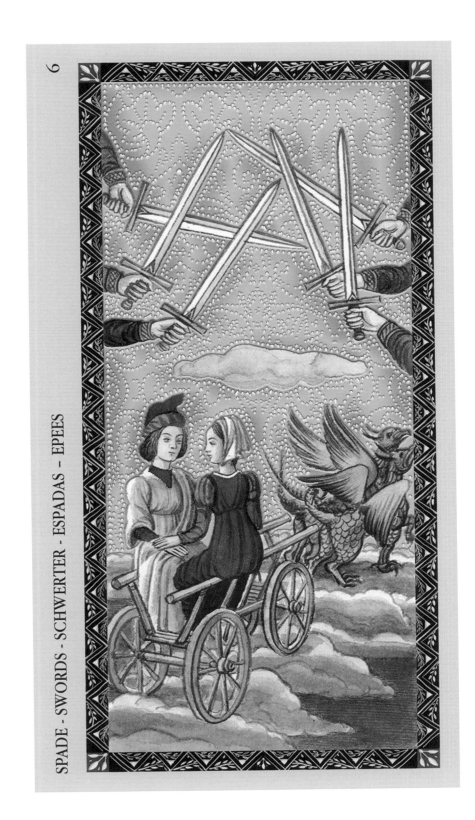

6

SPADE - SWORDS - SCHWERTER - ESPADAS - EPEES

▶ **THE WORLD**
Represents achievement
or fulfilment.

THE GOLDEN TAROT OF THE RENAISSANCE

Mantegna Tarocchi

Silver-gilded reflections of the early Renaissance worldview.

Creator: Unknown, 1400s
Illustrator: Unknown
Publisher: Lo Scarabeo, 2002

The seventy-five cards that make up this deck (based on the original fifty) inspire self-reflection and are often thought to be a guide to deeper understanding of the Greek muses, the cardinal virtues and the heavenly spheres. This deck was originally thought to be created from engravings by the Renaissance artist Andrea Mantegna, but recent studies have proved otherwise, and new research continues in the quest for its origins, with some fascinating hypotheses.

The deck (as a series of engravings on a sheet) appeared at the end of the fifteenth century and was contemporary with the Visconti-Sforza and d'Este decks. Yet it is nothing like the *trionfi* decks in style or content. Rather it consists of a series of fifty emblematic figures, divided into five categories, each of ten cards. The categories are: Human Conditions, Apollo and the Muses, Arts and Sciences, Geniuses and Virtues and Planets and Celestial Spheres.

The sixteenth-century Italian historian, painter and writer Giorgio Vasari wrote how Mantegna created copper engravings of *trionfi* and described a series of allegorical plates, which he then assumed were relevant to these images. Earlier experts believed that these were neither playing cards nor amusements for the Italian courts, but rather the deck would have been produced as an educational tool for understanding classical mythology, which was in vogue at the time. The only surviving specimens are uncut sheets, known as 'series E' and 'series S', and a selection of extant cards are held in the British Museum in London and the Bibliothèque nationale de France.

The cards are thought to have inspired later artists, such as Bolognese artist Amico Aspertini (*c*.1474–1552), who copied similar images in his notebooks and onto frescoes, and Albrecht Dürer (1471–1528) who prepared a series of cards in two groups, dating from 1496 and 1506.

Lazzarelli the Magician

However, some art historians suggest another painter, poet, writer and Hermetic philosopher, Ludovico Lazzarelli

▶ THE BEGGAR

▶ THE GENTLEMAN

▶ FORTITUDE

▶ VENUS

WRETCH
MISERABLE

ELENDER
ELLENDIGE

E MISERO - I 1

GENTLEMAN
GENTILHOMME

EDELMANN
EDELMAN

E ZINTILOMO - V 5

STRENGTH
FORCE

KRAFT
KRACHT

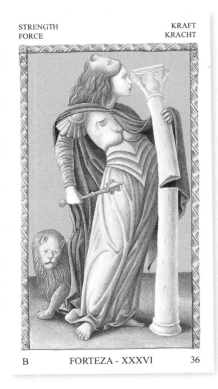

B FORTEZA - XXXVI 36

VENUS
VENUS

VENUS
VENUS

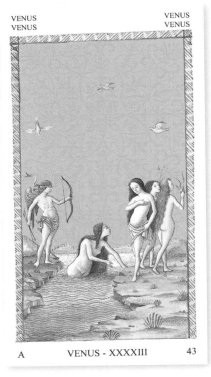

A VENUS - XXXXIII 43

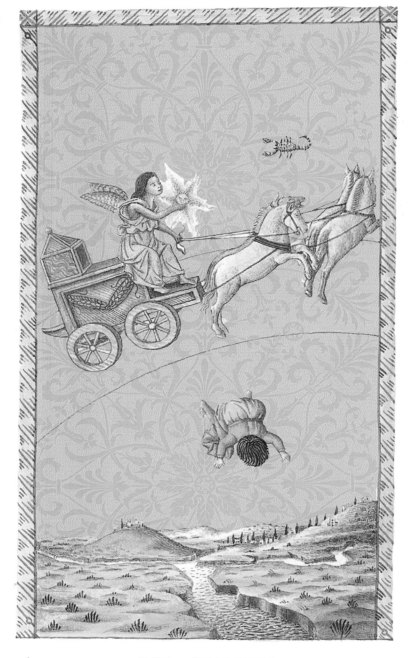

A SOL - XXXXIV 44

◄ **THE SUN**

Apollo's daily drive across the sky with his fiery chariot is interrupted when his son, Phaeton, took the helm and lost control. With the world endangered by the sun plummeting to earth, Jupiter struck Phaeton with a thunderbolt. This is a symbol of hubris, or excessive pride.

► **GEOMETRY**

From the Liberal Arts group of ten cards (four of which – Arithmetic, Music, Astronomy and Geometry – are motifs for science), the archetypes behind human thinking.

(1447–1500), may also have been involved in this series of images. Yet curiously, after deeper research, tarot experts now believe it may have been in fact Lazzarelli's manuscripts that were the real source and inspiration behind the Mantegna deck. But how?

Lazzarelli rose to fame at a young age and was lauded poet laureate in Venice in 1469. A magician, Hermeticist and diviner, he claimed he was the student of the flamboyant, eccentric and controversial preacher and sorcerer, Giovanni Mercurio da Correggio. Lazzarelli's poetical works included an illuminated manuscript especially created for the art-loving humanist, the Duke of Urbino, Federico Montefeltro. This poetical tract was decorated with images of the Muses, Spheres and Greek gods, inspired after watching a Trojan-War-themed tournament in Padova.

In another of Lazzarelli's works, he connected the use of Hebrew letters in divination with his own magical theory of language. He believed that words were directly connected with 'things' and could exert a magical power over them. In other words, an object or person could thereby be manipulated by magic spells. This was a similar belief held by other Renaissance Hermeticists and occultists, such as the German Heinrich Cornelius Agrippa (1486–1535), who avidly studied Lazzarelli's works.

Venice Bookshop

According to various sources, to decorate his manuscripts, Ludovico Lazzarelli searched through illuminations, pen drawings, woodcut prints and copperplate engravings in a Venetian bookshop. Out of his collection, he composed a unique set of illustrations for a 1471 (or possibly 1474) manuscript entitled *De gentilium deorum imaginibus*. The text contains twenty-seven illuminations, of which twenty-three are remarkably similar to the motifs of the so-called Mantegna Tarocchi.

For another of the Duke of Urbino's prized manuscripts, Lazzarelli unearthed images of the Liberal Arts. Although not identical, these are also similar to those in the Mantegna deck. The Liberal Arts were the basis of both science and philosophy in classical times. For example, for Grammar the symbol was a file and vase, for Music a flute, for Astrology a sphere of stars and for Theology a sphere of heaven and earth. These symbols were

▶ HOPE

Hope is a female character
praying towards a source
of (holy) light, while below
a phoenix burns on a pyre.
The phoenix is an alchemical
symbolic of renewal, reborn
from its own ashes.

considered to be similar to archetypes at work behind human thought in both Hermetic and Neoplatonic contexts.

It seems that Lazzarelli may have used his picture hoard to promote his secret beliefs in a symbolic way that only a few would understand. Interestingly, some Italian experts believe that he was also responsible for the creation of the Sola Busca Tarot (see page 164).

Hermetic and Hidden

If most of the Mantegna Tarot was inspired by, or even was directly, Lazzarelli's work, it's hardly surprising that these symbols glided surreptitiously, and extremely cautiously, along the marble hallways of the Italian courts where such ideas were compelling, unconventional but also heretical.

Albeit hidden in a guise of mythological learning, the tarot is also a complete mirror of Lazzarelli's Hermetic and humanistic ideas. Look closely at these images with a different eye and you see a different tarot; this is one laced with archetypal associations. For example, the second group of cards consist of the nine muses and Apollo. The muses include Calliope, 'the beautiful voiced', Urania, the 'heavenly' and Erato, 'the arouser of desire'. In Hermetic and Neoplatonic philosophy, the muses represent the creative inspiration for the soul, which can draw on the archetypal forces for transformation. This part of the tarot deck reflects the ideal at the core of the Renaissance-inspired artists, writers and musicians: to free their creative spirit, and subsequently be empowered with a sense of 'soul'. The Mantegna deck certainly conveys that.

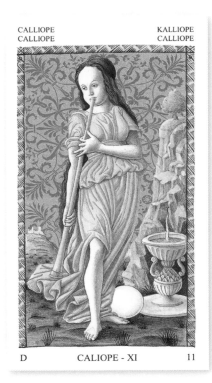

CALLIOPE KALLIOPE
CALLIOPE CALLIOPE

D CALIOPE - XI 11

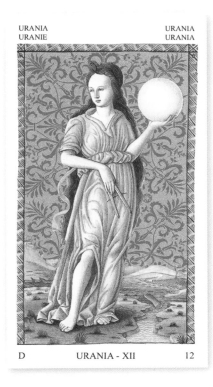

URANIA URANIA
URANIE URANIA

D URANIA - XII 12

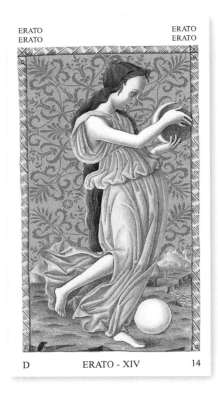

ERATO ERATO
ERATO ERATO

D ERATO - XIV 14

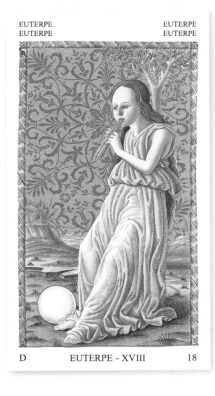

EUTERPE EUTERPE
EUTERPE EUTERPE

D EUTERPE - XVIII 18

► CALLIOPE

► URANIA

► ERATO

► EUTERPE

Minchiate Etruria (Anima Antiqua)

Florentine *tarrochi* with a wealth of major arcana or trump cards.

Creator: Unknown, 1500s
Illustrator: Unknown
Publisher: Lo Scarabeo, 2018

The Minchiate Etruria is an early-sixteenth-century card game, originating in Florence and made up of a deck of ninety-seven. The deck is closely related to the tarot, but contains forty or sometimes forty-one trumps. There are four suits of fourteen cards each, plus trumps and the Fool (or 'Matto'). The four suits are Cups, Coins, Swords and Staves.

The word *minchiate* comes from a word meaning 'nonsense' and is also derived from another Latin word for phallus. A similar word, *minchione* is also derived from the Italian word for 'fool', and *minchionare* means to laugh at someone. The original sense may have been to describe the cards as 'the game of the fool' as the Fool card was also called 'the Excuse'.

By the beginning of the sixteenth century, *minchiate* became known as *germini*, after the card 35 Germini, which was given the highest value of all trumps. The earliest record of *germini* dates back to 1506. The game spread from Florence to the rest of Italy and France and was similar to *trionfi*. Yet it seems that this kind of risky tarot was also about a game of life and death.

Lorenzo de' Medici, Duke of Urbino (1492–1519) was, like most nobles of the time, highly promiscuous, and entertained both male and female prostitutes so it's hardly surprising he became syphilitic at a very young age. Wounded in battle in 1517, and close to death, rumours abounded that he had actually been put in his coffin, while other information suggested that he was still alive. In fact, while lying on his sickbed, he was playing *germini* with friends and his brother-in-law Filippo Strozzi, and not, as some suggested, being buried with the cards in his hands.

For most Renaissance courtiers, card games had become an addictive and probably expensive habit, where gambling parties carried on throughout the night under cover of darkness and within castle walls. But Lorenzo's frail and syphilis-wracked body only got worse, and by 1519, he was close to death. He spent most of his time in bed, only receiving those who could cheer or entertain him, including Filippo Strozzi, who recounted how, up to the very moment he died, Lorenzo was still playing *germini*.

▶ **AQUARIUS**

The scythe and watering can are symbols here. In many mythologies the scythe cuts the old to make way for the new. Aquarius was ruled by the god of time, Saturn, and the figure simultaneously cuts through time yet waters life.

MINCHIATE ETRURIA (ANIMA ANTIQUA)

Mitelli Tarocchino

A baroque, fanciful variant of *tarrochi*.

Creator: Giuseppe Mitelli, *c.*1660
Publisher: Lo Scarabeo, 2018

The Mitelli deck is a *tarocchino* deck of sixty-two cards created for a variant of the game of *tarocchi*. This limited edition, numbered deck originally dates from Bologna, *c.*1660.

Renowned, charismatic and creative, the Italian engraver Giuseppe Mitelli (1634–1718) designed this baroque-style set of cards for a certain Count Filippo Bentivoglio. Mitelli appeared to excel at everything humanly possible. He was a technically skilled artist and became famed for his paintings, engravings and sculpture. He was also a great actor, horseman and indulged his passion for inventing games for everyone. At least six hundred of his engravings exist, including many etchings based on paintings by famous artists of his day. Later in life he focused on moralistic engravings, accompanied by a descriptive text, as well as designs on pages for games with dice or cards.

A few decades after Mitelli's death, an anonymous Bolognese card-maker reprinted and hand-painted the sixty-two cards in a number of unknown of copies for card players.

The trump cards are the same as a standard tarot with a few variations: the three virtue cards appear together after the Chariot; the Hermit and the Wheel of Fortune switch places; the Angel (Judgement) card has the highest value; and the suits of Cups and Coins have female Pages. The Papesse, Empress, Emperor and Pope were replaced by the Four Moors (due to the Church's objection towards not only gambling, but the inclusion of such characters in playing cards).

Count Bentivoglio received the six sheets of paper with ten or eleven copper engravings to a page. He then had to arrange for the engravings to be cut into individual pieces and pasted on to a hard backing, ready for card playing. A few uncut sheets still exist in museums today, along with several decks bound into books.

Not much is known of Count Bentivoglio, but as many other Renaissance nobility, he must have seen himself reflected in some of the cards – perhaps as the god Apollo (the Sun card) or as mighty as Atlas, seen holding up the heavenly firmament in the World card, and perhaps, if lived to an old age, as the Hermit (a familiar image of Kronos, the god of time).

▲ THE MOON

Artemis, the Greek goddess of the hunt, wild beasts and the moon, personifies the need to trust in one's intuition and the cycles of nature. Her brother, Apollo the sun god, symbolizes solar energy and human consciousness (see opposite page).

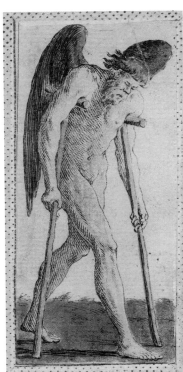

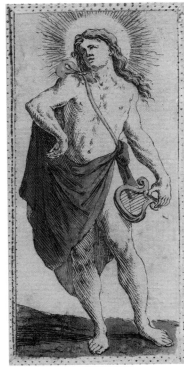

▶ THE STAR
(THE LANTERN)

Illuminating his journey, an old man trudges on, by the light of a lantern. The lantern represents a bright future, as long as we can focus on it.

▶ THE WORLD

▶ THE HERMIT

▶ THE SUN

MITELLI TAROCCHINO

Le Tarot de Paris

Ornate, dynamic and mysterious.

Creator: Anonymous
Publisher: Grimaud, 1969

These flamboyant cards from the early seventeenth century are by an unknown Parisian card-maker. The originals, housed in the Bibliothèque nationale de France, have dynamic designs and curious variations from the usual trumps. In an Italianate, baroque style, and with ornate mythical and fantastic beasts, this deck also has signs of Germanic influence. The Ace of Coins, for example, shows a stag and a lion holding flags, which is similar to the Ten of Falcons from a hunting deck dating from about 1445, known as the Abraser Hofjagdspiel cards (depicting the art of falconry).

So did this anonymous Paris card-maker/artist just steal or borrow ideas from other decks he or she may have come across, or is there more to the imagery? Was this in fact a commissioned *amuse-bouche* for some noble courtier or lady, or just a fanciful attempt by an artist who took a certain whimsical approach to the tarot? We don't know, but this is a deck that vividly mirrors the cultural life of early-seventeenth-century Paris.

The colours are vibrant, and the faces and features of the characters, although faded and somewhat crude, are finely drawn and strangely full of life; perhaps they are depictions of people the artist knew or those around him?

Social Mirror

Early-seventeenth-century Paris was rapidly developing. The city was filled with the bourgeoisie, made up of merchants, artisans, craftsmen, seamstresses, painters and engravers. Luxury goods for the nobility were in vogue, as were playing-card games and hand-printed books, literature and all the arts. We can spot some of these 'characters' in many of the cards such as the Bateleur or Fool, who appears to be some kind of merchant, bargaining, trading, selling goods or working on the market. A learned astrologer or scholar, shown in the Star, reflects the power of the university and the development of the Sorbonne and education.

The Hermit reveals a monk-like figure holding a rosary, at a time when intervention by the Vatican enabled over fifty religious orders to establish themselves in Paris, including Dominicans, Carmelites, Capuchins and the Jesuits.

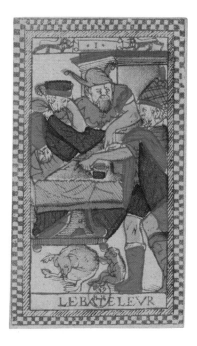

▲ THE MAGICIAN

ART AND COLLECTOR'S DECKS

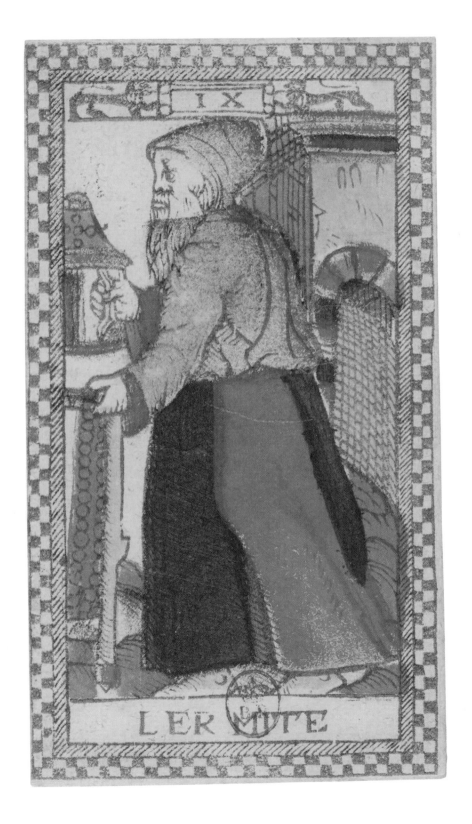

▶ **THE HERMIT**

LE TAROT DE PARIS

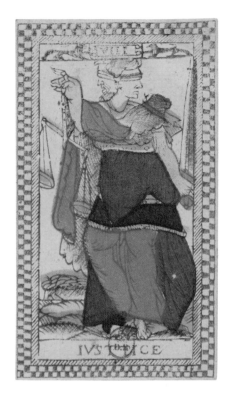

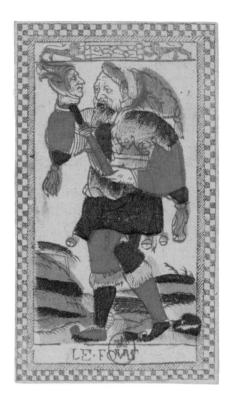

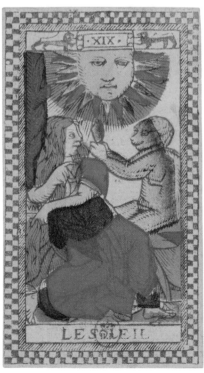

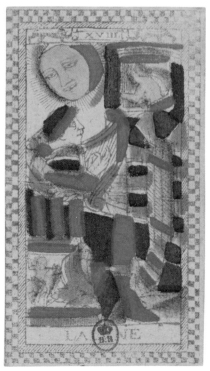

ART AND COLLECTOR'S DECKS

◀ **JUSTICE (THE SCALES)**
*A symbol of justice that dates back
to the ancient Egyptian goddess
Maat, who weighed the souls of
the dead and represented truth.*

◀ **THE FOOL**

◀ **THE SUN**

◀ **THE MOON**

There were also beggars, thieves and misfits, and a whole inner city known as the Cour de Miracles, with its own laws, where child beggars and thieves learned the art of faking anything from gangrene to blindness while begging on the streets. They would return back to their squalid dens completely well and healthy, presided over by the King of Thieves, just like the evil-looking figure in the Tower, reflecting a sense of chaos, trickery and horror of living such a life in squalor.

The Fool, depicted with a puppet head on a short stick and carrying some kind of pet animal, is reminiscent of the jugglers and performers who paraded the Paris streets. The city was renowned for its changing social life, the first cafes and cabarets, the founding of the Comédie-Française, theatre, processions, carousels and such wandering players.

Louis the Monkey
In the Sun card, a strange monkey holds a mirror up to a cringing woman beneath a serious-looking sun. Could this be a reference to the tumultuous relationship between the highly superstitious Marie de' Medici, her young son, Louis XIII and Cardinal Richelieu? In 1614, Louis XIII officially became an

adult, but Marie and her favourite courtier Concini refused to allow him to lead the Royal Council. In 1617, Louis, now taking over his mother's regency, had his captain of the guards assassinate Concini at the Louvre. Concini's wife was charged with sorcery, and beheaded and burned at the stake on the Place de Grève. Concini's followers were chased from Paris and Louis exiled his mother to the Château de Blois. Does this young monkey, on whom the sun shines so brightly, represent Louis XIII, who once old enough to take power sent into exile his own mother?

The Moon card depicts a musician playing a lute, gazing either at a painting of a naked woman or a lit window in which a woman bathes on a full-moon night. Louis XIII was a talented lute player, influenced by his mother's Florentine upbringing. But when he exiled Marie, he must have finally felt he had escaped from being under her spell. Her court intrigues had involved magic and were usually performed during a full moon.

This deck reflects not only the power struggle of a royal court, but the developing social melee of Paris in the seventeenth century. It is a deck with attitude and feeling, and is a superb mirror of social history.

Tarocchi Fine dalla Torre

Beautifully reproduced edition of an extant
seventeenth-century engraved woodblock deck.

Creator: Morena Poltronieri and
Ernesto Fazioli, 2016
Publisher: Museo Internazionale dei
Tarocchi, 2016

**This Bolognese deck follows the imagery of sixteenth-century
tarocchi, but has been recreated using extra cards to make a
complete deck of seventy-eight. The extant fifty-six cards held in
the Bibliothèque nationale de France were engraved in wood.**

Although the deck originally included depictions of the Popess,
Empress, Emperor and Pope, these were viewed unfavourably by
the papal authorities, and the Popess and Empress were replaced
with another Pope and another Emperor in the late 1660s.

In the eighteenth century, these were all replaced by images of
the four Moors. The four moors, or Eastern emperors or sultans,
had already appeared in various playing card decks dating back to
the sixteenth century. They had been used to reassure the Church
that gambling cards would not allude to anything to do with the
Catholic or any other church. But the change in the Bologna deck
is said to have happened in 1725 for another reason.

Canon Montieri of Bologna had created his own tarocchini
deck, which contained geographical or political information
about Italian cities on each of the trump images, one of which
suggested that Bologna was far more autonomous and free-
thinking than the papal states would like. A certain cardinal Ruffo
intervened and publicly burned the canon's deck of cards. To
avoid arousing local hatred and to save face, the Cardinal insisted
that the Pope, Popess, Emperor and Empress cards be replaced
by four Moors and the Angel card by a lady, although the latter
was ignored.

In the original deck, the High Priestess makes a sign or blessing
with a Latin gesture, and the feminine-looking Pope holds a closed
book in his stigmated hands. Both cards displayed connections
to Christianity. But the Popess also held a bunch of keys, a
symbol perhaps of unlocking the door to a more unconventional
spirituality than was accepted by the dogma of the Church.

In April 2014, Morena Poltronieri and Ernesto Fazioli
(of Museo dei Tarocchi) began work on recreating this
seventeenth-century deck. The museum team used computer
graphics to define and colour the cards as they originally might
have appeared.

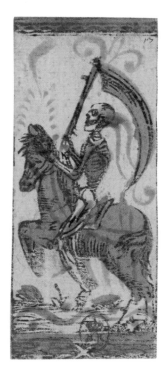

▲ DEATH

ART AND COLLECTOR'S DECKS

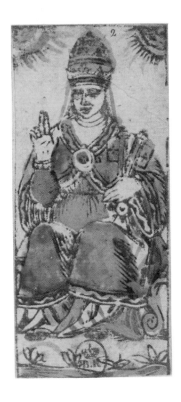

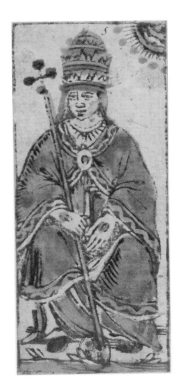

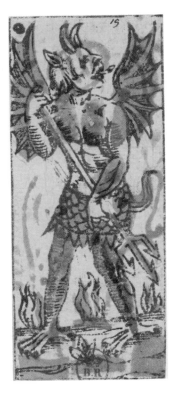

► THE POPESS

► THE POPE

► JUDGEMENT

► THE DEVIL

The 1JJ Swiss Tarot

Regal, Germanic, stylistic, with touches of nineteenth-century morality.

Creator: A.G. Müller
Publisher: US Games, 1972

Published in Switzerland by A.G. Müller and distributed in the US by US Games Systems, the Swiss tarot was first published in 1831 but has been somewhat modified over the years. It is the first tarot deck that US Games sold and was unexpectedly successful in the US market, making it an important milestone in the history of the tarot.

In his *Encyclopedia of Tarot, Volume 1*, Stuart Kaplan (then of US Games) tells how, in 1968, he visited the annual Nuremberg Toy Fair in West Germany. In a small booth at the fair, he discovered the publisher A.G. Müller, who showed him a deck of colourful cards called the 1JJ Swiss Tarot deck. Intrigued, as it was the first time he had ever seen a tarot pack, he found the imagery compelling and the deck of cards stuck in his mind.

When he returned to New York, he showed the 1JJ Swiss Tarot deck to Henry Levy, a buyer at Brentano's bookstores, who placed a small trial order for the decks as long as they included a booklet of instructions about the origin and use of the cards. Kaplan reveals this was the pivotal deck that led him to begin his research into the history of the tarot. Since then he has authored many books about tarot cards and methods of divination and created his own tarot decks.

The two Js in the title refer to Jupiter and Juno, the Roman equivalents for the Greek deities Zeus and Hera. They also replaced the Pope and Popess so as not to offend the Catholic Church. The drawings for these two cards are not quite as refined as the rest of the trumps, and may have been added later.

The two are posed in regal splendour. Juno is accompanied by a peacock (representative of the Resurrection in Christian and Byzantine traditions), while a bored Jupiter leans on his fist, and an eagle at his feet flaps its wings. The eagle is symbolic of masculine power and regal presence. The Devil card shows a seated woman with her head in her hands, while the unthreatening Devil casually holds a pitchfork. This may allude to the moral dilemma of a misogynist Europe in the nineteenth century, where seductive women were often associated with evil. The lady's shame symbolizes her guilt, while the devil represents the man who is innocent.

▲ JUNO

► JUPITER

Regal but reflective, Jupiter here seems to have resigned from being the king of the gods. The industrialization of nineteenth-century Europe did not bode well for the sky deity, who had little to do but contemplate humanity's materialistic progress and come down to earth himself.

Le Tarot Astrologique

Stunning art deco, zodiac-inspired deck.

Creator: Georges Muchery
Illustrator: Henri Armengol
Publisher: Grimaud, 1927

Reflecting the fashionable art of the times and George Muchery's own astrological chart, Le Tarot Astrologique is a tarot deck that bears no resemblance to any traditional tarot.

With forty-eight cards, this relatively small deck consists of thirty-six minor arcana decan cards – three for each star sign – and twelve major arcana cards: nine for the astrological planets; one for the moon's nodes; one for the Ascendant; and one for the part of Fortune. The decan system used by Muchery is an ancient astrological way of dividing up the zodiac. It was favoured by Renaissance occultist Heinrich Cornelias Agrippa and became popularized in the twentieth century by astrologers such as Marc Edmund Jones. According to this system, the 360 degrees of the zodiac can be split into thirty-six segments, with three segments of ten degrees given to each of the twelve signs. Each of these ten degrees are aligned to certain qualities. Le Tarot Astrologique also includes a short booklet that explains how the cards are designed to not only divine the future, but provoke deeper thoughts about oneself, something that astrologer and occultist Georges Muchery was, it seems, very apt to do.

Georges Muchery joined the French navy in 1911, and in 1914, while serving on the battleship *Le Suffren*, found time to study psychology and his childhood passion of astrology while the ship was under repair at Toulon. It's likely, while docked at the port, he also visited local cafes and bars where he met fortune-tellers who inspired him to take a further interest in chiromancy and tarot reading. In 1915, Muchery asked for a transfer to a new fleet of seaplanes based in Corfu. Whether through luck, intuition or profound thought, he avoided a terrible fate when, in November 1916, *Le Suffren* was torpedoed by a German U-boat off the coast of Lisbon, sinking within seconds and taking all 648 crew members with her.

Love of the Occult
In 1918, Muchery was less fortunate, this time directly involved in a seaplane crash. He survived, but endured several years of convalescence and a weakened physique. Due to his frail health

▶ SCORPIO

▶ LIBRA

▶ MERCURY

▶ THE MOON

ART AND COLLECTOR'S DECKS

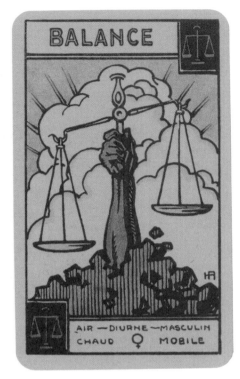

10 SCORPION

BALANCE

AIR — DIURNE — MASCULIN
CHAUD ♀ MOBILE

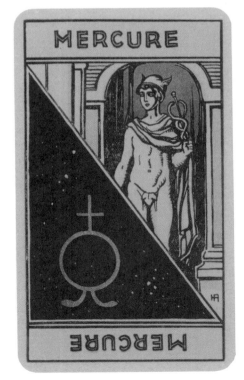

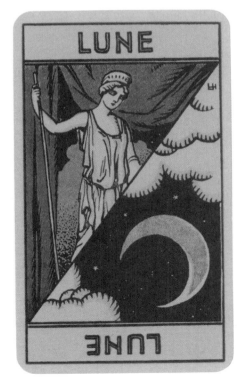

MERCURE

LUNE

MERCURE

LUNE

ART AND COLLECTOR'S DECKS

◀ THE ASCENDANT AND THE EGYPTIAN SPHINX

A mythical beast, part human, part lion, the Sphinx is more than just a motif for Egyptian dynastic power; it is also a guardian of mystical secrets. Pouring forth the waters of knowledge, new information is revealed so the seeker gains insight into his quest.

▶ GEMINI

Although the zodiac sign of Gemini is normally associated with the well-known twins Castor and Pollux, Muchery's version depicts siblings Apollo (with a lyre) and Hercules (wielding a club). Born to different mothers, they were often referred to as 'twins' and depicted as such in ancient star charts.

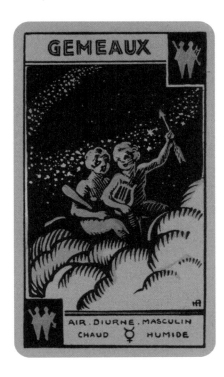

he realized he would never be able to take up a career in the navy again, so he became a journalist, pursuing his childhood love of astrology and other occult sciences by writing articles for magazines and later (after the tarot deck was published) setting up his own publishing house.

By the mid-1920s, Muchery had established a name for himself as a writer and astrologer (although often discredited by academics at the time). Working for film magazine *Mon Ciné*, he contacted famous actors, such as Douglas Fairbanks, to ask permission to take their handprints for analysis and to write about their personalities. This was an exciting time after the terrors of the First World War, when glamour, luxury, the arts, cinema, mysticism and literature were all in vogue. In Paris, the Exposition Internationale des Arts Décoratifs et Industriels Modernes of 1925 brought the elegant, sophisticated art deco style to all aspects of life. It coincided with Muchery's collaboration with artist/illustrator Henri Armengol to create this tarot deck,

a fine example of the merger of Art Deco and the occult. (The original artwork is now housed in the Bibliothèque nationale de France in Paris.)

1920s Paris

No one really knows exactly where Muchery met Armengol, a highly respected illustrator of adventure magazines and MGM film posters. Armengol's bold style conveys both art deco influences but also the roots of his bohemian Montmartre life from the early 1900s, where he mingled with the likes of Picasso and Van Dongen. The thriving 1920s Paris art world was full of artists who earned their living from illustrating magazines, so there, somewhere among the boulevard cafes and elegant interiors, Muchery and Armengol's paths crossed and Le Tarot Astrologique was born. A few years later, Muchery published a book *The Astrological Tarot*, which is a guide to using astrology with tarot divination.

Although astrological in nature, the deck can also be read as a reflection of Muchery's birth

In Greek myth, Heracles was sent to slay the ferocious Nemean lion, a motif for invincible power. The hero fired endless arrows to kill the lion, to little effect, but with a sign from the gods, he took the beast by the jaws and destroyed it. Defeating the lion signifies resourcefulness in the face of greatest challenge.

chart, too. Planets in an astrological birth chart fall in different signs of the zodiac. (Most people know their sun sign, but where the other planets lie in the chart needs to be calculated depending on time, date and place of birth.) Muchery not only had the sun in Scorpio, but had four more planets in that sign, too. One of these planets is Venus at 20 degrees Scorpio, which according to traditional astrology is in a negative position, often described as 'in exile'. This is mirrored in the 20 Scorpio decan card, where a lonely wolf howls in the moonlight calling for the pack. This card signifies a place of loneliness – the individual enveloped by the dark side of the cosmos, one in which Muchery seemed to find himself in his occult world.

Curious, foreboding, Scorpionic images occur in many of the cards, such as the Medusa's head for 10 Taureau and the menacing vulture at 10 Capricorn. While the moon's north node is depicted as the light we must shine on life, the south node represents the 'serpent being' we once were. So was Muchery inspired to create his own astrological take on the tarot simply due to the popular revival of fortune-telling and interest in the occult, or simply an unconscious desire to create a visual revelation of himself?

Sabian Symbols

Muchery's Mercury, the planet of thought and inspiration, is at 11 degrees Scorpio, and his

card for 10–11 Scorpio shows the World serpent devouring his own tail. His interpretation for this card is 'ending and rebirth', hence the ouroboros, a symbol of the eternal cycle of nature. By chance (or synchronicity), far away in the USA in 1925, the eminent astrologer Marc Edmund Jones was also working on the decan system. With gifted clairvoyant Elsie Wheeler, he revealed symbolic descriptions for each of the 360 degrees of the zodiac. Known as the Sabian Symbols, 11 degrees Scorpio in this degree system reads 'a drowning person is being rescued' (and if you think about it, Muchery was 'rescued from drowning' twice in his life). His 20–21 Venus Scorpio degree is also described as 'obeying his conscience, a soldier resists orders', while Muchery's interpretation of the card is 'theft, fear, wickedness'. Muchery saw the dark side of Scorpio, while Marc Edmund Jones (sun in Libra with moon in Leo) saw the positive.

So whether obeying his conscience and resisting orders (not sticking to the traditional format), or through the fear he had experienced in his near drowning experiences, Muchery found a direct, but profound way of disclosing his version of the symbolic language of the zodiac decans. By using the power of the 'archetypal nature' of tarot, combined with Armengol's brilliant artwork, he created this unique astrological deck, reflecting not only the art and times of the period, but his own birth chart, too.

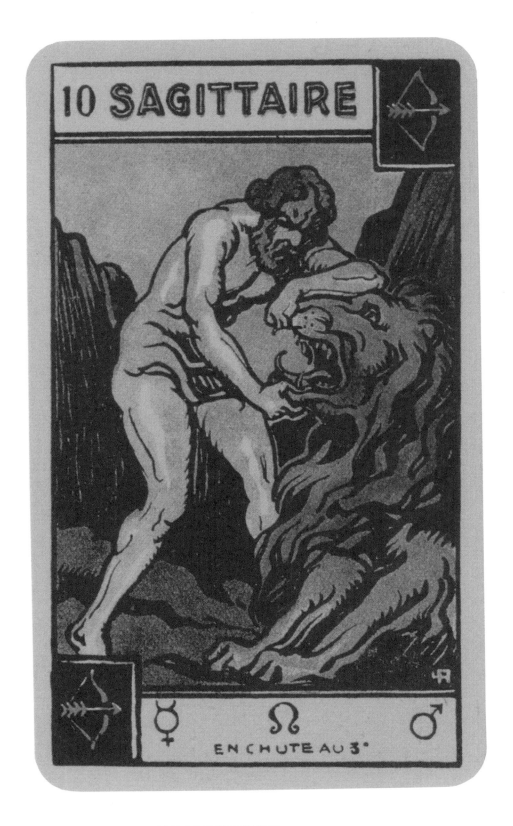

John Bauer Tarot

Fantastical northern landscapes merge
with archetypal myth and magic.

Creator: John Bauer
Illustrator: John Bauer
Publisher: Lo Scarebeo, 2018

This deck celebrates the artwork of the Swedish artist John Bauer (1882–1918), who was one of the most renowned illustrators of the early twentieth century.

Having completed over one thousand works of art by the time of his tragic death at the age of thirty-six, John Bauer created work that captured both the darkness and light of Nordic myth, landscape and folklore. His work is a blend of fairytale, and fantasy inspired by Pre-Raphaelite and symbolist art. Mystical characters, trolls, ogres and other fairytale creatures light up the dark forests and combine with the eerie, somber effects of living in a far northern latitude, where there is too much light in summer, and too little in winter. The forests of Småland, nature, Sámi life, culture and early Renaissance Italian painting were of all of great inspiration to Bauer's unique style.

The deck has been designed and crafted from various images taken from John's paintings and illustrations. A work of art in itself, as a tarot deck it is easy to interpret and understand the archetypal themes represented by these fantastic characters and landscapes entwined with myth. Throughout the deck, the paintings include many details from John's works, which were often rendered in a powerful mix of greys, blacks and beige; the darker hues and colours found in Swedish landscapes and forests.

Vivid Imagination

As a child, John Bauer apparently had little interest in school, but was highly imaginative and talked of how he even had various trolls as playmates. When very young, he began to write fairytales and caricatures of friends, teachers and local celebrities filled his textbooks. All he really wanted was to be accepted into the Royal Swedish Academy of Fine Arts in Stockholm. Eventually he was, and, among other work, he became a successful illustrator for a publication called *Bland Tomtar och Troll* (Among Gnomes and Trolls), which was published at Christmas times from 1907 to 1915. He also worked on etchings, murals and theatre design, exhibiting in Sweden, the US, Italy, Germany and England.

▶ **THE HIEROPHANT**
No longer a religious figure, the Hierophant is, in fact, a boulder. He sits patiently, passing on ancient wisdom to lost children who have climbed on to his knee. The boulder symbolizes conventional knowledge, security, reliability and ancient roots. In Norse mythology, runestones were inscribed with empowering magical messages sent from the gods.

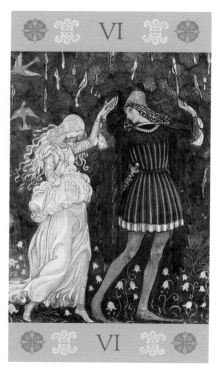

◄ **FOUR OF CUPS**
This card shows a lonely, yet smiling and reflective princess alone in a dark foreboding forest, where hope and faith in her surroundings bring belief in love, too.

◄ **THE LOVERS**

◄ **DEATH**

◄ **THE HIGH PRIESTESS**
The High Priestess depicts a girl sitting at the edge of a pool gazing into the water, symbolic of the ability to intuit and commune with nature and be at one with the moment.

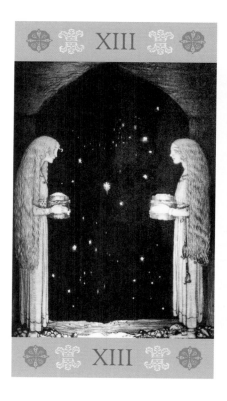

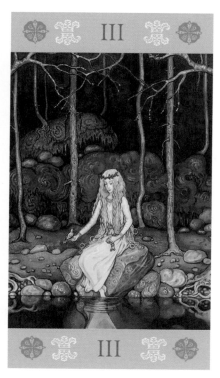

Knights are usually searching for the quintessential nature of the suit they represent. In this case, the Knight of Cups accepts that the ideal love he is chasing is as far away as the clouds above.

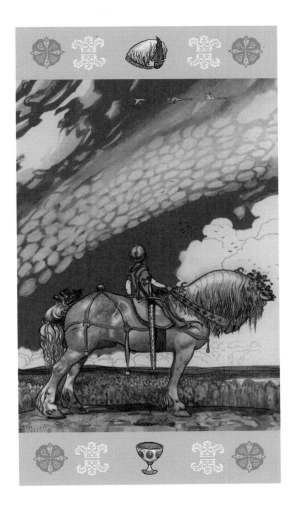

Tragedy

In 1906, John Bauer married Ester Ellqvist, but they led separate lives – John in the forests where he was inspired to paint and Ester who lived by her beloved sea. Although they wrote loving letters to one another, their relationship suffered. They agreed to work out their differences and in 1918 planned to move into their newly built house in Djursholm. But as they began to piece together their lives, and John's art became more and more successful, tragedy struck. On their way to Stockholm, John and his family crossed Lake Vättern on a passenger boat, which tragically sunk, and all aboard were drowned. Four years later, the authorities managed to salvage the boat, and the family's bodies were finally laid to rest. A monument to John Bauer was erected in Stadsparken in Jönköping, and in 1931 a memorial was also placed by his grave in the Östra Kyrkogården cemetery. The inscription begins, 'Friends and admirers of John Bauer's art laid this stone in 1931'.

Yet it is perhaps these brilliant images, collated into this superb mythological and fairytale deck that are the finest memorial of all to John Bauer's artistic talents.

Tarot of the Thousand and One Nights

A tarot that celebrates the legendary world of
Scheherazade, Eastern magic, poetry and eroticism.

Creator: Léon Carré
Illustrator: Léon Carré
Publisher: Lo Scarebeo, 2005

This exquisite art deck is inspired by and draws on the original illustrations by early-twentieth-century French Orientalist artist Léon Carré for the book *Thousand and One Nights*. The cards depict scenes and characters from the tales and reveal the magical and sensual Eastern world that was idealized by eighteenth-century European aristocrats.

According to oral traditions of the Near East, the series of stories were told by Scheherazade, a legendary Persian queen. There was once a Persian king who wooed a young girl every night, and unsatisfied, the next day would have her head chopped off. But one princess, Scheherazade, was cunning, and the first night she related the king an enchanting, fantastical story, which she left unfinished as dawn rose. In his frustration to hear more, he would spare her life to the next night, and so it went on. For 1,001 nights the princess continued to tell stories to the king, until he finally fell in love with her and agreed to spare her life forever. The tales include the well-known voyages of Sinbad the sailor, Ali Baba and the forty thieves and Aladdin and his wonderful lamp. Translated into English in the nineteenth century by Richard Francis Burton, the tales became essential, and often secret, reading for prim young ladies in Victorian society.

Mythical and magical, the major arcana cards depict dragons, winged beings, giant snakes and flying thrones. The minor suits of Chalices, Wands, Swords and Pentacles reveal the humbler side of life – anything from landscape scenes, inns, fishermen, merchant ships and blacksmiths.

This deck relies on the appeal of its art rather than any powerful divinational aspect. The traditional archetypes and scenes have been reinterpreted and broadened in meaning, but this rich and detailed artwork inspires the tarot reader with Arabian mystery, secrets and romantic associations of sensual and Eastern delights.

▶ FOUR OF SWORDS

ART AND COLLECTOR'S DECKS

THE EMPEROR IV L'IMPERATORE
EL EMPERADOR L'EMPEREUR

DER HERRSCHER DE KEIZER

KNIGHT OF PENTACLES CAVALIERE DI DENARI
CABALLO DE OROS CHEVALIER DE DENIERS

RITTER DER MÜNZEN MUNTEN RIDDER

ACE OF SWORDS 1 ASSO DI SPADE
AS DE ESPADAS AS D'ÉPÉES

AS DER SCHWERTER ZWAARDEN AAS

COURAGE XI IL CORAGGIO
EL VALOR LE COURAGE

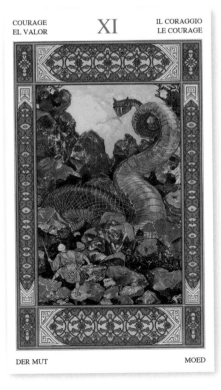

DER MUT MOED

► THE EMPEROR

► KNIGHT OF
PENTACLES

► ACE OF SWORDS

► COURAGE

Crystal Tarot

Sublime, dynamic, kaleidoscopic artwork
with atmospheric natural colours.

Creator: Elisabetta Trevisan
Illustrator: Elisabetta Trevisan
Publisher: Lo Scarebeo, 2002

Worked in tempera paint on glass, Elisabetta Trevisan's artwork for the Crystal Tarot is inspired by Renaissance and Pre-Raphaelite artists, not forgetting Gustav Klimt. Each court card and major arcana is a unique painting, like a stained-glass window, through which you peer to a hidden spiritual and emotional world.

Creating patterns within patterns is Elisabetta Trevisan's greatest talent. Her art is a fusion of colours, such as the fuschias, turquoise and ochres of Temperance, or the bold but subtle shades of blues in the World, and the vivid purples, reds and greens of the Devil – a devil who could be androgynous, with a wry smile, empty eyes and a serpent-like companion to invoke our own devil within. Who are we really, what is our real face when put to the temptation test?

Born in 1957 in Merano, northern Italy, Elisabetta went on to art school in Padua. With a famous cartoonist/illustrator father and inspired by his work, she has devoted her life to painting. She lives in Treviso and works on panels using mixed media techniques, including gouache, pastel and watercolour. She has also decorated clay, glass, wood, fabrics, mural surfaces and papier-mâché and contributed as an illustrator to many magazines and a children's book on ecology.

Like many artists, Elisabetta is unassuming and private, but she admits that her favourite subjects are focused on the female form, whether real or mythological. These feminine subjects are always engaged with their surroundings, such as the Strength card, where a beautiful, yet powerful Pre-Raphaelite-style diva takes control of an accepting lion. Elisabetta says that her paintings are a world of their own, a blend of plant and animal microcosms, in which the figures become an integral part of that world. With an acute attention to detail, she explores all aspects of the environment, whether including plants, landscapes, the sea, the sky or interiors.

This is a tarot deck that is a journey into another world all of its own, and its exploration is never complete.

▶ **KNAVE OF SWORDS
(THE CHESSBOARD)**

The knave contemplates and analyzes what life can offer him. Similarly, the chessboard on which he stands is a symbol of the practice and use of logic as a means to success.

ART AND COLLECTOR'S DECKS

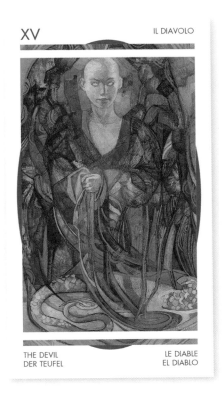

XV IL DIAVOLO

THE DEVIL LE DIABLE
DER TEUFEL EL DIABLO

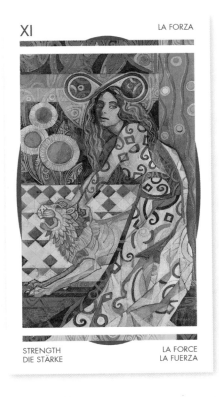

XI LA FORZA

STRENGTH LA FORCE
DIE STÄRKE LA FUERZA

FANTE DI SPADE

KNAVE OF SWORDS VALET D'EPEES
BUBE DER SCHWERTER SOTA DE ESPADAS

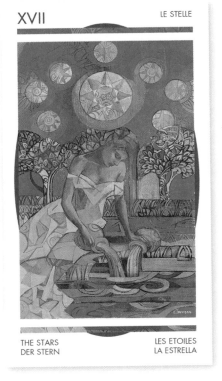

XVII LE STELLE

THE STARS LES ETOILES
DER STERN LA ESTRELLA

The Dalí Universal Tarot

Surreal motifs combine with traditional
tarot archetypes for artistic eccentricity.

Creator: Juan Llarch
Illustrator: Salvador Dalí
Publisher: US Games/Taschen,
2014

The Dalí Universal Tarot was believed to have been originally created by Salvador Dalí in the early 1970s. The controversial, surrealist Spanish painter was commissioned by film producer Albert R. Broccoli to design a deck of cards for the James Bond film *Live and Let Die*. It was Roger Moore's first role as the suave 007, and a deck of cards was needed for the character Solitaire (played by Jane Seymour), the fortune-telling lover of a Caribbean drug baron.

Broccoli believed in commissioning only the best designers, actors, directors and artists in the world, and with a healthy budget he approached the eccentric and equally well-heeled Dalí, who accepted. It is likely that Dalí was egged on by his wife Gala, who was known to be into all things esoteric. However, Dalí, halfway into the project, demanded an even more exorbitant fee, much higher than Broccoli was prepared to give, and the contract fell through. Dalí was dropped from the film for lesser-known artist Fergus Hall, whose Tarot of the Witches appeared in the film. Dalí decided to progress with his own deck, and it went on sale as the first tarot deck created by an artist of his standing in 1984 when he was eighty years old.

Traditional tarot archetypes were included, but the paintings are filled with Dalí's surreal motifs, such as butterflies (in The Lovers), roses (in Death), his wife Gala (the Empress), while The Magician and King of Pentacles are self-portraits. There are many allusions to surrealist principles, such as the Queen of Cups having a rakish moustache, the Moon as a woman's face gazing upon a modern metropolis while a weird crustacean-like creature looks on, and Death as a sinister skull in a floating cypress tree. The image of the Emperor is more like Sean Connery than Roger Moore, perhaps a strong statement to the fact that Dalí had parted ways with Broccoli and no longer intended this deck for his film.

Many of Dalí's fanciful images are combined with collaged details from classical European paintings and occult symbolism, resulting in this dramatic yet eccentric, surrealistic art deck, which is in a class of its own today.

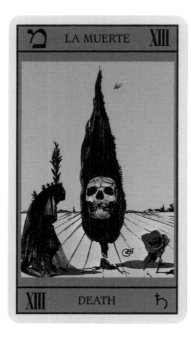

▶ DEATH

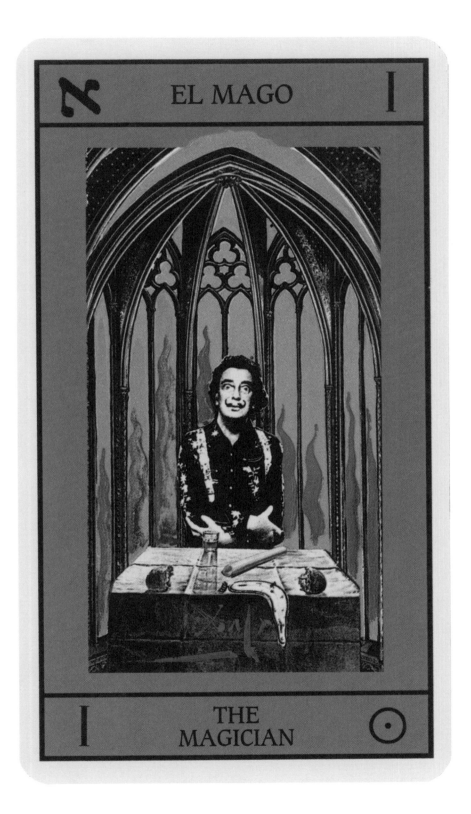

THE MAGICIAN
(SELF-PORTRAIT)

The Wild Unknown Tarot

Minimalist pen-and-ink drawings and subtle symbolism take you to the deeper mystery.

Creator: Kim Krans
Illustrator: Kim Krans
Publisher: HarperCollins, 2012

Throughout this unadorned, simple, yet enigmatic tarot deck, animals and nature abound. The minor arcana cards are different from most traditional decks, and Kings, Queens, Pages and Knights are replaced by Father, Mother, Daughter and Son. The Pentacle characters are deer, the Wands are snakes, the Cups are swans and the Swords are owls. Other animals make up the major arcana. For example, the Magician is a leopard, the High Priestess a tiger and the Fool a duckling; although the Moon is still the moon, high above a silent forest. The Wild Unknown Tarot is a world in itself, created by artist and author Kim Krans.

Kim lives on the West Coast of the USA where she teaches workshops that promote personal growth through creative practice, meditation and bodywork. She loves to surf, draw and contemplate the great mysteries of life, the kind of reflection from which her tarot deck was born. According to Kim, the title 'Wild Unknown' was taken from the lyrics of a Bob Dylan song called 'Isis'. It was also a nickname Kim used for herself and a publishing company she started back in 2007. After the tarot deck was first published in 2012, Wild Unknown became an online community of tarot enthusiasts, artists, visionaries, freethinkers and believers from all over the world in search of a deeper understanding of one's inner nature and mystery.

Kim maintains that the 'wild unknown' is also a feeling; a sense of a deeper place within ourselves that we don't understand, but long to know more about. Whether we call it the unconscious, the inner self, soul, universal magic, ch'i or God, we are always very close to it. Yet we are never truly at one with this place, except at the most poignant or 'living for the moment' times of our lives. This mysterious soul side of the self, which flows through us, moves us towards personal growth, no matter how uncomfortable it can be.

Beyond the Unknown

For Kim, this inner energy was the trigger for creating the tarot deck, even though she doubted herself and her work at

▶ **THE HIEROPHANT**
In many traditions the crow is a symbol of intelligence, flexibility and destiny. It also represents audacity and fearlessness, while the key unlocks the door to wisdom.

ART AND COLLECTOR'S DECKS

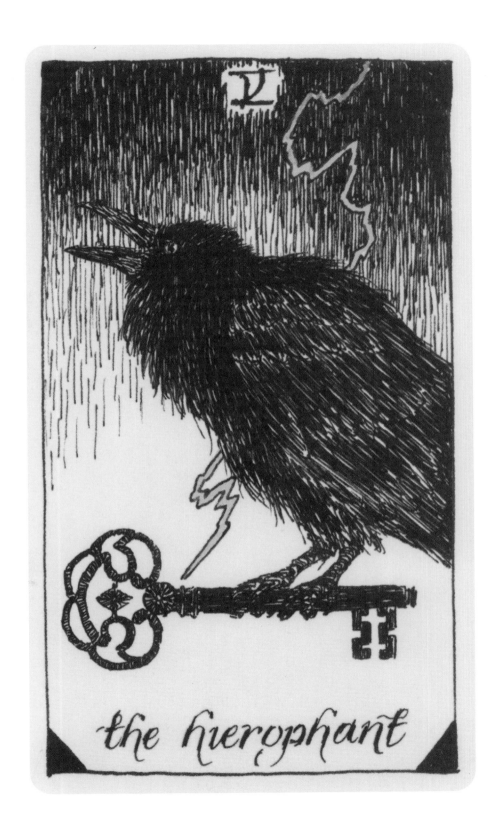

the hierophant

every drawing. Whether it's known as Jung's 'individuation', or the soul's calling, Kim's 'wild unknown' is active energy; it moves within us, and with us. Similarly, this deck allows the seeker or tarot reader to both meditate and seek answers, and to feel a hidden mysterious energy within ourselves, by connecting to the spirit of the natural world.

The 'wild unknown' is a land you have never visited before, the unknown factors you come across in life and something that is always just out of reach, and yet you know it exists within and without you. She says, 'It is beyond wild, beyond unknown and beyond generous'.

Although this deck is a 'wild unknown' experience, it carries on the tradition of RWS tarot symbolism and interpretation. Even though the Five of Swords strangely depicts an earthworm cut in two, it still reveals an inner conflict or self-sabotaging of one's desires by separating the real truth from a situation. The Devil card reveals a shaggy, horned goat emerging from the dark. His hooves seem to be on fire. Here the goat reminds us of pagan horned gods, such as Pan or Cernunnos, and their link to base instincts such as lust, survival and greed. The goat appears to know his feet are on fire – so do our addictions and desires fire us up to be little devils, or is this a sign that we can put out our own devilish fires?

The tarot deck is a tool for personal growth, a guide to understanding the wild unknown within oneself and most of all, a unique minimalist artwork that brings to life the natural world and its place in our own tarot world.

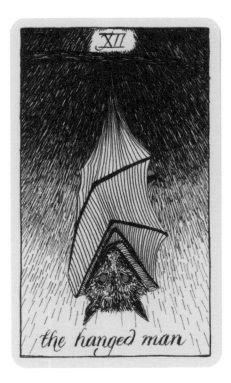

the hanged man

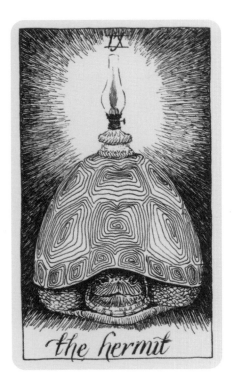

the hermit

mother of swords

father of wands

The Golden Tarot of Klimt

Stunning Klimt-inspired artwork aligns with tarot archetypes.

Creator: Atanas Atanassov
Illustrator: Gustav Klimt
Publisher: Lo Scarabeo, 2005

Atanas Atanassov (1964–) is one of the favoured artists for Lo Scarabeo. His works include the Bosch, Klimt, Leonardo and Botticelli decks.

Working in tempera, watercolour and crayon, Atanassov's artwork is made up of nudes, landscapes and complex figurative compositions with a refined and elegant style. He has exhibited his own work throughout Europe, and his imagination brings to life the cultural background of the artists showcased in each tarot deck.

Atanassov created the cards for this exclusive tarot deck using distinctive versions of Gustav Klimt's paintings. For example, Strength is *Judith II*, the High Priestess is the *Portrait of Frieda Reidel*, while the Lovers is taken from one of Klimt's most famous works, *The Kiss*, thought to depict himself and lifelong companion Emilie Floge.

The early-twentieth-century Viennese symbolist painter Gustav Klimt is, these days, renowned for his unconventional approach to sensual elegance. But during the Belle Epoque period, his bohemian lifestyle and erotic portrayal of nude women shocked critics, the public and art lovers, who considered it pornographic. The unconventional Klimt wore sandals and robes, fathered fourteen children by different women, and his greatest commission to decorate the halls of Vienna University with choice portraits ended in disaster. Instead of a hall of academic alumni, he chose to paint a collection of superb nude females. The university was outraged, and the paintings were deemed obscene. He was forced to pay back his fee.

Yet his style adapted to many different movements, including impressionist landscapes and avant-garde painters like Matisse and Chagall. He became the leading artist in the art movement known as the Vienna Secession. The exhibitions were highly successful, as was his 'golden period' (*The Kiss* is the greatest example of this era), but in 1918 Klimt suffered a stroke, followed by contracting the influenza epidemic sweeping across Europe at the time, and he died on 6 February 1918. Numerous paintings were left unfinished, and the paintings in Vienna University were later, sadly, destroyed by retreating Germans in 1945.

Klimt's influences were eclectic, from Classical Greek, Byzantine and Egyptian art, to the early photography and symbolic realism. This deck, beautifully worked by artist Atanas Atanassov, displays it all, and empathizes with the creative soul that exudes through this tarot.

▶ STRENGTH

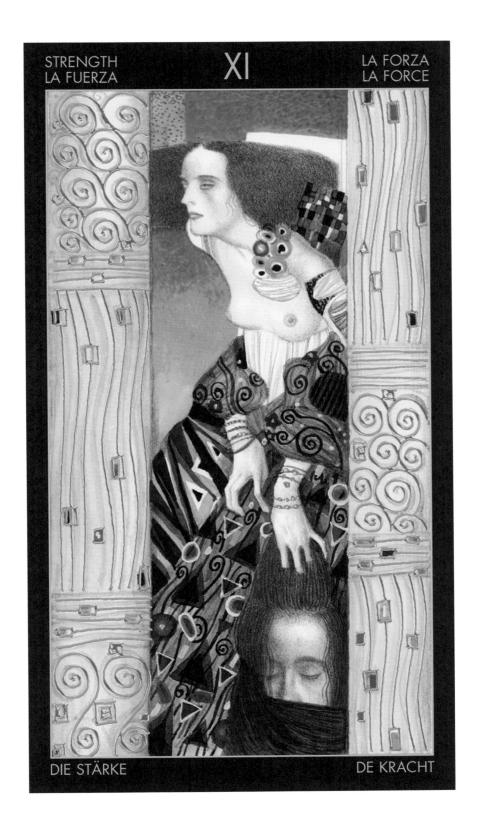

STRENGTH
LA FUERZA

XI

LA FORZA
LA FORCE

DIE STÄRKE

DE KRACHT

THE GOLDEN TAROT OF KLIMT

Deviant Moon Tarot

Quirky, fantastical, off-the-wall world of tarot.

Creator: Patrick Valenza
Illustrator: Patrick Valenza
Publisher: US Games, 2016

Tarot artist Patrick Valenza has also published the decks Trionfi della Luna and the Abandoned Oracle. His Deviant Moon Tarot is one of the most outré of contemporary art tarot decks.

The Deviant Moon was inspired by Valenza's love of tombstones and his fascination with the new crescent moon, which he calls a 'fingernail' moon. The new moon's power and energy was to become the deck's entire focus, while the name 'deviant' was a revelation that came to him while he was attempting to find a title to link his characters to the moon. As a child, Valenza used to play with his friends in local graveyards. When he was older, he photographed numerous stones and tombs in great detail to capture this best-loved period of his childhood, not really knowing what he would do with the collected works at the time.

When the idea for the tarot came to him, and with thousands of photographs at his fingertips, he manipulated many of the background textures and scenes into boots, hats, coats and clothing for the Deviant 'citizens'. His moon-faced characters were originally based on an ancient profile style of painting often found on Greek vases. But because he thought too many profiles would be boring, he worked on a way to show a quarter view of the face, so the darker side aligns with the unconscious, and the lighter with consciousness.

Also incorporated into the artwork are scenes of buildings and landscapes from photographs of an abandoned insane asylum. Decayed doors, windows and walls became castles, factories and cities. For the minor arcana, Swords are angst-ridden beings set in a medieval world. Cups are people made up of fish parts and gravestones. Wands have a tribal, earthy appeal with bodies made up of insects and leaves. Pentacles are based on the decaying industry of the late nineteenth century.

Likening the whole creative process to raising seventy-eight children, he is now proud to see they have made it big in the tarot world. Valenza's booklet includes a unique ten-card spread called the Lunatic Spread, which mimics the shape of the full moon. It's hardly surprising that the Deviant Moon Tarot, with its fantastic characters and lunar fascination, has become a cult deck.

▲ THE MAGICIAN

ART AND COLLECTOR'S DECKS

► ACE OF WANDS

The card depicts a moth or butterfly mother cradling her chrysalis infant. The chrysalis represents birth and new beginnings and the moth and butterfly are both signs of the rapid, creative growth of ideas.

DEVIANT MOON TAROT

The Lost Code of Tarot

A fictitious tale of tarot's origins with
intriguing and fanciful illustrations.

Creator: Andrea Aste
Illustrator: Andrea Aste
Publisher: Lo Scarabeo, 2016

**This fictitious and highly creative tarot deck was inspired by
Leonardo da Vinci's coded notebooks and also the cryptic text
and illustrations of the Voynich manuscript. Nothing like any
traditional deck, its symbols, cards and accompanying story is like
a giant riddle, one that moves your mind to say, 'Well, what if?'**

The Lost Code of Tarot suggests an alternate history of tarot,
imagined by the creator and artist, Andrea Aste. He relates how
an ancient alchemical laboratory was discovered by archaeologist
Dr Abbot in London, containing secret manuscripts and 'the first
tarot deck ever created'. He described his tarot as a multimedia
experience, where adventure, magic, science and mystery
entwine. This web of tarot intrigue revolves around ancient occult
power struggles and the obscure writings (a book of shadows) of
a fictional alchemist. He tells how Dr Abbot decoded the book to
reveal the original meanings and truth of the tarot. The *Book of
Shadows* accompanying the deck tells the story of the lost code in
a fictionalized, documentary style and is as intriguing as are the
cards themselves.

Without any simple or obvious interpretations of the cards,
this brilliant deck may be hard for the beginner to grasp, but it
creates an alternative and refreshing angle on using tarot.

▲ THE TOWER

ART AND COLLECTOR'S DECKS

► THE WORLD

Prisma Visions

Original, imaginative artwork that follows classic tarot symbolism with a modern approach.

Creator: James R. Eads
Illustrator: James R. Eads
Publisher: Self-published, 2014

A beautiful art lovers' deck with rich colours, evocative images and a unique style of panoramic artwork in an impressionist style. When the minor arcana cards are placed in sequence, the suit makes up a complete painting. Each card is itself a painting, yet placing the cards together like a jigsaw puzzle opens the reader's eye to the bigger picture of the meaning of the four suits.

Working with the classic format of a traditional tarot deck, plus a surprise 'strawberry card', the deck has a beauty of its own, which although not easy for divination is a great deck for meditation and inner reflection.

Based in Los Angeles, James R. Eads works in both traditional and digital media. He explores ideas of the soul, spirit and mind, and his deck is full of narrative and intriguing symbols. The stork marooned on a lifebuoy post in the moonlight (perhaps saying 'Can we really not see the truth of where we are going?') or the High Priestess who leaves a trail of pomegranates in her wake (the pomegranate an ancient symbol of fertile body and spirit) are just a couple of examples.

The suit of Cups, or here Chalices, is referred to as the 'Ballad of Chalices' and tells the story of love. The narrative behind the 'Rise of Pentacles' explores hard work, materialism, achievement, prosperity and poverty. Wands represent the magic, creativity and passion of Fire, while Swords represent the challenges of Air, such as power games, disillusionment and overthinking.

Finally, the surprise extra Strawberries card in a reading represents a burst of vitalizing energy, or an important part of your life is being blessed by the universe.

► **JUDGEMENT**

► **THE FOOL**

► **TEN OF PENTACLES**

► **STRAWBERRIES**

JUDGEMENT

THE FOOL

TEN OF PENTACLES

STRAWBERRIES

Tarot Noir

A stylish, contemporary, medieval-inspired deck.

Creators: Matthieu Hackiere and
Justine Ternel
Publisher: Editions Vega, 2013

With quirky, darkly beautiful artwork inspired by fifteenth-century French religious and secular life, the Tarot Noir brings a new dimension to the standard Marseilles-style deck. Using a larger format than mainstream tarot, each card captures the essence of gothic eccentricity found in fantasy films.

Tarot Noir is melancholic and yet always amusing. Whimsical creatures vie with the weird and wonderful. Characters are depicted in subtle medieval attire, such as the Queen of Pentacles (Reyne des Derniers), Strength (La Force) and the High Priestess (La Papesse). Although the latter resembles a female pope, she is referred to in the text as possibly a sorceress in disguise. At the time, the only powerful women who had any connection to divine matters were usually enchantresses and witches. By dressing her in ecclesiastical clothing, her pagan associations were less apparent. The Devil (Le Diable) is a contemporary version of a cloven-hoofed beast amusing itself with puppet-like masked creatures.

Other medieval inferences include the Ace of Cups, as Sangreal (holy blood), also known as the Holy Grail. (Medieval literary chroniclers created romances around the Church's belief in the elusive chalice that held the blood of Christ.) There is much twisted humour, too, where Death wears a sci-fi gas mask; Cupid in The Lovers (L'Amoureux) is no longer a cherub, but bears ugly wings and defiantly obscures the sun. The deck is a mix of artful fantasy style, peppered with fifteenth-century embellishments.

The Tarot Noir was inspired by two versions of the Marseilles deck: the sixteenth-century Jacques Viéville deck and the Grimaud deck popularized in the nineteenth century. Hackiere was later inspired to create a twisted, but humorous take on an encyclopedia of demonology originally published in 1818 and known as *Le Dictionnaire Infernal*. Using his signature-style illustrations of menacing beasts and humans, he reinterpreted demonic beings such as Beelzebub, Cerebus and Satan.

Probably the most unconventional but also the most evocative dedication to the Marseilles-style deck, Hackiere's Tarot Noir is dark, entrancing and filled with allusions both to medieval life and the fantastic world of the horror show.

▶ **THE HERMIT**

▶ **THE FOOL**

▶ **TWO OF COINS**

▶ **THE DEVIL**

IX

L'ERMITE

LE . MAT

HACKIERE * 2012-2013 TERNEL

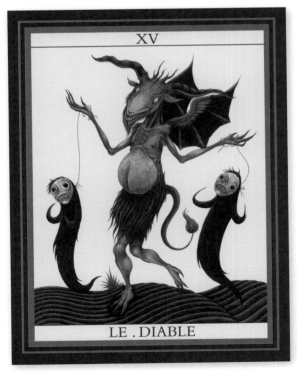

XV

LE . DIABLE

The Gilded Tarot Royale

A stunning and sophisticated fantasy, futuristic-world deck.

Creator: Ciro Marchetti
Illustrator: Ciro Marchetti
Publisher: Llewellyn, 2019

The Gilded Tarot Royale is not a revised version of Ciro Marchetti's earlier Gilded Tarot, but a full reworking of every card in the deck to showcase his unique talent as an artist and designer. It is alive with characters, animals, life, landscape and feeling.

Graduating from art college in London, Ciro Marchetti went on to co-found a multinational corporate design and branding service, now based in Miami. In 2006, the publisherLlewellyn asked Ciro, who had always been intrigued by the visual symbolism behind astrology and tarot, if he would be interested in creating his own tarot deck. Most tarot users were familiar with the RWS format, so he stuck to that standard, but he set out to add personal touches and imbue the deck with his own unique quality and style. The Gilded Tarot became a classic deck in itself.

But since the development of more sophisticated software, Ciro decided to rework his original deck to created the even more stunning Gilded Tarot Royale. Every card was recreated to provide more detail, emotion and connection to the essence of the archetypal meaning behind the tarot symbolism.

To Ciro, the tarot is like a stage upon which the seeker's journey can be made. In this deck, Mother Earth is that stage, so the cards are filled with details of birds, landscapes, rocks, blades of grass and skies. These details add richness and depth and give the reader a different perspective on the nature of their own reflection as they gaze into the tarot mirror.

For example, in the Six of Swords, a woman sets off on a journey. She looks blindly to the future, unaware of the toad (one's objective self), who witnesses her stealthy travel. The Nine of Cups reveals the innkeeper's good spirits, while the barrels are a symbol of abundance. Rodents peer into the vessels, reminding us that pleasure is also about acceptance of all aspects of the joy of nature. The Eight of Pentacles shows a lonely apprentice working late into the night. His unlikely companion is perhaps his conscience, or is it his sense of dedication and spirit of enterprise?

Ciro Marchetti's Gilded Tarot Royale is an exquisite deck of truly fine digital art and stands out as one of the most ingenious and emotive of all contemporary tarot decks.

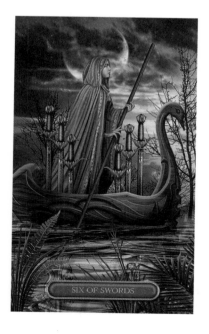

▲ SIX OF SWORDS

ART AND COLLECTOR'S DECKS

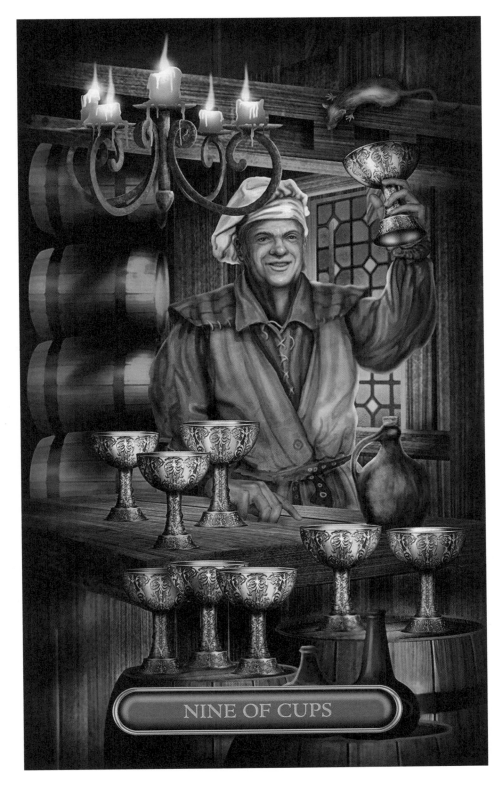

NINE OF CUPS

► NINE OF CUPS

THE GILDED TAROT ROYALE

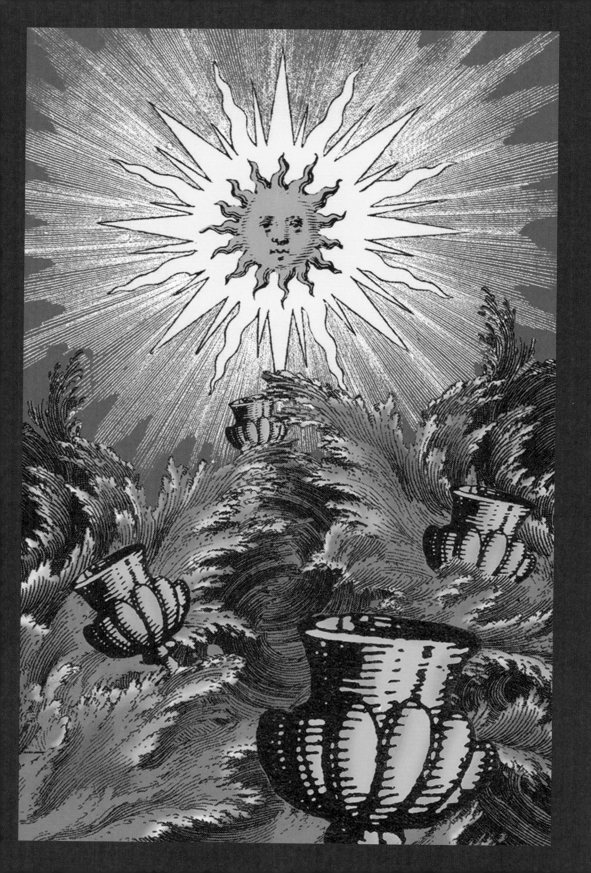

Esoteric and Occult Decks

There is a still an ongoing debate about whether the tarot, in some form or other, predated the Renaissance, deriving from earlier ancient belief systems, or whether it is simply concurrent with the ideas and philosophies of Renaissance Europe. Was it, like the fine art of that period, a means of disseminating not only religious values but new humanistic ones, too? Was the tarot a set of miniature paintings to celebrate elitist families and their life, but also a way to spread the word about esoteric ideas, often heretical, in a discreet way? This is all still open to question, but tarot was also used as a vehicle to develop archetypal, occult and other esoteric complex systems.

This section looks first at one of the earliest and most mysterious of these 'occult' decks, the Sola Busca, and its influence on and relation to all the others that followed it. It wasn't until much later at the end of the nineteenth century, with the rise of spiritualism and esoteric thought, when Oswald Wirth, around the same time as the Hermetic Order of the Golden Dawn, observed that different belief systems corresponded to the tarot; or rather, the tarot could be common ground through which all such symbols could be found. The Hermetic Order of the Golden Dawn had its own tarot philosophy dressed in rituals and secrets, but offshoots sprang up to challenge this belief system. A.E. Waite redressed the tarot in more spiritual and psychological interpretation (see page 56), and Crowley in the 1930s went on to focus on the tarot's occult aspects.

Most of these Golden Dawn-style decks spawned a host of New Age esoteric decks, which are available today. Other decks set their own standards, including Robert M. Place's Alchemical Tarot (see page 178), the Hermetic Tarot (see page 182) by Godfrey Dowson, and, more recently, the English Magic Tarot (see page 174) and Splendor Solis (see page 190).

Whatever aspect of the esoteric world the tarot can illuminate, or rather whatever aspect of the occult world one would like to illuminate, the tarot is a pictorial vehicle for doing just that, and it is through these wonderful decks that this other hidden world comes alive.

Sola Busca Tarot

A Renaissance alchemical deck, with dazzling
art and mysterious associations.

Creator: Unknown, fifteenth century
Publisher: Llewellyn, 2019

The Sola Busca Tarot is the only complete Italian deck dating
from the end of the fifteenth century where all seventy-eight cards
are depicted pictorially. The mystery behind these apparently
'classically' inspired miniature copperplate engravings has always
fascinated both art historians and tarot experts. There are many
riddles, such as who was the painter? Was this deck created for
a marriage or ceremony, and is the depiction of mythical heroes
simply in keeping with the fashion for everything classical at the
time, or is there a hidden meaning to the work?

This northern Italian deck dates to the year 1491 and is named
after the Milanese Sola Busca family, who previously owned it
before they sold it to the Italian government in 2009. It is now
housed in the Pinacoteca di Brera in Milan. The seventy-eight
engravings are believed to be the inspiration behind the RWS's
pictorial pip cards, when A.E. Waite and Pamela Colman Smith
saw photographic replicas of the originals in the British Museum.
 Some art experts believe the deck was painted by Renaissance
artist Nicola di Maestro Antonio of Ancona, or by an unknown
artist for the marriage of the Duke of Ferrara, Alfonso d'Este,
to Anna Sforza. The dating fits the latter better, as Alfonso was
married to Anna, the niece of Ludovico Sforza, Duke of Milan,
in January 1491. In the same ceremony, Ludovico was married
to Alfonso's younger sister, Beatrice d'Este in a double wedding
orchestrated by Leonardo da Vinci. Politically, the wedding was
designed to cement ties between the two families. Like most of
the d'Este dynasty (see page 104), Alfonso was a great patron of
the arts and, of course, of all things humanist or magical. He later
had the honour to be the last husband of the scandalous femme
fatale of the Italian courts, Lucrezia Borgia.

Secret Codex
There are many allusions to alchemy and Hermeticism
throughout the deck. Researchers have shown that behind the
charade of historical narratives from the literary Roman world,
the Sola Busca may well have been a secret codex of alchemical

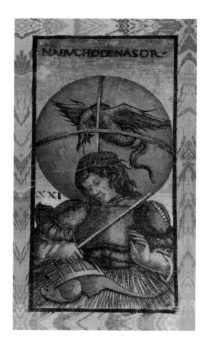

▲ TRUMP XXI THE WORLD
*The flying dragon represents the
freedom of the spirit after the
alchemical process has been
completed, and is similar to
the Hermetical basilisk in an
engraving by David Beuther.*

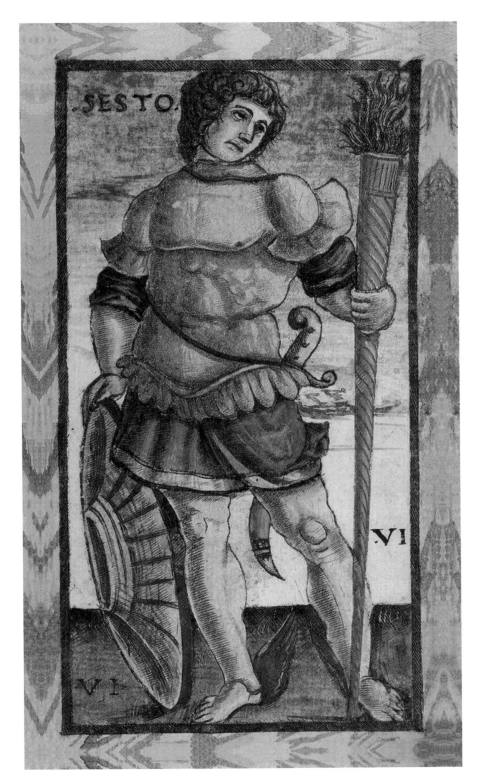

▶ **SESTO VI**

Winged feet are a symbol of Hermes and his ability to fly between the heavens and the underworld to deliver messages from the gods.

SOLA BUSCA TAROT

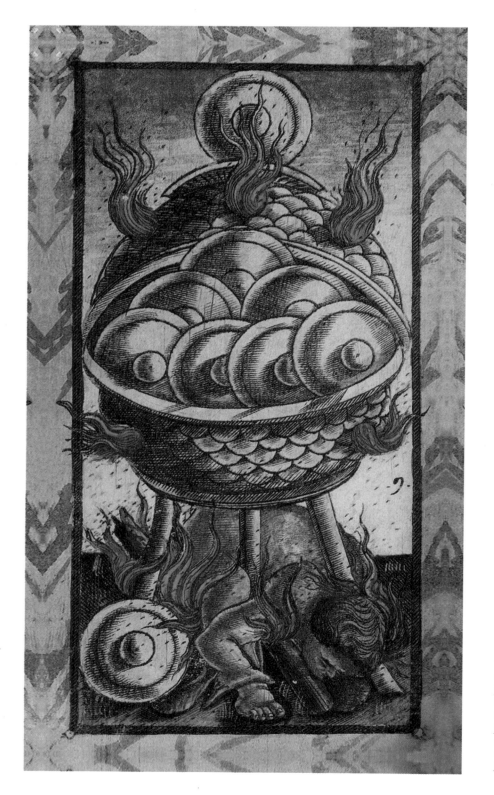

◄ **NINE OF DISCS**

The blazing furnace represents the alchemical process of 'burning through' the base material of oneself to purify the spirit, and is similar to a medieval alchemical image by Janus Lacinius.

ESOTERIC AND OCCULT DECKS

knowledge; a pathway to learning how to transform 'lead into gold', or in more esoteric terms, transform the lead of human-ness into the gold of spiritual enlightenment. These ideas were much in vogue among the wealthier elite of the Renaissance. Ritual magic, astrology and a keen interest in alchemy were an essential part of a daily strategy to maintain rulership, to survive in dangerous and violent times, to keep control and to save their skin. Throughout the deck there are ambiguous spellings and symbols that point to this alchemical process at work; a work of personal illumination.

The Sola Busca appears in parts to correspond to a medieval, Venetian codex, entitled *Secretum Secretorum* (The Secret of Secrets). This text is made up of an exchange of letters between the philosopher Aristotle and his pupil Alexander the Great, where Aristotle teaches Alexander the mystery of astrology, alchemy, theurgy and philosophy, and how to manage those powers.

During the medieval period, Alexander the Great had been romanced as a heroic, mythical figure, and became one of the most illustrious historical figures in aristocratic circles. He had already been deified in ancient times and a legend maintained that he had ascended to heaven on a chariot hauled by griffins. Here, Alexander appears as the King of Swords. Other characters linked to him in the deck include Amone, the Knight of Swords. Amone is Zeus Ammon, the mythical father of Alexander and a deity combining the Greek Zeus and the Egyptian Amun. Olinpia, the Queen of Swords, is Olympias, the mythical mother of Alexander, known as the 'snake lady'. Alexander's 'magician teacher' is Aristotle accompanied by a character known as Natanabo, as seen in the Knight of Cups.

Hermetic Magic
Alexander was also hailed as a new 'Sun' – an ancient alchemical symbol of gold and the resulting

Philosopher's Stone or *lapis philosophorum*. The Trump card XVI, Olivo, illustrates the triumph of the Sun and shows a basilisk, a well-known alchemical creature, which when turned to powder was a key ingredient for making the alchemical 'gold'.

More research by Italian experts throws a torchlight on a possible creator – the flamboyant Hermetic magician and mystical philosopher, Ludovico Lazzarelli (see page 110, the Mantegna Tarocchi) whose alchemical and Hermetic influence and power held sway in the courts of Ferrara, Urbino, Padua and Venice at the end of the fifteenth century. So could he be the true orchestrator of this secretive work?

Lazzarelli, as we have seen with the Mantegna deck, was a mystic, poet and adept of Hermetic magic. The *Hermetica* is a collection of second-century CE texts presented as a dialogue between the magician Hermes Trismegistus and a student of esoteric wisdom (in a similar style to the Venetian codex). Translated by Marcilo Ficino at the end of the fifteenth century, it may well have influenced the Hermetically-driven Lazzarelli to create this work.

For example, the Ten of Cups figure reveals a man with a turban, similar to a medieval engraving of the mythical Hermes Trismegistus. Other symbols that appear in alchemical and Hermetic tracts include: the *illuminato*, or the philosopher's illumination, which emits from the adept's head as in the Three of Wands; the alchemical furnace in an engraving by Janus Lacinius and in the cauldron in the Nine of Discs; the winged feet of Sesto (Trump VI), just like those of Mercury, god of alchemy and magic. Interestingly, Lazzarelli had a vast collection of engravings and illuminated manuscripts that he had collected from bookshops in Venice. Could these be the sources for this extraordinary deck of cards?

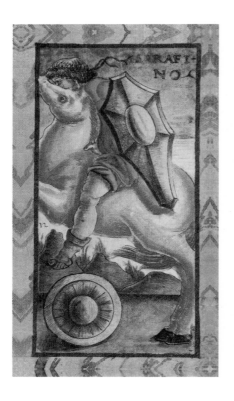

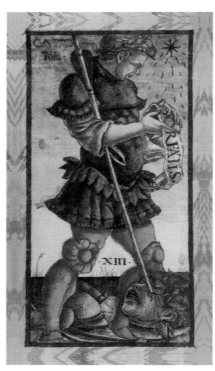

◄ SARAFINO
(KNIGHT OF DISCS)

◄ CATONE XIII

Meanwhile, many of these dukedoms resorted to darker alchemy and magic to secure their power. For example, one of the most sinister and dramatic of cards, XIII Catone, shows an eye penetrated by a spear.

According to a medieval astrological text, *The Book of Hermes on the Fifteen Fixed Stars*, the fixed star, Caput Algol, was considered highly malefic and was used in astrological magic to curse others. The constellation in which it was situated was associated with the ancient hero Perseus, who decapitated the serpent-haired Gorgon, Medusa. Algol, representing the Medusa's head, was discovered by the second-century astronomer Hipparchus.

In the card XIII Catone, a spear penetrates an eye, which may represent Medusa's eye and its power to turn a cursed person to stone. In the tarot, the card suggests the power to curse, but also the idea that someone is out to curse you, too.

Whether alchemical, magical, created by Lazzarelli or painted by some 'master tarot artist', the Sola Busca Tarot is an extraordinary work of art. Its secrets are closely linked to the Hermetic-alchemical culture that permeated the heart of Renaissance Italy in the fifteenth century and spread across the rest of Europe.

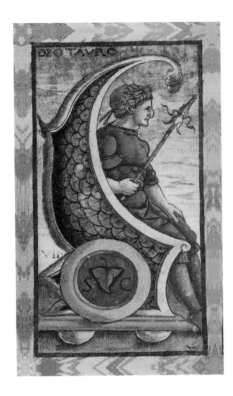

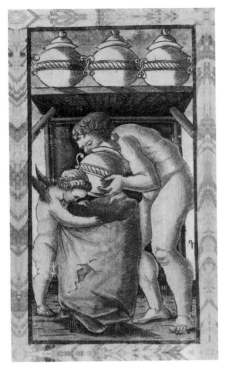

► DEO TAURO

► FOUR OF CUPS

► ACE OF DISCS

► THREE OF SWORDS

SOLA BUSCA TAROT

Oswald Wirth Tarot

Historical guiding light in the world of esoteric tarot.

Creator: Oswald Wirth, 1889
Publisher: US Games, 1991

Joseph Paul Oswald Wirth (1860–1943) was a Swiss occultist, artist and author. He studied esotericism and symbolism with Stanislas de Guaita, a nineteenth-century French poet and Rosicrucian, who was also a renowned expert on all things occult. In 1889, under the guidance of de Guaita, Wirth created a divinatory tarot consisting of only twenty-two major arcana. Known as the *Arcanes du Tarot Kabbalistique,* and first appearing in 1889, the illustrations were based on the Marseilles deck (see page 44), but incorporated occult symbols. It has since been extended to create a full seventy-eight card pack.

Oswald Wirth was essentially a Freemason, who wrote many books on astrology and other occult subjects, and at the time was well-known for a set of three short books explaining the Freemasonry's first three degrees, or levels of initiation into the society. Since his death, he is associated mostly with the tarot through his book *The Tarot of the Magicians,* which describes in detail all the esoteric and occult associations he could find, particularly from Kabbalistic, Hermetic and Masonic viewpoints. He pays great tribute to Éliphas Lévi, the great nineteenth-century ceremonial magician and occultist, who was also highly influential on the Golden Dawn's system of tarot.

Wirth meticulously described how the tarot corresponded to different disciplines in his book. Writing in a philosophical vein, he reflected on why the Fool was unnumbered. Wrestling in his mind, he pointed out that as it is an unnumbered card, it comes neither before the Magician or after the World, but if the cards were laid out in a circle or wheel, then it would be placed between the beginning and the end. The Fool is therefore symbolic of the infinite, the very essence of ourselves.

Symbols and Egypt
Wirth believed that symbols are a subtle way of teaching us deeper truths, which touch us at a different level than the limited way of words (similar to Jung's archetypal realm). He believed that it was through the medieval magicians, occultists, alchemists and Hermeticists and earlier systems, such as Kabbalah and

► **THE DEVIL**
The sigil of Mercury over the genitalia of the devil suggests that the alchemical transformation of Hermetic magic is about removing the devil within before you can achieve illumination.

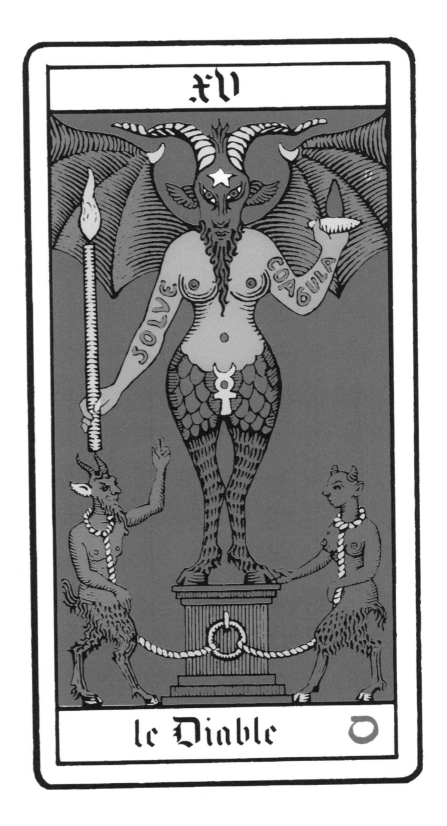

OSWALD WIRTH TAROT

► THE WHEEL OF FORTUNE

A mythical beast falling down the Wheel represents our sins, while the Egyptian wolf god Wepwawet, meaning 'opener of the ways,' climbs the wheel to evoke progress and change. (Some scholars identify this figure with Anubis, who is usually shown with a black head, guiding souls to the afterlife.) At the top sits a sphinx-like creature, guardian of secret knowledge. The card signifies a turning point or important change in one's life, or a time to open up to fresh opportunities.

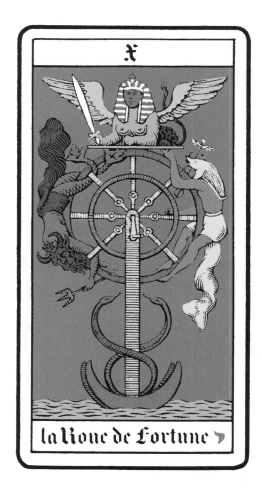

ancient Egypt, that the tarot developed to enable us to see the depths of one's own self. He maintained there was no other symbolic concept that portrays these hidden truths better than the tarot.

Regarding the Kabbalah, Wirth notes that the sephiroth (numbers) reveal the mystery of creation and that each of the twenty-two major arcana are related to one of these numbers. For example, Kether (One) signifies the Crown or Diadem, and accordingly the Magician card, as the source of all. The second sephira is called C'hocmah, which corresponds to wisdom and the creative process, as does corresponding tarot card, the High Priestess. He also looked at the symbolism of the medieval sorcerers and associated Hermetic alchemy to

every card. For example, the Hanged Man is the accomplishment within oneself of the Great Work, usually known as the magnum opus in alchemy. The Hanged Man is the paradoxical card, where only when we see oneself from a different angle, can we see what we are about to accomplish.

It may not be the most artistically beautiful, nor showy of decks, but its simplicity reveals a tarot of esoteric understanding when used in conjunction with the book.

One of the first occult decks with Hebrew numbering attributed by Éliphas Lévi, preceding RWS by nearly twenty years, it still stands out as a historical beacon in the light of tarot.

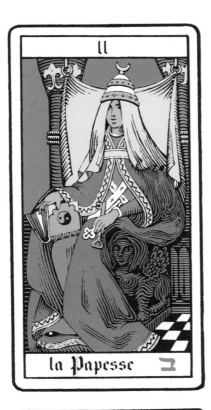

la Papesse

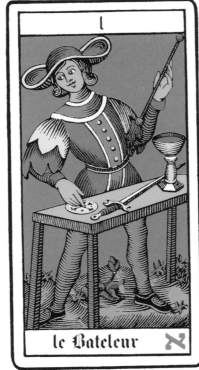

le Bateleur

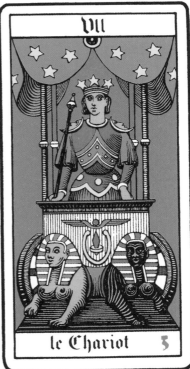

le Chariot

▶ THE HIGH PRIESTESS

▶ FOUR OF SWORDS

▶ THE MAGICIAN

▶ THE CHARIOT

OSWALD WIRTH TAROT

The English Magic Tarot

Animated, graphic symbols enriched with magical layers.

Creators: Rex Van Ryn, Andy Letcher and Steve Dooley
Publisher: Red Wheel/Weiser, 2016

If the occult is all that is hidden, and the tarot a journey reflecting each of our own lives, then the English Magic Tarot carries both an underlying narrative of hidden truths and our magical connection to the universe.

Comic and movie artist Rex Van Ryn first collaborated with playwright, Howard Gayton in 2012 when they created a graphic novel, *John Barleycorn Must Die*, an 'esoteric detective story' where the protagonist uses his tarot deck to help unravel clues to a mystery. It was, in fact, Barleycorn's fictional tarot deck that became the inspiration for the English Magic Tarot.

Developing artwork he'd created for the earlier Barleycorn tarot, Van Ryn found further ideas for the images for the English Magic Tarot during daily spiritual rituals, along with his tête-à-têtes over tea with Devonshire neighbour Andy Letcher. Writer, druid, folk musician and expert in neopaganism, Letcher had similar interests in natural magic, and worked with Van Ryn to create the key theme for the deck based on Rex's idea that it had to be something about English magic. Letcher also went on to write the accompanying book while the colouring of the cards, an essential part of the storytelling, was handed over to illustrator Steve Dooley.

Magical Layers

This unique deck tells stories on different levels. The striking imagery shows characters (many of whom were based on real-life friends in their local community) representing the period when magic and occult practice was at its most potent in English history – from the end of the fifteenth century until the middle of the seventeenth century. Elizabeth I's favoured astrologer, Dr John Dee, appears as the Magician card, for example.

Secondly, Letcher inserted secret messages and codes on each card, with random coloured letters, unusual alphabets and mirror writing. For example, The Empress card's backward writing when mirrored, reads 'solid thing', part of a clue that, when combined with all the other riddles, creates an occult treasure hunt leading to an ancient truth and binding the deck as a whole.

▶ **TWO OF SWORDS**
A blindfold is usually considered to signify the refusal to accept or see the truth, or having no sense of direction. In ancient Greece, Tyche was the goddess of luck and chance, and later the Romans used Fortune, the 'blind goddess of fate' to depict her ambivalent nature.

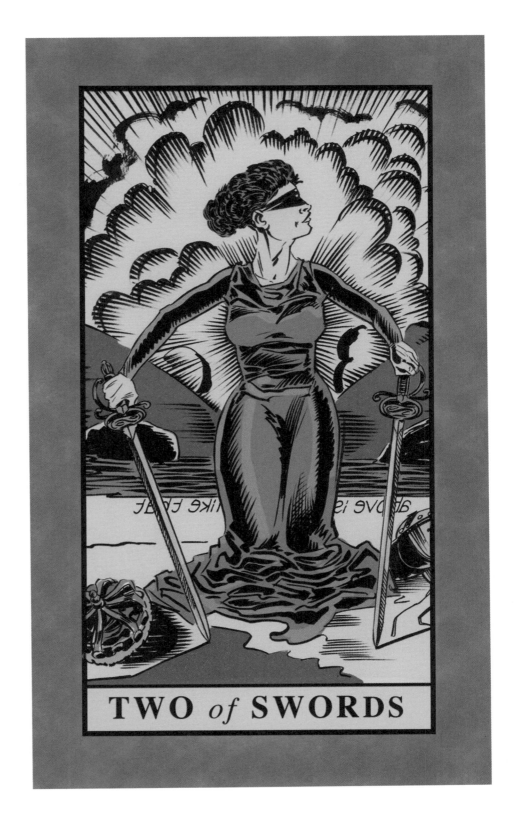

TWO of SWORDS

THE ENGLISH MAGIC TAROT

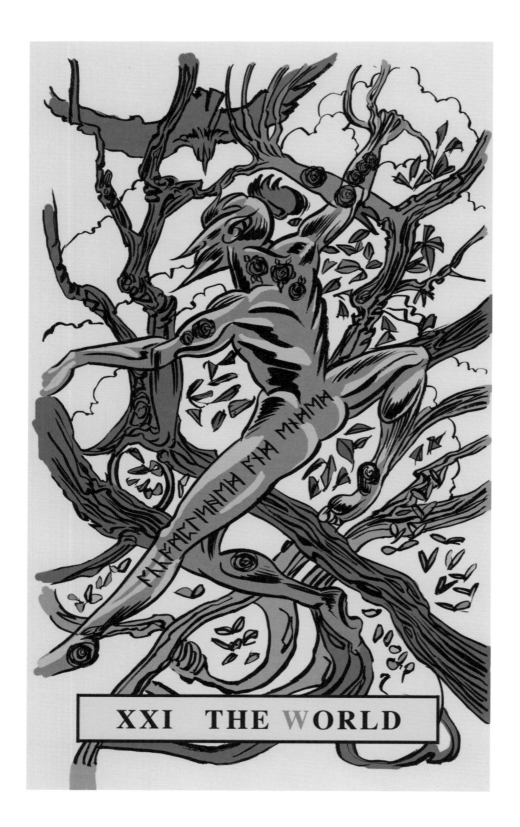

XXI THE WORLD

ESOTERIC AND OCCULT DECKS

◀ **THE WORLD**

The runes' symbolic alphabet is often used as a divinatory technique; as here, one of the many clues to a deeper mystery behind this deck. Traditionally the World signifies 'completion and fulfilment'. The runes when deciphered are 'accomplished and ended'.

▶ **THE FOOL**

The unnumbered archetypal Fool card (cheekily illustrated with the face of co-creator Andy Letcher) reminds us to move on, take a risk or leap into the dark to find the light.

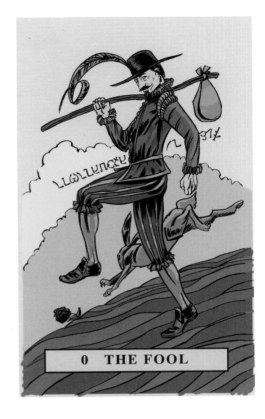

Letcher says in a blog that he shut himself in a friend's garden shed to write the accompanying book. Unsure of how to interpret the cards, he relied on his own tarot knowledge and the immediacy of what was before him, each card 'speaking to him' as he wrote down the vivid messages coming from the artwork.

Mystery Novel

If this deck sticks to the RWS format, then its graphic imagery and magical levels for the reader to discover is a new departure. This 'mystery novel' tarot is complemented by Letcher's revival of a Renaissance memory technique used by occultists to elevate their thinking to higher planes. The great proponent of the Art of Memory Theatre was fifteenth-century Italian philosopher Guilio Camillo; and other memory systems were used by the likes of Dr John Dee, and magus and philosopher Giordano Bruno. A kind of symbolic, imaginative mind-mapping, memory theatre is similar to the mnemonic techniques popular in ancient Rome as a way or recalling or creating information. Through placing each idea in a different room or space, the ideas are recalled as you imagine yourself walking through the rooms. Similarly, it can be used to learn to read tarot cards by associating the 'idea' behind a card with the card's symbolic imagery, and thus recalling its meaning.

If tarot itself speaks on many levels, then this deck speaks on even more. Characters tumble into life, enigmas, clues and the weaving of ideas and symbols, make this an animated deck, which enables the reader to rediscover their magical connection to the universe. It also offers a pathway to understanding the web of occult knowledge hidden within oneself.

THE ENGLISH MAGIC TAROT

The Alchemical Tarot Renewed

Seventy-nine-card deck based on alchemical symbolism.

Creator: Robert M. Place
Illustrator: Robert M. Place
Publisher: Hermes Publications, 2007

Born out of the mystical vision of artist, author and tarot expert Robert M. Place, the Alchemical Tarot Renewed is a seventy-nine-card tarot using alchemical symbolism and traditional tarot imagery. Whether the reader is on an alchemical or tarot quest, the deck is designed to lead to the gold of inner knowledge.

This digitally coloured and redesigned version of the original is enriched with antique alchemical illustrations, and extra symbols are incorporated into each card. Also included is the original Lovers card that, in the first publication of 1995, was censored as being too sexually explicit and which was later replaced with the imagery of a couple kissing. In this version, Robert Place includes both cards, and we see the alchemical king and queen in a playful love-making position as Cupid shoots a dart, and again in the kissing version.

Robert began his own tarot journey in a strange way, and has since become one of the leading authorities on tarot history, symbolism and divination. He recounts how he first encountered the tarot in a dream state, in which he was told he would receive an inheritance, which must be used wisely. A few evenings later, a friend visited and wanted to show off his recently acquired deck of tarot cards. Robert was spellbound by the RWS deck, and although he was not unfamiliar with it, he realized that this was in a way 'his inheritance'. Coincidentally, or rather in a moment of synchronicity, another friend gave him as a present a copy of the Marseilles deck. The tarot filled Robert's world with creative ideas and he was soon guided to his first writing partner, Rosemary Ellen Guiley, and publisher, HarperCollins. Twenty years after the first publication, the alchemical tarot is now in its fifth edition.

The World Soul

Robert believes that the tarot wanted to be published, and it was the anima mundi or 'world soul' who was the protagonist for the whole project, while Robert was merely the craftsman following her guidance. He believes it is the anima mundi who speaks through the cards, and he is merely a channel for that wisdom.

► THE EMPRESS

► THE LOVERS

► THE EMPEROR

► THE DEVIL

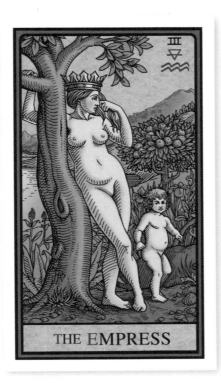

THE EMPRESS

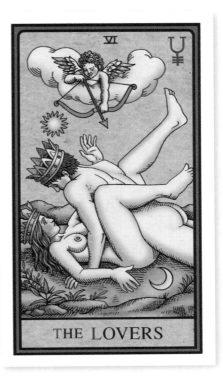

THE LOVERS

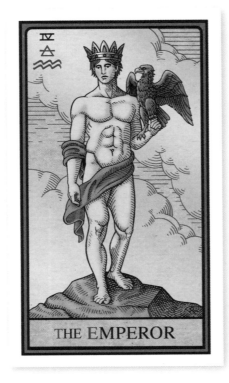

THE EMPEROR

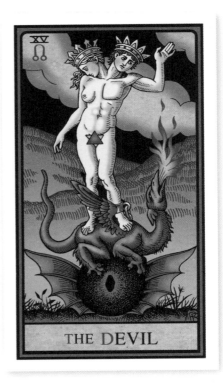

THE DEVIL

Alembics sit on shelves, yet one has fallen to the ground, perhaps disturbed by the thieving birds in search of nectar. The elemental sigil for Water reminds us that Cups are about feelings and emotions. This card represents regret in love, but there are more opportunities for happiness if we open our eyes to see there are still unbroken 'cups' on the shelf.

His interest in the link between alchemy and the tarot grew when he saw, in a flash, how a medieval alchemical illustration for the anima mundi was similar to that of the World card. He began to recognize links with other alchemical illustrations and each of the major arcana. He quickly began to believe that the cards were alchemical, and that the major arcana describe the Great Work. This was the beginning of a journey that led Robert into a period of scholarly and artistic research. It also helped him to understand spiritual transformation and divination techniques, and led to the opus mundi itself, the Alchemical Tarot.

Strength depicts a lady astride the green lion (in alchemy, a symbol of vitriol purifying matter, to leave the gold behind) with sol and luna, the sun and the moon, behind. The Hierophant holds open a book of alchemical symbols, while in the Tower a couple stand beneath an alembic, the vessel holding the alchemical ingredients of transformation. The naked Magician is Hermes with his caduceus, while the glyph for Mercury and his winged hat reaffirm his magical abilities. The caduceus tells the myth of how Hermes once tried to stop a fight between two serpents by throwing a rod between them, so they coiled themselves around the staff to represent how opposing sides can be reunited by the power of negotiation.

This deck is filled with other glyphs, symbols and images that may require a little more work to identify, but the distinct and clear Robert M. Place graphics will suit both beginners to alchemy and seasoned occultists alike.

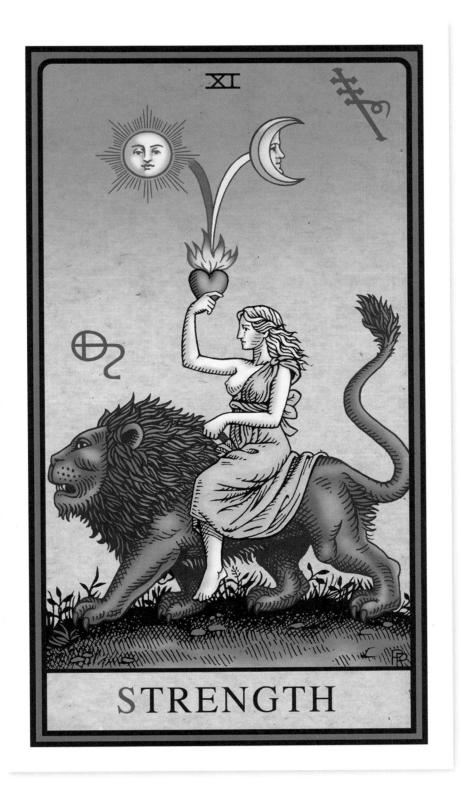

► STRENGTH

The symbol at the top right of the card means 'boil', while below left is the sigil for oil of vitriol (sulphuric acid). The green lion symbolizes the process of vitriol purifying matter to leave the gold behind.

STRENGTH

The Hermetic Tarot

Motifs from alchemy and astrology showcase
the Golden Dawn's Hermetic philosophy.

Creator: Godfrey Dowson
Publisher: US Games, 1990

The black-and-white Hermetic Tarot, filled with occult signs and glyphs, is a highly detailed deck based on the tarot system of Samuel Mathers (a founder of the Hermetic Order of the Golden Dawn). Creator Godfrey Dowson includes elements of Western astrology combined with Kabbalistic symbols as interpreted by the Golden Dawn. In the major arcana, a corresponding Hebrew letter appears on the top left corner, too. The names of the angels of the decans of the heavens by day and by night are included on all the minor arcana.

In Golden Dawn style, the High Priestess is renamed the Priestess of the Silver Star, the Empress is the Daughter of the Mighty Ones and the Hierophant becomes Magus of the Eternal Gods.

The Lovers are called Children of the Voice Divine, and the card depicts the well-known Greek legend of Perseus and Andromeda. Andromeda is chained to a rock as a monster rises from Neptune's deep waters to snatch her away. Perseus wields a sword and turns the monster to stone with the Medusa's head. It is a departure from earlier tarot Lover cards in that it shows them before their union. This union, or *conjunctio* as it is known in alchemy, relies on a trigger to spark the union. In the various stages of alchemical transformation, there is a separation process before the conjunction, a division of the pure from the impure.

Mathers used this myth to explain that, before perfection is achieved, turmoil is necessary. In a tarot reading, this card represents how we are not destined to be alone, but only by accepting oneself, one's inner turmoil and separateness, can a true *conjunctio* be achieved. Only when we love ourselves and all our faults, or turmoil, can we love another.

This deck reveals the alchemical process of turning lead into gold as a profound transformation in oneself, both psychologically and spiritually. The complexities of alchemy shine through this deck, but hidden among the wealth of symbols is the other aspect of this tarot – to illuminate our connection with the world soul.

The Magus of Power

▲ THE MAGICIAN
(THE MAGUS OF POWER)

ESOTERIC AND OCCULT DECKS

Child of the Great Transformers

▶ DEATH (CHILD
OF THE GREAT
TRANSFORMERS)

*A sigil for Scorpio,
long associated with
transformation and
change and the ending
of one cycle for another
to commence.*

Brotherhood of Light Egyptian Tarot

Minimalist depiction of Egyptian mythical culture.

Creator: C.C. Zain, 1936
Illustrator: Vicki Brewer, 2003
Publisher: The Church of Light, 2009

A minimalist deck devised from cards designed by Gloria Beresford in 1936 as a companion to C.C. Zain's book *The Sacred Tarot*. It is likely that this deck is one of the first to influence later Egyptian-styled tarot decks.

Zain's tarot cards were, in fact, inspired by images from a 1901 book entitled *Practical Astrology*, which itself had drawn on the works of Paul Christian, a notable French occultist, and a mysterious manuscript titled *Egyptian Mysteries*. This unauthenticated ancient manuscript had described Egyptian initiation rituals and how the symbols of the major arcana were carved into the initiation chamber, but it's likely the manuscript was published in the seventeenth century at the height of the Egyptian revival.

C.C. Zain ('Zain' is a Kabbalah letter that corresponds to a sword or dazzling ray) was the *nom de plume* of US occultist, Elbert Benjamine (1882–1951). Zain became a noted astrologer, and his writings are known as *The Brotherhood of Light Lessons*. He was devoted to re-establishing the Religion of the Stars, first associated with Akhenaten, the Eighteenth Dynasty pharaoh.

The cards allude to ancient Egyptian mythology, such as the magical, yet all-empowering goddess Isis. There are two Isis cards: 'veiled' as the hidden High Priestess and unveiled as the Empress. The symbolic and philosophical motif of the pyramid appears powerfully in the Tower card, and pyramids replace the two mountains usually seen in the Moon. The Sarcophagus, or Judgement, shows a mummified family rising from a sarcophagus, revealing the power of the belief in the afterlife as an ancient signature of judgement and redemption.

In 2003, artist Vicki Brewer redesigned the original black-and-white images, and in 2009 completed the full-colour deck to bring this Egyptian-styled tarot to life. With its muted symbolic colours true to ancient Egyptian dynastic art, it resonates to the power of the myths and belief systems of the ancient world. For whatever reason or way it was inspired, with its strong symbolism, this is a deck that conveys the spirit of the revival of Egyptian occult at the beginning of the twentieth century.

► THE HIGH PRIESTESS

► THE TOWER

► THE MOON

► JUDGEMENT

ESOTERIC AND OCCULT DECKS

2 II ♍

ב B ג

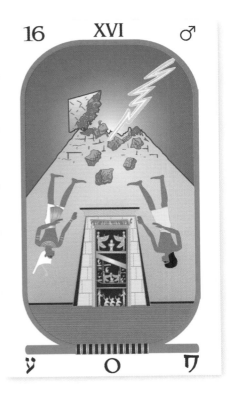

16 XVI ♂

ע O פ

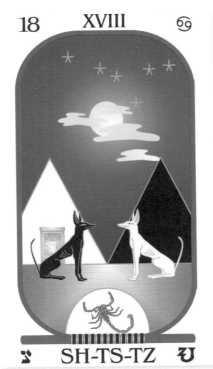

18 XVIII ♋

צ SH-TS-TZ ת

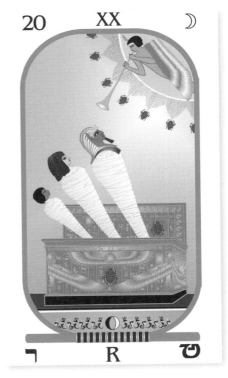

20 XX ☽

ר R ט

Tarot Illuminati

Modern take on the power of spiritual wisdom and illumination.

Creator: Erik C. Dunne
Illustrator: Erik C. Dunne
Publisher: Lo Scarabeo, 2013

This deck illustrates the power of divine light, whether from sun, moon, stars or fire, and the wisdom derived from such energy, which is essential for spiritual growth. Using this deck takes the reader on a journey to personal reflection and inner illumination. Its title has nothing to do with the secret society known as the Illuminati, but refers only to the Light of Wisdom and to the artistic style of the cards and their allusions to light.

Erik C. Dunne is a US-based freelance illustrator and designer, who stumbled on to his tarot journey in a metaphysical bookshop. His fascination with the tarot began by studying the RWS (see page 56), Aquarian (see page 74) and several Renaissance decks. Erik began to understand that there was an inner light of truth and illumination within the tarot. He designed his first card, the Queen of Swords, and tested it out on social media. He quickly had a huge following. He continued to work on the deck's art, and one night an epiphany moment came to him. He realized the deck was about the light of wisdom and the universe that shines through everything, and thus the Tarot Illuminati was born. By the time he had worked on all seventy-eight cards, his original choice of author suddenly was unavailable, and so chance, or a moment of synchronicity, brought him into contact with tarot author Kim Huggens, whose accompanying book sheds infinite 'light' on this dazzling work.

Erik's Magician is named the Alchemist, the one who performs the ritual of transforming raw, base materials into spiritual gold. He is dressed in the principal colours of the alchemical process, red and white, and could even be Hermes Trismegistus himself. Working with this alchemical premise, Erik focused on a global theme for universal enlightenment, and the four suits equally represent four different cultures: Cups, a European fantasy; Pentacles, mostly Asian or Japanese; Wands directed towards Moorish or Persian traditions; and Swords, English, particularly the Elizabethan era. All these cards are highly theatrical, and although there is no direct divination link to RWS or even Marseilles-type decks, these cards are about beauty, illumination and feeling and create an emotive reaction.

▶ **QUEEN OF PENTACLES**

In ancient cultures, the grape was a sacred fruit propitiated to the gods. It symbolizes abundance, fertility and prosperity.

ESOTERIC AND OCCULT DECKS

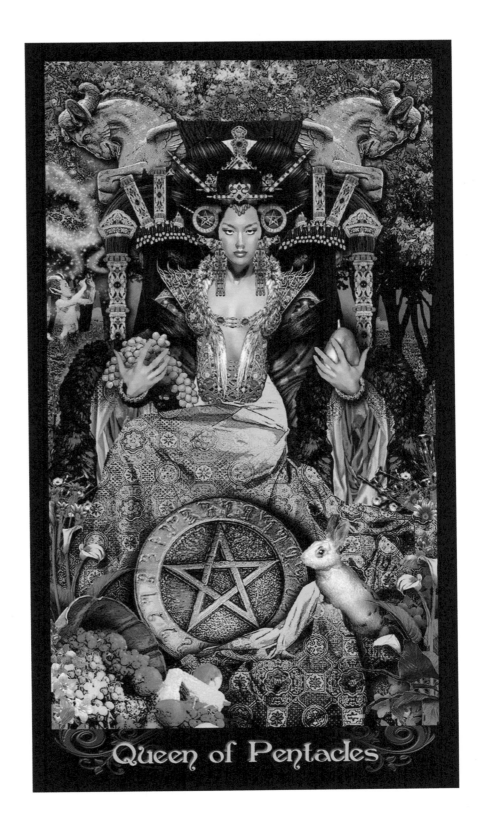

Queen of Pentacles

TAROT ILLUMINATI

Via Tarot

Thoth-inspired deck for spiritual growth and enlightenment.

Creator: Susan Jameson
Illustrator: Susan Jameson
Publisher: Urania, 2002

An accomplished engraver, artist and illustrator, Susan Jameson lives in southern England and is an initiate of a 'magical order'. In this beautiful deck, she primarily draws on the Thelema tradition of Crowley's Thoth deck (see page 64), along with other sources, including Kabbalah, alchemy and astrology.

The cards depict archetypal themes and myths wrapped up in vivid, figurative art with a rich source of symbolism, and are far easier to relate to than the abstract artwork of Lady Frieda Harris's original Thoth deck paintings. Jameson recalls how the major arcana images came to her first through visionary dreams, then by scrying rituals using an obsidian crystal.

The minor arcana cards were inspired by Jameson's own inner spiritual work, as well as an interpretation of Crowley's notes and designs. The court card characters are theatrical, vibrant and often depicted in landscapes or seascapes (the Princess of Cups, for example).

The bubble characters in Via Tarot are given dramatic expressions or movements to reveal the energy behind each card. For example, the Ace of Wands shows an exuberant character holding aloft a flaming wand, demonstrating the passion behind the card and its association with the element of Fire. The deck's artwork was created with coloured pencil although Susan usually paints with watercolour or oils. This is a brilliant Thoth-style deck for spiritual readings, inner reflection, personal growth and magical meditations.

► THE AEON

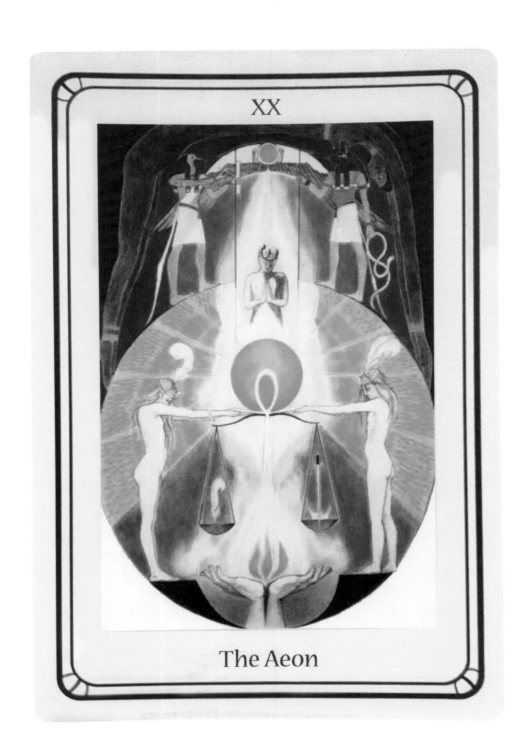

XX

The Aeon

Splendor Solis Tarot

Based on a sixteenth-century illuminated alchemical manuscript.

Creator: Marie Angelo
Illustrator: Debbie Bacci
Publisher: FAB Press, 2019

The Splendor Solis Tarot is an exquisite illuminated pathway to understanding the inner process of alchemical transformation within oneself. The major arcana represent the Artisans, or the archetypes that reveal transformative powers in the process. The minor arcana are the four suits that express the four worlds of Spirit, Soul, Mind and Body.

The original illuminated alchemical text, the *Splendor Solis* (Splendour of the Sun), dates from around 1582, and is attributed to the legendary Salomon Trismosin, thought to be the teacher of Paracelsus. The work consists of a sequence of twenty-two images illustrating the symbolic alchemical death and rebirth of the king. It incorporates the seven flasks, or alembics, each associated with the key planets known at the time.

The creators, Marie Angelo, an archetypal and Jungian author and scholar, and Debbi Bacci, an artist, publisher and tarot reader with over twenty-five years experience, collaborated to create this unique, beautiful deck and to reveal the secret alchemical message of discovering one's gold within – a message that they believe is hidden, and can be revealed through working with the tarot.

▶ THE MAGICIAN

▶ THE EMPRESS

▶ FIVE OF WANDS

▶ DEATH

ESOTERIC AND OCCULT DECKS

I ~ ALCHEMIST ~ 1

Alchemy of the Magician

III ~ ROYAL PAIR ~ 3

Alchemy of the Empress

5 ~ MARS of LIVING FIRE

Alchemy of the Five of Wands

XIII ~ WHITE BIRD ~ 13

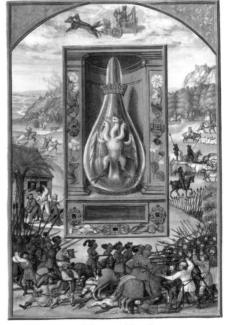

Alchemy of Death

Cosmic Tarot

Vintage New Age deck encompassing a range of belief systems.

Creator: Norbert Losche
Illustrator: Norbert Losche
Publisher: AGM-Urania, 1986

The Cosmic Tarot, based on the Golden Dawn system, has become a popular mystical New Age deck, which embraces all belief systems and gives the seeker cosmic power to bring insight into oneself for both divination and reflective purposes.

The creator, Norbert Losche, lives in Germany and, after an early career as surveyor, followed by a study of the history of art, he finally achieved his ambition to become an artist and illustrator. This complete seventy-eight card deck is a newly illustrated version of the original Golden Dawn version, with the exception of the court cards. The major arcana are, however, more in line with Waite's own version of the Golden Dawn, apart from a few cards that align to the original Golden Dawn tarot.

For example, the Wheel of Fortune depicts a huge wheel in the night sky, the planets arranged to correspond to the Kabbalah's Tree of Life. A series of astrological glyphs surround the planets around the central motif of the Sun.

However, Norbert's tarot deck attempts to recreate a tarot that includes as few symbols as possible in order to capture the archetypal essence of all those doctrines, whether astrology, Kabbalah, Hermeticism or numerology. In the Six of Wands, the young man wears a laurel wreath for victory, the crowned lion acknowledges the youth's success and the glyph for Jupiter on the man's tunic reveals that wisdom is the pathway to taming our base instincts. Maybe there are fewer symbols than many tarot decks, but there are enough to 'show the reader the way' and to connect to the deeper archetypal collective held within the tarot. This 1980s vintage-style deck has vivid court card portraits, many of whom could be Hollywood stars according to many reviews, or maybe they are simply archetypal portraits of the era's cultural ideals of beauty, as all tarot cards are.

The accompanying book, *Cosmic Tarot* by Jean Huets, is a complete guide to Losche's tarot, with card interpretations for three different levels: the cosmos, the social world and the individual world.

▲ SIX OF WANDS
The proud young man wears a laurel wreath, which, in the classical world, symbolized victory.

ESOTERIC AND OCCULT DECKS

Wheel of Fortune

▶ THE WHEEL
OF FORTUNE

Tarot of the Holy Light

Like many contemporary occult decks, this stunning tarot is filled with symbols and details to inspire and provoke deeper awareness into what those symbols mean to the reader.

Creators: Christine Payne-Towler and Michael Dowers
Publisher: Noreah Press, 2011

Digitally created with collages of late medieval and Renaissance artworks, the Tarot of the Holy Light is a rich amalgamation of esoteric beliefs and occult workings from this era. Christine and Michael have merged the symbolic premises and philosophies of magicians and occultists, such as Cornelius Agrippa, Paracelsus and Christian mystic, Jacob Boehme, with other beliefs of Rosicrucians, Kabbalists and Neoplatonists.

This deck discloses the power of occult 'correspondences'. The symbolic associations of numbers, alphabets and astrology (as revealed in tarot) is part of a long tradition of Western occult philosophy, which was noticed by Court de Gébelin in the eighteenth century and Éliphas Lévi in the nineteenth century, but which was deconstructed by the Hermetic Order of the Golden Dawn's disparate beliefs of various members, and which resulted in a departure from traditions believed to date back several thousand years.

Beautifully coloured and filled with symbols, the cards' meanings are not directly obvious, but this is a deck that invites the seeker into the world of occult philosophy and its ancient links with astrology. For example, in this deck, the Three of Swords is associated with the last decan of Libra, ruled by Mercury and representing communication and impetuosity. A serpent (malice) coils around a chrysalis-like heart, while a zodiac pointed star, replete with alchemical symbols, lights the sky. This card tells how hasty words are often the cause of self-sabotage and pain.

Drawing on the correspondences between alchemical elements and astrological associations, the deck is enriched with the magical thinking of early seventeenth-century esotericists, such as Jacob Boehme. This fusion of esoteric knowledge comes to light in the major arcana cards. The Tarot of the Holy Light illuminates the spiritual knowledge of the medieval magi, who preceded the later occultists, and offers a unique deck for study, contemplation and further knowledge of alchemy and the early esoteric masters before Etteilla and Court de Gébelin.

▶ **THE CHARIOT**
The all-seeing eye refers both to the Christian Eye of Providence, who sees all of humankind, and to the Egyptian god Horus, who's wadjet (eye amulet) was placed in pharaohs' coffins to protect them in the afterlife.

ESOTERIC AND OCCULT DECKS

7 The Chariot II

TAROT OF THE HOLY LIGHT

Rosetta Tarot

Powerful imagery invites self-discovery and soulful transformation.

Creator: M.M. Meleen
Illustrator: M.M. Meleen
Publisher: Atu House, self-published, 2011

The creator of the Rosetta Tarot is the mysterious M.M. Meleen, an artist and Thelemite (a follower of Crowley's philosophy of 'do as thou wilt'). Based on Crowley's Thoth deck, this tarot is rich with astrological, alchemical and Kabbalistic symbols.

This deck shows that the tarot speaks a universal language with roots in the Golden Dawn. As noted in the Tarot of the Holy Light (see page 194), the Golden Dawn reworked many of these ancient correspondences to align with their own belief system.

Different art mediums were chosen to reflect the nature of each suit. The major arcana, here considered the fifth or quintessential suit of Spirit, were painted in acrylic. The Wands (Fire) were created with a combination of coloured pencils and acrylic. The Swords (Air) were done in a dry-point etching technique, later hand-painted in acrylic. The Cups (Water) were done in a mixed-media of water-based inks and paints, and finally acrylic. The Disks (Earth) were painted in oil pigments and acrylic. The use of acrylic in all suits emphasizes the Spirit element of the cards.

Although this tarot is Crowley-inspired, Meleen's deck incorporates more alchemical symbolism. The Three of Disks depicts a wasp constructing cells in its nest. Each cell contains an egg, and each egg shows a glyph for Mercury, sulphur and salt respectively. The Five of Disks shows an array of horological mechanisms, while the Nine of Disks depicts an abacus.

The name 'Rosetta' refers to the Rosetta Stone, an ancient Egyptian granite stele discovered at the turn of the nineteenth century in Rosetta and dating to 196 BCE. This slab, inscribed with three scripts – Egyptian hieroglyphs, Demotic text and ancient Greek – proved to be the key to decoding previously unknown Egyptian hieroglyphs. Similarly, the Rosetta Tarot weaves Egyptian symbolism, Greek myth and philosophy with alchemical symbolism. If tarot is a language, then it is this unique combination of languages that unlocks the pathway to deeper understanding, enabling the reader to connect to the archetypes at work within themselves. This deck is a potent tool for meditation, self-discovery and soulful transformation.

▲ THE HIGH PRIESTESS

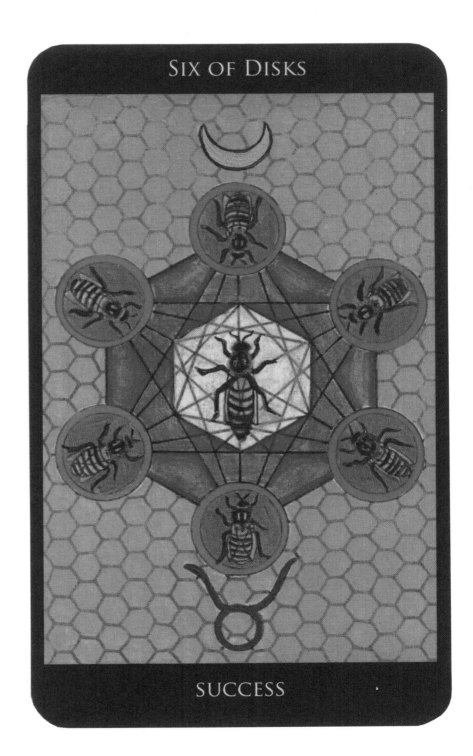

SIX OF DISKS

The bee has always been associated with the ability to achieve. To the ancient Druids, the bee symbolized the sun and success; mead, the main ingredient of fermented honey, was drunk at their sacred meetings.

ROSETTA TAROT

XVI The Tower

CHAPTER 5

Contemporary Decks

With tarot's popularity growing, there are hundreds of decks published every year, and choosing a special few is never easy. But here are some that stand out from the crowd for a variety of reasons. They may be artistically unique, focused on a bizarre theme or directed at a target audience. These include New Age-style decks that reflect our cultural desire to discover more about spiritual growth, pagan beliefs or our deeper link with the universe, including all things to do with divination. This New Age is also concerned with finding a code of being that respects humanity, nature and our place on Earth.

So whether you adore a fantasy deck filled with witches or vampires, or feel empowered by the mystical imagery of a meditational deck, it is the 'living tarot' that remains true to itself and dictates the journey for each creator, dressed in whatever finery the creator chooses.

The tarot system, whether RWS, Thoth or any other, lives and breathes on through the plethora of fantasy, fairytales, comic and mythological heroes, themes of danger and disaster, artists and their amazing works or simply as the animals we love or the food we eat. It is not these themes that have taken over the art of tarot, it is tarot that has infiltrated our lives and found a way to empower us.

This section looks at tarot in a contemporary environment. We may of course then begin to wonder what might become of tarot in the future? What can our 'reading' of this book foretell? Will tarot move with the times and yet still remain itself, just reflecting changing cultural trends, yet always alive with its own archetypal nature?

Tarot questions us to think not of just our own quest, but of its own, too.

Meanwhile, here are some of the best contemporary decks around; there will always be more.

Dreams of Gaia

Mythical and mystical influences for trusting in one's deepest self.

Creator: Ravynne Phelan
Illustrator: Ravynne Phelan
Publisher: Llewellyn, 2016

When Australian-born Ravynne Phelan began to suffer from mental health issues in her teens, no one realized it might be a symptom of her deeper need for creative expression. Her dreams of becoming an artist had been dashed by circumstances, by other people's expectations and by her own lack of self-belief. Yet something deep within struggled to the light when her health improved through art and other forms of therapy. In her mid-thirties she began to work as a professional artist and to express her creative connection to the divine.

The name of the deck derives from the Greek goddess Gaia, mother of all the gods, and more commonly known now as Earth Mother. As such, this stunning tarot deck imagery brings us face to face with our individual dream of the divine, and the dreams of the archetypal nature of Gaia, for we are all of her, too.

Ravynne admits on her website that she is eternally changing, as are we all. She believes we must be ourselves and trust in that self. The Dreams of Gaia deck embraces this individual sense of 'self' in a totally different way than most other tarot decks. The philosophy is simple: 'to seek, to feel, to grow and to heal'. With eighty-one cards, the minor arcana are divided into the four elements – Air, Fire, Water and Earth – and the major arcana, although akin to the RSW format, have diverse archetypal symbols, such as the Crone, Healing, Abundance and Perception, although still mirroring similar attributes. For example, The 0 card is named Choice, echoing the Fool and the Fool's journey of choices. Here, we must learn to take responsibility for the choices we make, for it is those that determine our destiny.

The extensive accompanying book and the vivid imagery enables the reader to enter an idealized world of pagan lore and legend, filled with mystical beings and mythical creatures. Ravynne admits to being a 'toolmaker', who has created a tarot system through her art, so that the reader can make decisions for themselves. An artist, healer and visionary, Ravynne's Dreams of Gaia reminds us that our dreams are interconnected to the universe, and that learning to trust in the deepest part of yourself will enable to to do what is right for you.

► QUEEN OF AIR

► ABUNDANCE

► CHOICE

► THE CRONE

XIII. QUEEN OF AIR

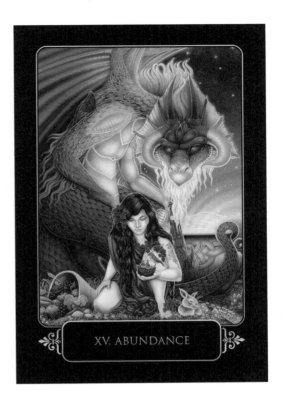

XV. ABUNDANCE

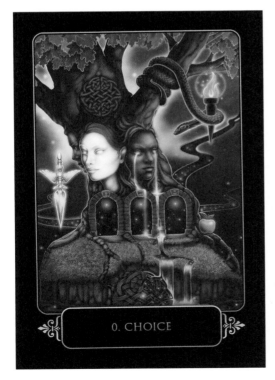

0. CHOICE

VI. THE CRONE

Bianco Nero Tarot

Unique black-and-white deck, with simple imagery.

Creator: Marco Proietto
Illustrator: Marco Proietto
Publisher: US Games, 2016

Marco Proietto may be an elusive Italian illustrator and painter whose work seems to cross the board from erotic to the pure, but his clean-cut, yet highly detailed black-and-white tarot deck is a fascinating modern twist on tradition. With a mixture of Rider-Waite-Smith pictorial-themed minor arcana and an infusion of Visconti-inspired imagery, this is a deck for both beginner and experienced reader alike. Contemporary, but archetypical, this simple deck is easy on the eye and yet filled with symbol and meaning.

Drawing on the style of antique engravings and woodcuts, the illustrator's use of cross-hatching highlights the chiaroscuro effect, to create vivid imagery and contrast in each card. For example, the Chariot card is illustrated with one horse darkened with detailed line work, the other in contrasting white. In the Justice card, the lady with the scales is illustrated in a sharply defined black-and-white drawing, while the Lovers are nude, erotic but lovingly drawn, touched with influences of Aubrey Beardsley and Art Nouveau woodcuts.

This is a deck that fuses the power of simple symbolic motifs with the tarot's message that everything you see in the cards is, in fact, a mirror of you. Yet here, in stark black-and-white contrast, the message is sharper, more defined and easily understood.

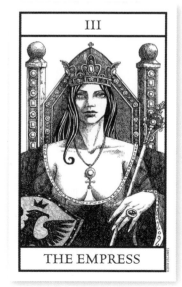

◄ **THE EMPRESS**
The Empress holds the eagle-decorated shield seen in the Visconti-Sforza deck and wears a pendant with the astrological sigil for Venus.

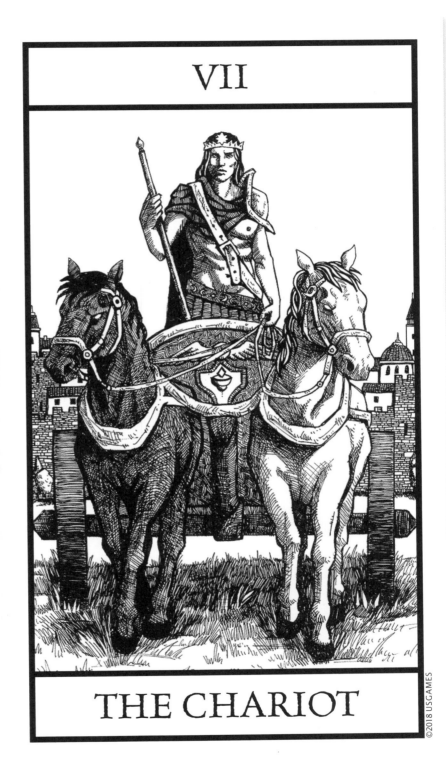

VII

THE CHARIOT

©2018 USGAMES

▶ **THE CHARIOT**

The confident warrior symbolizes success, determination and self-control.

Tarot of the New Vision

Unusual 'behind the scenes' tarot; adds depth to every reading.

Creator: Pietro Alligo
Illustrators: Raul and Gianluca Cestaro
Publisher: Lo Scarabeo, 2003

Based on the RWS format and style, but with a different perspective to each card, this deck provides unusual back stories to the original RWS symbolic viewpoint. Rendered in soft colours, giving it a vintage feel, the major and minor arcana scenes are drawn and observed from different positions, sometimes 180 degrees, sometimes at right angles. Although in many cards, such as the Queen of Pentacles and the King of Swords, the characters' faces are turned away, the landscape around them indicates what they may be confronting, what is going on behind them or what has 'just been happening' to reach this archetypal moment.

For example, in the Ten of Swords we now see a devilish character descending from the heavens and responsible for our nightmares. The Magician is now facing a large audience, as a sly monkey hides behind him tugging at his cloak; the Magician is less a magician and more the trickster. The High Priestess, now gazing away from us at the moon, is accompanied by two nuns or priestesses, and a wise owl perches upon a pomegranate (both symbols of hidden knowledge). The deck's illustrators are in fact twins, and this merger of two different yet symbiotic perceptions brings this deck to life with new meanings to be discovered in every card.

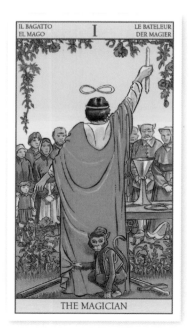

◄ THE MAGICIAN
All the cards in this deck can be used in conjunction with the original RWS deck to give a wider interpretation as to what lies 'behind the scenes' of these familiar archetypes.

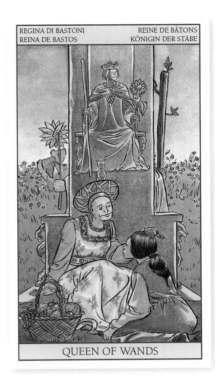

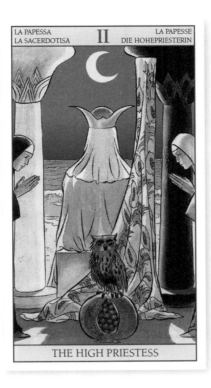

▶ **THE HIGH PRIESTESS**

▶ **QUEEN OF WANDS**

▶ **THE FOOL**

▶ **THE WORLD**

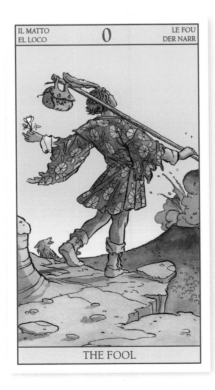

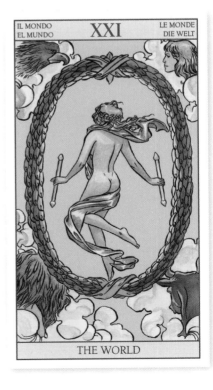

TAROT OF THE NEW VISION

Nefertari's Tarot

An Egyptian magic and mythology revival tarot.

Creator: Silvana Alasia
Publisher: Lo Scarabeo, 2000

Alasia created this deck, an opulent gold-leaf reworking of the Tarot of the Sphinx, as a tribute to the power and magic of Egyptian mythology and culture. With striking Egyptian-style two-dimensional artwork and a rich golden background, this deck is filled with ancient symbols and is the perfect deck for meditation and divination.

All seventy-eight cards have full pictorial images and redevelop the connection established by nineteenth-century occultists between the tarot and Egyptian hieroglyphics.

Nefertari was the highly respected wife of Ramses II. She was also known as Nefertari Merytmut (meaning the Beautiful Companion, Beloved of Mut) and Ramses II celebrated his love for her with monuments and poetry dedicated to her honour. She is even known to have accompanied Ramses on military campaigns. Upon her death, Ramses built an incredible tomb for her in the Valley of the Queens near Thebes. The tomb is covered in frescoes, among which can be seen versions of Nefertari's crown, which is associated with the goddesses Isis and Hathor, who help her in the afterlife.

Similarly, this tarot is a mythological journey into a world of the unknown, beyond the one we know to a world that lies hidden in oneself.

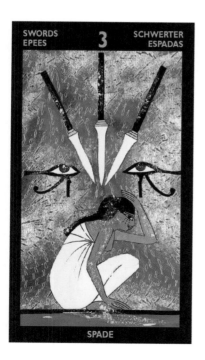

◄ **THREE OF SWORDS**
This card usually signifies sadness and suffering, or the pain we feel when wounded by other people's thoughts, words or actions. Yet it also suggests that we have a choice to either remain in this dark place or chose to find the light.

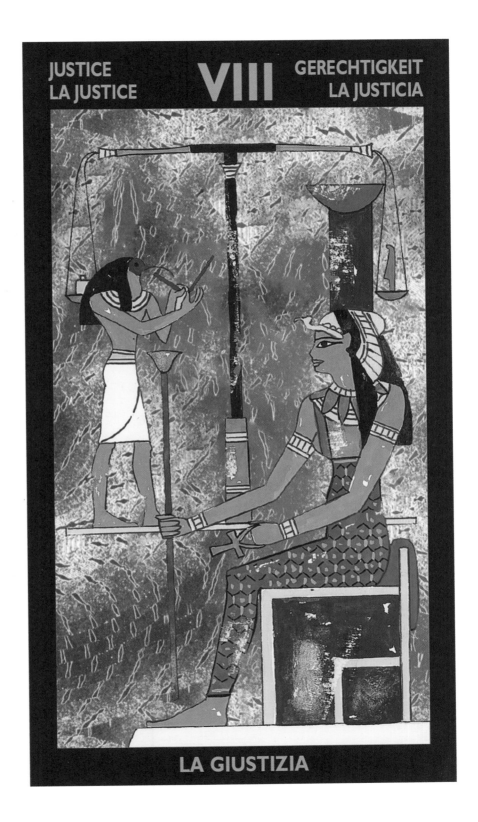

LA GIUSTIZIA

▶ **JUSTICE**

While Anubis weighs the heart of the deceased against Ma'at (truth) to determine the soul's fate, whether heavenly or hellish, Isis, co-ruler with Osiris of the Land of the Dead, holds the ankh, or key of life, and awaits the verdict.

Anne Stokes Gothic Tarot

Fantasy deck with foreboding images.

Creator: Anne Stokes
Illustrator: Anne Stokes
Publisher: Llewellyn, 2012

In this dark deck, full of mythical creatures and strange beings, Anne Stokes has created a tarot world of the grotesque and magical. Whether you are into vampires and dragons or fantasy Goth, this deck will delight and dare you to explore this bizarre and sometimes alarming world. For the minor arcana, Dragons replace the Wands, Vampires the Cups, Skeletons stand in for Pentacles, and the Swords have become Angels. Most of the images were taken from pre-existing artwork, so there are some strange matchings in the major arcana; for example, a flame-spitting dragon for the Chariot and a coiling serpent for the Hanged Man.

A full-time fantasy-art illustrator, Anne Stokes lives in the north of England, having previously resided in London where she worked on designing tour products for the rock bands Queen and the Rolling Stones. She has also worked on illustrations and themes for Dungeons and Dragons, and more recently created her own branded illustrations for T-shirts, posters, mugs and other accessories, not forgetting her love of tarot. Her underworld vision in this dark deck reveals both the Gothic horror of blood, foreboding castles and vampire steampunk and the magic of mystical beings and fairy folk. A powerful expression of her art, this is a tarot deck that will take you out of yourself into a darker fantasy world.

► **QUEEN OF SWORDS**
Swords reflect our struggles with our thoughts, beliefs and reactions to others. Even though the Queen has regrets, she has acquired enough knowledge to stay strong in the face of disillusionment.

QUEEN OF SWORDS KÖNIGIN DER SCHWERTER

REINE D'ÉPÉES REINA DE ESPADAS

Book of Azathoth

Creepy occult meets esoteric subtlety.

Creator: Nemo
Illustrator: Nemo
Publisher: Nemo's Locker, 2012

This bizarre deck, created by writer and illustrator Nemo, was inspired by the horror and science fiction writer H.P. Lovecraft (1890–1937). Although there are plenty of characters throughout the deck from Lovecraft's stories – such as Cthulhu, Nyarlathotep and the fish-eyed Deep Ones – the cards do not replicate a particular tale. Lovecraft's work is full of esoteric knowledge and dark truths that only a few discover, and his horrific universe is the perfect landscape for such an imaginative tarot deck.

Nemo's minor arcana have Men for Pentacles, Deep Ones for Cups, horned demon-like Humanoids for Wands and Humans for Swords. The major arcana are made up of figures and themes from Lovecraft's macabre world. The Azathoth landscapes are similar to Lovecraft's sunken city of R'lyeh, where all is loathsome corpses and nightmare slime. The ancient sea creature Cthulhu lies there dead, but still dreaming, and appears as the Emperor card. Azathoth, in Lovecraft's world, is a blind idiot god.

Nemo's inspiration was the well-known Crowley Thoth Tarot (see page 64) and suggests it was inevitable that in Lovecraft's world, there would be a tarot called the Book of Azathoth, perhaps once used in the sunken city of horror. Reclusive author and creator Nemo recounts how every card was hand drawn with pen and ink, and the complete deck took six months to complete. He admits that once his pen and creative vision were engaged, Lovecraft's world took over his imagination.

Lovecraft's own inspiration came from memories of childhood nightmares and Gothic horror stories told to him by his grandfather. His other influences were Edgar Allan Poe and the revolutionary changes in scientific knowledge at the beginning of the twentieth century. This busy, frantic, nightmarish sci-fi energy is perfectly depicted in the cards, which are also filled with esoteric symbols and signs, such as a zodiac wheel around the sun and the alchemical symbols for the four elements in the Sun card, or the alchemical magic square in the Magus (the Magician).

This tarot is in a world of its own, but it is one that sings of Lovecraft's mad darkness filled with a new tarot light.

▶ **THE HIGH PRIESTESS**

▶ **SEVEN OF CUPS**

▶ **THE CHARIOT**

▶ **THE WHEEL OF FORTUNE**

CONTEMPORARY DECKS

II — THE HIGH PRIESTESS

DEBAUCH — SEVEN OF CUPS

VII — THE CHARIOT

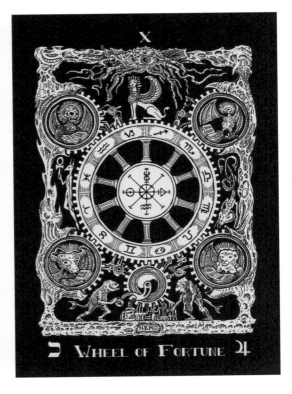

X — WHEEL OF FORTUNE

213 BOOK OF AZATHOTH

Shadow Scapes Tarot

A mythological fantasy deck filled with dryads, nymphs and sirens.

Creator: Stephanie Law
Illustrator: Stephanie Law
Publisher: Llewellyn, 2009

Stephanie Law has created a world filled with archetypal messages wrapped in a kaleidoscope of mystical colours, tree spirits, fairies, butterflies and insects.

The major arcana cards each tell a tale related to the archetypal theme. For example, the Fool shows a siren atop a precipice at the edge of the world. A fox sits at her feet, uncertain that her leap of faith, or literal leap in the dark, is safe. Yet as any fool knows, she will take the risk, her spirit of adventure will see her safely across the abyss. The Empress card depicts butterflies and spirits delivering a wreath of gifts to lay on her head, then in the swirling breeze they are gone, representing the abundance of creativity and embracing ideas.

Each suit is coded by animal kingdoms. For example, the Pentacles have dragons and sometimes chameleons, Cups include sea creatures, Swords have swans and Wands have foxes and lions. The Page of Wands depicts a nymph-like violin player, who in her musical dream attracts fairies and foxes to stop and listen to her music. Deep in concentration, she is focused and aware, as all Pages of Wands are.

A Californian-born professional artist, Stephanie has made a name for herself through her beautiful watercolour and mixed-media artwork and illustrations. Archetypal symbols are the main inspiration behind her tarot images, but she also uses her knowledge of choreography and dance to orchestrate her fantasy world, where insects, sirens and animals waltz, tango and swirl through each intricate painting. Her twenty-year experience as a dancer has helped her to understand and articulate in her illustrative work the rhythm and flow of the humans, birds, trees, wild winds and skies that appear throughout the deck.

Law's fantasy world, as seen through the tarot archetypes, brings the reader closer to the sacred aspects of nature and all of life.

▶ **THE TOWER**
A symbol of sudden illumination and release from ignorance, lightning was once thought to be a sign of punishment enforced on mere mortals by Zeus, the Greek god.

XVI *The Tower*

SHADOW SCAPES TAROT

Vision Quest Tarot

Native American spiritual traditions.

Creators: Gayan Sylvie Winter and Jo Dose
Publisher: US Games, 1998

Using the motifs and symbols of Native American peoples, this deck embraces not only sacred teachings and wisdom, but the archetypal elements of traditional tarot. It is a perfect tool for working with shamanic visions or dreamwork and for meditation.

Among the major arcana cards, the Chaos card (the Tower) shows a rearing horse in a ring of fire. In Native American mythology, the horse represents personal power and the card shows us that when all around is 'on fire', it is our inner strength that will guide us through any chaos. The High Priestess has evolved into the Medicine Woman, and the Wheel of Fortune is transformed into the Small Medicine Wheel, while the Empress becomes the Grandmother. The deck cleverly weaves tarot's major archetypal themes into the Native American tradition. For example, the Shaman card (the Hierophant) asks us to look within, to find our inner spiritual guide, and to blend this knowledge with the wisdom of the Elders.

The minor arcana are classed as the four elements – so Air as Swords, Fire as Wands, Water as Cups and Earth as Pentacles. All cards include scenes and symbols from Native American culture, such as totem animal spirits, medicine wheels and healing motifs. Arrows and wands represent Fire, jars and bowls symbolize Water, birds are for Air and vegetation for Earth. The court cards depict people engaging in the energy, such as working with sacred flames in Fire, or weaving in Earth.

▶ SHAMAN

▶ FATHER OF FIRE

▶ MOTHER OF FIRE

▶ FOUR OF WATER

V
Shaman

Father
of Fire

Mother
of Fire

Four of Water
Abundance

Golden Thread Tarot

Eclectic, mythological deck with simplistic but powerful illustration.

Creator: Tina Gong
Illustrator: Tina Gong
Publisher: Labyrinthos Academy, 2016

Minimalist, subtle and starkly black and gold, the deck began as an illustration project to learn more about the tarot and eventually evolved into the Golden Thread. Gong began the deck as an illustration project, though it evolved into the clean-cut lines and stylized figures of a complete RWS-inspired deck. There is also a companion mobile application if necessary. With strong golden lines, its simple, but bold eclectic imagery carries notes of worldwide mythological influences, such as Aztec, Taoist, Sumerian and Egyptian.

Conveying a powerful symbology, Tina Gong admits that the concept was inspired by the night sky. She also suggests it drew on 'the archetype of a single string that connected all things within the universe, threading images in a murky unknown'. Incidentally, the Yellow Way in Taoist cosmology describes the path of the sun through the year, and ancient diviners would work with the solar energy to signal auspicious times for prosperity, harmony and making life-changing decisions.

Similarly, the Golden Thread tarot can be used for both inner psychological work, for understanding more about ourselves, how to be at one with the universe (not forgetting tarot's mirroring effects of our own lives), and as a solar pathway to shine a light on appropriate action and decision making.

◀ EIGHT OF WANDS

▶ THE TOWER

▶ TEMPERANCE

▶ SIX OF CUPS

▶ THE CHARIOT

XVI

THE TOWER

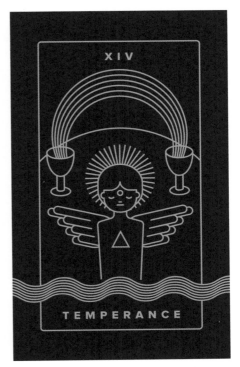

XIV

TEMPERANCE

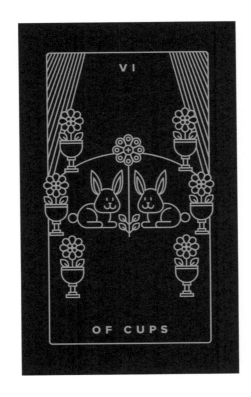

VI

OF CUPS

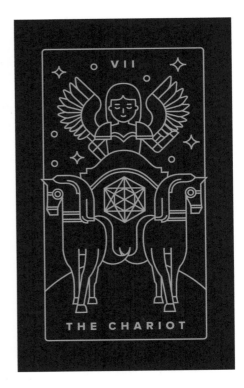

○ VII

THE CHARIOT

The Goddess Tarot

Evocative tarot deck celebrating the goddesses of
myth and legend and their relevance in our lives.

Creator: Kris Waldherr
Illustrator: Kris Waldherr
Publisher: US Games, 1997

**Drawing on many worldwide mythologies and cultures, the
goddesses and their attributes correspond to the archetypal
nature of the major arcana. For example, Justice aligns to the
Greek goddess Athena, the Star to the Sumerian goddess Inanna,
the Moon to the Roman goddess Diana and Judgement to the
Welsh goddess Gwenhwyvar. In Welsh myth Gwenhwyfar,
meaning 'white phantom', was the embodiment of the landscape
and the earth itself, and her union with a king gave him a divine
right to rule. She later became better known as Queen Guinevere,
the wife of King Arthur.**

Guinevere was forever romanced by knights and was considered
both a virtuous noble lady, but also a traitor who betrayed
Arthur when he was away from court. As the card Judgement,
Gwenhwyvar symbolizes that if we embrace the 'land' within
(the solid part of ourselves), we are being true to our intentions,
whatever judgement or opinion others project on us. And like
Guinevere, we may have to answer for our decisions, but not feel
ashamed by what we felt is right to do at the time.

The minor arcana suits resonate to goddess themes, too, such
as Venus to Cups, Freyja to Staves (Wands), Isis to Swords and
Lakshmi to Pentacles.

Writer and professional artist, Kris Waldherr has exhibited
in many galleries and museums, including the Ruskin Library
in Lancaster, England, and the National Museum of Women in
the Arts in Washington, DC. Working and living in Brooklyn,
New York, she believes tarot reading helps one seek and find the
truth within oneself and understand that it is our own actions
that create our future. Through goddess energy, we can begin
to work with the archetypal qualities we need for being the best
version of ourselves for healing and transformation. This is not a
deck for fortune-telling, but for finding oneself and one's pathway
through life.

▲ ISIS

*Here the Magician card is
represented by Isis, the Egyptian
goddess of magic and the moon.*

▶ VENUS

*The goddess Venus is the ultimate symbol
of love and romance, passion and desire,
but her predecessor, Aphrodite, was also
vain and obsessed with her own beauty.*

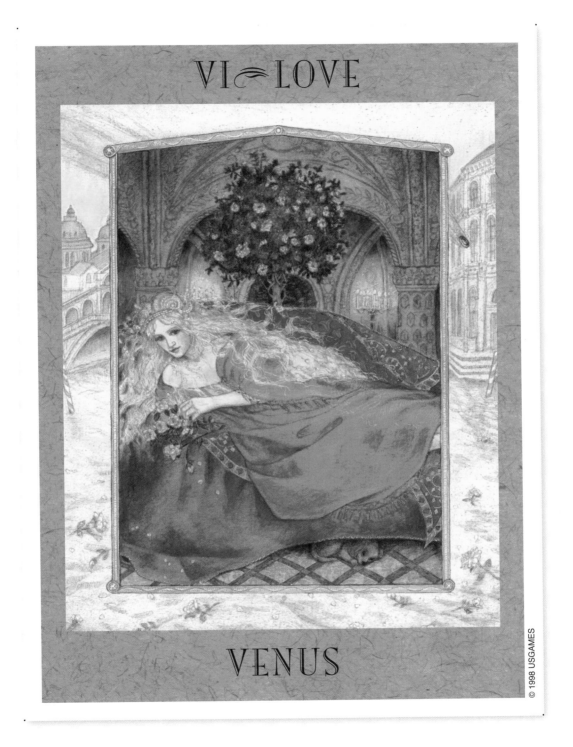

VI · LOVE

VENUS

THE GODDESS TAROT

Conclusion

Aleister Crowley's belief that 'tarot is an intelligence in itself' is perhaps more viable than many think. In fact, as you read the stories and secrets of the earliest decks and their creative accomplices, or turn to the pages of contemporary tarot whereby artists respect and utilize the tarot's archetypal nature to showcase their own creative power, you are engaging with this living force.

If tarot is an energy, a voice, a secret, an intelligence, a messenger of all that has been and will be, then in a way it is a divine thing, too. So much so, that when we turn to it, we will find that moment of 'being at one with the universe', and for just that instance know the truth of who we are, and where we are going.

Tarot is a curious paradox; it is brutally honest, yet kind enough to tell us the way forwards. In fact, the tarot never lies, and always tells the truth. Not only does it mirror those who read its messages and those who paint or create new versions of those messages, it also mirrors the depths of who you are.

The playwright George Bernard Shaw wrote, 'You use a glass mirror to see your face; you use works of art to see your soul'. Maybe tarot is the most accomplished and finest work of art of all.

Index

Sarah Bartlett (D. Psych. Astrol.) is the author of international best-selling books such as *The Tarot Bible, The Little Book of Practical Magic, The Witch's Spellbook* and the *National Geographic Guide to Supernatural Places*. Contributing astrologer to media such as *Cosmopolitan, She, Spirit & Destiny,* the *London Evening Standard* and BBC Radio 2, Sarah now practices tarot, natural magic, astrology and other esoteric arts.